AARON DOUGLAS
ART, RACE, AND THE HARLEM RENAISSANCE

AARON DOUGLAS

ART, RACE, AND THE HARLEM RENAISSANCE

Amy Helene Kirschke

UNIVERSITY PRESS OF MISSISSIPPI
JACKSON

The author and the University Press of Mississippi gratefully acknowledge the use of materials from Fisk University and Special Collections Division of Fisk University's Library; Schomburg Center for Research in Black Culture; Howard University; Bennett College; Theatre Arts Monthly; Survey Graphic Magazine; James Weldon Johnson Memorial Collection, Beinecke Library at Yale University; National Association for the Advancement of Colored People; National Urban League; the Library of Congress, Manuscript Division; Viking Penguin Books; and Scribner, an imprint of Simon and Schuster.

2nd Printing 1999

The paper in this book meets the guidelines for permanence and durability of the Committee on Production Guidelines for Book Longevity of the Council on Library Resources.

Library of Congress Cataloging-in-Publication Data

Kirschke, Amy Helene.
 Aaron Douglas : art, race, and the Harlem Renaissance / Amy Helene
Kirschke.
 p. cm.
 Includes bibliographical references (p.) and index.
 ISBN 0-87805-775-7 (alk. paper). — ISBN 0-87805-800-1 (pbk. :
alk. paper)
 1. Douglas, Aaron. 2. Artists—United States—Biography.
3. Douglas, Aaron—Criticism and interpretation. 4. Harlem
Renaissance. I. Douglas, Aaron. II. Title.
N6537.D62K57 1995
741.6'092—dc20
 [B]
 94-44276
 CIP

British Library Cataloging-in-Publication data available

For
TOM
(MY TRUE LOVE)

Contents

	Illustrations	ix
	Preface	xiii
	Acknowledgments	xvii
One	**A Hungry Spirit**	I
Two	**The Pulse of the Negro World**	14
Three	**An Artist Concerned with Black Life**	32
Four	**A Visual Artist with an Authentic Voice**	55
Five	**The Evolution of Douglas's Artistic Language**	71
Six	**The New Negro and Other Books**	92
Seven	**The Hallelujah Period**	105
Eight	**The Father of Black American Art**	125
	Notes	135
	Bibliography	149
	Index	159

Illustrations

1. Winold Reiss, *Roland Hayes*, 1925
2. Reiss, *Dawn in Harlem*, 1925
3. Reiss, *Interpretations of Harlem Jazz*, from "Jazz at Home," 1925
4. Reiss, *The Librarian*, from "Four Portraits of Negro Women," 1925
5. Reiss, *Two Public School Teachers*, from "Four Portraits of Negro Women," 1925
6. Reiss, *Elise Johnson McDougald*, from "Four Portraits of Negro Women," 1925
7. Aaron Douglas, *The Black Runner*, September 1925
8. Douglas, *Self-portrait*, September 1925
9. Douglas, *Mulatto*, October 1925
10. Douglas, *Roll, Jordan, Roll*, November 1925
11. Douglas, *I couldn't hear nobody pray*, November 1925
12. Douglas, *An' the stars began to fall*, November 1925
13. Douglas, *Untitled* (head of man with cityscape), December 1925
14. Douglas, *To Midnight Nan at Leroy's*, January 1926
15. Douglas, *Untitled* (industrial issue of *Opportunity*), February 1926
16. Douglas, *Untitled* (farm life), February 1926
17. Douglas, *The Creation* (reprinted from *The New Negro*), February 1926
18. Douglas, *Invincible Music, the Spirit of Africa*, February 1926
19. Douglas, *Poster of the Krigwa Players Little Negro Theatre of Harlem*, May 1926
20. Douglas, *Untitled* (male figure), June 1926
21. Douglas, *Tut-Ankh-Amen*, September 1926
22. Douglas, *Feet O' Jesus*, October 1926
23. Douglas, *I needs a dime for a beer*, October 1926

24. Douglas, *Weary as I can be*, October 1926
25. Douglas, *On de No'thern Road*, October 1926
26. Douglas, *Play de Blues*, October 1926
27. Douglas, *Ma bad luck card*, October 1926
28. Douglas, *Untitled* (black portrait head), November 1926
29. Douglas, *Untitled* (three shepherds), December 1926
30. "Opinion" to accompany Three Shepherds, December 1926
31. Douglas, *Princes shall come out of Egypt: Ethiopia shall soon stretch out her hands unto God*, May 1927
32. Douglas, *Mangbetu Woman* (from *L'Exposition de la Croisiere Noire*), May 1927
33. Douglas, *Untitled* (laborers), July 1927
34. Douglas, *The Burden of Black Womanhood*, September 1927
35. African Mask. Ivory Coast, ca. 1925
36. Douglas, *The Young Black Hungers*, May 1928
37. Douglas, *Untitled* (abstract drawings), n.d.
38. Douglas, *Untitled* (NAACP twentieth anniversary), May 1929
39. Douglas, *The Crisis* (NAACP cover), January 1930
40. Douglas, *Untitled* (Emperor Jones), February 1926
41. Douglas, *Forest Fear* (Brutus Jones), February 1926
42. Douglas, *Fire!!*, Fall 1926
43. Douglas, *Untitled* (artist), Fall 1926
44. Douglas, *Spark*, 1934
45. Douglas, *Rebirth*, 1925
46. Douglas, *Sahdji*, 1925
47. Douglas, *Surrender*, 1927
48. Douglas, *The Fugitive*, 1927
49. Douglas, *Untitled* (book decorations), 1927
50. Douglas, *Untitled* (advertisement for *Nigger Heaven*), 1926
51. Douglas, *Untitled* (advertisement for *Nigger Heaven*), 1926
52. Douglas, *Listen, Lord*, 1927
53. Douglas, *The Creation*, 1927
54. Douglas, *The Prodigal Son*, 1927
55. Douglas, *Go Down Death*, 1927
56. Douglas, *Noah Built the Ark*, 1927
57. Douglas, *The Crucifixion*, 1927
58. Douglas, *Let My People Go*, 1927
59. Douglas, *The Judgment Day*, 1927

60. Douglas, *The Blacker the Berry*, 1929
61. Douglas, *Congo*, 1929
62. Douglas, *Charleston*, 1929
63. Douglas, *The West Indies*, 1929
64. Douglas, *Africa*, 1929
65. Douglas, *The People of the Shooting Stars*, 1929
66. Douglas, *Apollo*, 1930
67. Douglas, *Philosophy*, 1930
68. Douglas, *Drama*, 1930
69. Douglas, *Music*, 1930
70. Douglas, *Poetry*, 1930
71. Douglas, *Science*, 1930
72. Douglas, *Diana*, 1930
73. Douglas, *Dance Magic*, 1930–31
74. Douglas, *Harriet Tubman*, 1930
75. Academie Scandinave
76. Douglas, *Untitled* (female nude sketch), ca. 1931
77. Douglas, *Untitled* (male nude sketch), ca. 1931
78. Douglas, *Untitled* (cafe scene, Paris), ca. 1931
79. Douglas, *The Negro in an African Setting*, 1934
80. Douglas, *Slavery Through Reconstruction*, 1934
81. Douglas, *An Idyll of the Deep South*, 1934
82. Douglas, *Song of the Towers*, 1934

Preface

Aaron Douglas was the first African-American artist to explore modernism and to incorporate African art into his work. Douglas rose from humble origins to become an important leader in African-American art and the most significant visual artist of the Harlem Renaissance. Despite his prominent role in that movement, however, Douglas remains relatively unknown. No biography of him or significant scholarly treatment of his work has been done. This book seeks to fill that important gap in the history both of American art and of the Harlem Renaissance. Douglas saw the Renaissance as a unique cultural movement, a "magic moment in history," whose authenticity as an expression of African-American culture was never in question despite the involvement of white patrons.[1]

The first half of this book analyzes Aaron Douglas's early years, when he undertook a remarkable odyssey from the small but progressive black community of Topeka, Kansas, to the teeming streets of Harlem and New York City in the 1920s. The artist's life unfolded at the time of the outbreak of World War I, the large-scale black migration to northern cities, and increasing racial conflict and consciousness. That new consciousness was reflected in the famous March 1925 issue of *Survey Graphic*, the magazine that inspired Douglas to come to Harlem at the height of the Renaissance. The problems, limitations, and contradictions within the Harlem Renaissance have been the subject of recent scholarship. Douglas's personal experience, however, offers a glimpse into the artist's encounter with white patronage, the vogue of primitivism, and the importance of group identity among the artists. Although his art depicted the black working class, he himself became a member of the African-American elite, associating with its intellectuals and political leaders and illustrating their works. Douglas's artistic career

owed its rapid success not only to his own talent and creativity but also to the help provided by three key men—Charles S. Johnson, Winold Reiss, and W. E. B. Du Bois. Each had a distinct effect on Douglas, helping him to achieve the self-confidence, artistic style, and racial consciousness that would distinguish his art.

The second half of this book analyzes and evaluates Aaron Douglas's art, focusing primarily on his magazine and book illustrations and his more famous murals. Douglas was a frequent contributor to the magazines *Crisis* and *Opportunity* and played a major role in the publication of *Fire!!*, a magazine that appeared only once but reflected the passion and intensity of the Renaissance's younger artists and writers. As Douglas's style developed over time, it reflected his increasing racial consciousness, the influence of the European modernists, and his attempt to incorporate African art into his work. His book illustrations exhibit his innovative draftsmanship, heavily influenced by Art Deco, synthetic cubism, and Egyptian art. After a year at the Barnes Foundation, the prominent art collection and educational institution in Merion, Pennsylvania, Douglas concentrated increasingly on murals, usually with specific racial or political themes. He also spent a year in Paris and returned to America during the Great Depression to execute some of his most important and politically radical murals. Although his artistic creativity waned as he grew older, he undertook the role of educator and influenced a new generation of African-American artists. By the time the productions of the Harlem Renaissance were rediscovered in the late 1960s, Douglas had earned the title "the father of African-American Art."

Several important issues and questions appear throughout Douglas's life that affect almost every artist in American society but are especially acute for those from minority groups. Douglas wanted to earn his living as an artist and hoped for mainstream recognition. But he lived in a segregated society and illustrated almost exclusively black subject matter. In one sense he was a victim of the "dualism" that W. E. B. Du Bois discussed so often. Douglas was both an American and a black, and he tried to satisfy both black and white audiences while maintaining his own autonomy and artistic independence.

Douglas emerged as an artist at a tense and troubled period of American history, a time of both heightened racial awareness and increased racial violence. The revival of the Ku Klux Klan, discrimination in

northern cities, and the persistence of lynching in the South were frequent subjects of articles in the *Crisis* and *Opportunity*. A black artist could hardly ignore important issues that were part of his life experience and heritage. Yet, did a black artist have to make his art racial in nature? Douglas, like other members of the Harlem Renaissance, had to decide whether to create art as a black or simply as an artist.

Forty years after the Harlem Renaissance, when in interviews Douglas reflected on this period, he saw most of his actions of the time as deliberate statements in reaction to important political and racial issues. This was, in part, hindsight. Douglas was genuinely interested in depicting the issues that were important to his race, and he did eventually choose to paint as a black artist and to express the black experience. His letters indicate that he was always aware of his race and the resulting prejudices. Yet the political context of his art was in many ways the result of supply and demand. Racial art was demanded by black leaders in Harlem, and Douglas responded. As he created his works, he became more aware of racial issues and for a short time, particularly in the 1930s, became politically radical in his personal life as well as artistically. Although his political radicalism faded, Douglas, not unlike Du Bois, would vacillate between advocating separatism or integration as the primary strategy to advance the cause of American blacks. Ultimately Douglas came to favor maintaining a racial identity in an integrated society, a forerunner of the concept that remains at the heart of the debate about American society which is now called multiculturalism.

Acknowledgments

I thank Clifton Johnson of the Amistad Research Institute at Tulane University for his assistance in this project, Beth Howse, Ann Allen Shockley of the Rare Manuscript Division, and Professor L. M. Collins at Fisk University, Malcolm Sweet at the Schomburg Center for Research in Black Culture, Priest, of the 135th Street YMCA in Harlem, and Esme Bahn at the Manuscript Division of Howard University, whose encouragement and guidance were particularly helpful. Herbert Peck's knowledge and skill in photography were vital to the project. At Tulane University, I owe deep gratitude to Clarence Mohr of the History Department, who was willing to support an interdisciplinary project when others would not take such a risk, and Jessie Poesch of the Art Department, who has both guided me and greatly inspired me and is the reason I began to work in this field. Seetha A-Srinivasan was a supportive, knowledgeable, enthusiastic editor who made finishing the book a positive experience. Trudie Calvert was an excellent copy editor, as well as a warm and encouraging person.

David Levering Lewis was instrumental in redirecting this manuscript, and I am deeply grateful for his help. His suggestions and generous encouragement enabled me to complete the project. David Driskell was also a tremendous help to me and introduced me to new sources and documents to help me finish the manuscript.

Professor Mercedes Carrara of Florence, Italy, changed the direction of my life and career by making art history exciting and accessible. Father Tony Lehmann, S.J., gave me the encouragement, love, and confidence, as he gives all of his students, to follow my dreams. At Loyola University, Father Stephen Rowntree, S.J., unknowingly redirected my life by making me see things differently in his philosophy classes, as did Bernard Cook in history.

Colleagues at Vanderbilt, who are also my dear friends, were extremely helpful in this project, including Sam McSeveney, Jimmie Franklin, and Joel Harrington in history and Ellen Konowitz in fine arts.

I also thank friends who have offered me their unwavering support, including Diane Doolittle, Diana Murkerson, Joan Breyer, and especially Kaye Drahozal and my brother-in-law Thomas Stockdale whose editing skills were tremendously helpful. Valena Minor Williams Waits was always warm, enthusiastic, encouraging, and generous with her time and resources and has made Aaron Douglas all the more real and dear to me.

My family has always been my source of joy and strength, including my father, Harry Kirschke, who motivated his daughters to achieve; my stepfather, the late Robert Bruce, who encouraged me to follow my dreams; my mother, Jane Stamos Bruce, who has always been her daughters' greatest supporter; and my sister and best friend, Melissa Kirschke Stockdale. My daughters, Helene and Genevieve, have made my life full and exciting.

Most of all, I thank my husband, Thomas Alan Schwartz. Words cannot describe his role in this book. He has been my greatest supporter and adviser. His warmth, humor, and love in our daily life together, as well as his invaluable assistance in this project, have made it all possible.

AARON DOUGLAS
ART, RACE, AND THE HARLEM RENAISSANCE

One

A Hungry Spirit

The young boy spent hours watching his mother paint and draw. Growing up in Kansas in the early years of the twentieth century, Aaron Douglas had little understanding of the world of the arts, but he knew that his mother's drawings were beautiful, and he longed to imitate her. Elizabeth Douglas was trained by itinerant artists who traveled through Topeka. Her modest still lifes inspired her son, who showed an early fascination with color and shade. The boy read voraciously, dreaming of a life beyond the confines of being a baker's son in Topeka. His origin in a small town far from the cultural centers of the East presented many hurdles to realizing his ambitions. But the most important hurdle was neither poverty nor provincialism but the fact that Aaron Douglas was an African-American at a time when most whites expected blacks to be either servants or menial laborers, segregation ruled much of the country, and its most horrible outgrowth, lynching, was not an uncommon event in America. In such a time of restraints and repression, even the idea of a black man becoming an artist seemed preposterous. Remarkably, Douglas was not discouraged. From early in his life, he refused to accept the limits the America of this era placed on blacks. Optimistic, adventurous, and self-confident, he was determined to become an artist, determined to receive the best training possible, and

convinced that he should play a role in the changing fortunes and fate of his race. This unflinching resolve and dogged faith in his own ability would lead Douglas to become the primary illustrator of the Harlem Renaissance and one of the most significant African-American artists of the twentieth century.

Aaron Douglas was born in Topeka, Kansas, on May 26, 1899. His father, Aaron senior, was a baker, originally from Tennessee. His mother, Elizabeth, a homemaker, was from Alabama. He had several brothers and sisters, none of whom demonstrated the same ambition or thirst for education that Aaron did. The family experienced constant financial struggle throughout Aaron's childhood, but his parents insisted that he pursue an education. Aaron attended segregated elementary schools, but in high school his classes were mixed, and some of his teachers were white.[1] From the time Aaron entered high school, he was virtually on his own in his efforts to educate himself. His parents were able only to feed and clothe their children. But Aaron did have the advantage of living in a city, an experience that was in many ways unique for African-Americans.

Many of the "Exodusters"—black Mississippians who migrated to Kansas after the Civil War—had settled in Topeka, and it had a relatively large, thriving black community, almost 10 percent of the city's eighty thousand inhabitants in a state where blacks numbered only 3 percent of the total population. It was also a remarkably cohesive and politically active community, culturally literate and reform-minded, imbued with the self-help creed of Booker T. Washington. Separate black institutions were formed as early as 1895, when the Kansas Industrial and Education Institute under the leadership of a Tuskegee graduate, William Carter, began its activities. Supported by both Carnegie grants and the Kansas legislature, the institute embodied Washington's philosophies of racial progress and self-help. The black church also played a major role in reform in black Topeka, sponsoring the Library and Literary Society and programs of social welfare within the community. Other black agencies for reform included the Alpha Assisi Charity Club and the Kansas Hospital Aid Association, both directed by black sponsors. Cultural organizations also provided activities for blacks. Among these were the National Federation of Colored Women's Clubs and the Interstate Library Association, which offered lectures, readings from Shakespeare and Tennyson, and musicals and art exhibitions.[2]

Black Topekans tended to follow Progressive intellectual and social doctrines, and strong and responsible black leadership was more the norm than the exception. Organizations such as the Black Topeka Federation encouraged economic development and political action. Blacks had greater access to elective and appointive offices and were less restricted or constrained in their dealings with whites than in most urban areas. Black literacy was high and supported an active press. The three newspapers, espousing the creeds of reform and self-help, kept the community informed of important political and social issues and covered such events as the symposium on the "Negro" question in 1913.[3] (The newspapers also enthusiastically identified black graduates of Topeka High School and reported increases in their numbers from year to year.) In Topeka, Aaron Douglas found a strong and supportive black community in which he learned the values of education and social uplift at an early age.

In later years, Douglas spoke of being torn between studying art or becoming a lawyer. In the black middle-class world of Topeka, the temptation to pursue the more secure and lucrative legal career must have been powerful. But Douglas finally decided that his greatest gift was his talent for painting. At Topeka High School he took college preparatory exams, convinced that he would need a fine arts degree to be an artist. But Douglas had no real understanding of the hazards and risks that lay ahead. Determined to become educated, he read "serious books" throughout his elementary and high school years, including the writings of Emerson, Bacon, Montaigne, Hugo, Dumas, Shakespeare, and Dante. This self-imposed curriculum, though intellectually stimulating and demanding, underlined the weakness of his academic background. Short of money, Douglas decided to work before trying to enter college. During high school he had worked at the Union Pacific Materials Yard and saved twenty-five dollars to use as travel money. Along with a friend, Edward Foster, he sought a higher-paying job away from Topeka. The two decided to travel east, like thousands of other blacks during this period, to find work at the Ford automobile factories.

Douglas was very different from the vast majority of these migrants, who were largely former sharecroppers or farm laborers, unskilled, uneducated, and poor men seeking jobs in industries of the North because they were being replaced by new farm technology in the

South. Douglas was a member of the middle class and hoped to pay for a college education and become an artist. He sought a job, money, and excitement, but his final goal was to finance his education. Still, he related to his fellow blacks: "In those days, black people were on the move. The World War was in progress, and we, black people were getting out of the South. Masses of them were coming North."[4]

Douglas and Foster traveled via the railroad shipman method, a common practice for recruiting black laborers for northern factories. Men were given a ticket and told to meet a group leader at a certain time to board the train. Although comfortable accommodations were promised, the two dollar ticket bought only a place in the baggage car. Douglas and Foster got off the train in Alton, Illinois, where Foster decided to stay. Douglas got back on, heading toward Detroit. The boy who had never been more than fifty miles from Topeka was now alone in a strange world among illiterate, tough farmhands from the cotton fields of Mississippi. Not only must their behavior have been a shock to Douglas, but the harsh treatment they received also affected him. Passengers were prevented from getting off the train early by armed men who threatened to shoot them. The danger of racial violence was also ever present, because many whites resented this influx of blacks into the cities.

In his autobiography, he gave a generally positive description of his journey, evincing the optimism and self-help philosophy that influenced his thinking:

> I saw some of the centers of mid-western America with all of their mad hustle and two-fisted pioneer spirit just as they were during the six months prior to the entrance of America into World War I. The parts of these areas that I was privileged to see were smelly, harried, and uncouth, but honest. This was America: the land of the free which promised a place for all who were willing to chip in and earn their way. Kansas City was grimy. St. Louis and its neighbor East St. Louis were sweaty, mean and ready to burst into the tragic mob violence and did so the very day after I left.[5]

Douglas's description of the cities he encountered reveals the great hope and ambition he brought to his journey:

> Cleveland was too large and gloomy to be understood by a lonely young Negro lad whose only viewpoint was from the docks, railway yards, and

warehouses that seemed to stretch without end as far as the eye could see. Detroit, the money Mecca of every young Negro youth who yearned to escape the oppressive conditions of his life, was the place where my journey came to a temporary halt. I was not quite sure of myself at this time and willingly chose every opportunity to test my strength and prove my manhood.[6]

The Detroit which Douglas found, the "money Mecca" for blacks, was a lively place, "wild and wooly," he would later recall. Douglas lived in a seedy section of town near the red light district, sharing a room with many others and sleeping in shifts in four beds. Throughout this experience, he remained positive and hopeful. He saw it as an adventure, a temporary stop on life's journey, not a permanent condition.[7]

Douglas found a job with a group of plasterers who were working on the Fisher Body Company building, mixing and carrying mortar. He worked with Italian masons who made the walls for the building. The job proved to be too much for the 130-pound youth, and he quit to go to work for Cadillac. His job there was to shake loose the black molding sand from hot automobile radiators after they had cooled sufficiently to be piled on the floor of the foundry. His boss was an Italian immigrant who gave Douglas directions in Italian, a language he did not understand. "I always got the worst jobs, they were certainly unskilled, they were the hardest jobs."[8] Douglas later reflected on this experience and his anger at the discrimination and racism:

> All kinds of outlandish myths were concocted to justify the exclusion of black men from our industries. It was seriously argued, for instance, that the black man's eyes, ears and reflexes were not sufficiently keen for regular factory work or our sense of touch was considered to be inadequate for the control and effective handling of fine tools, delicate instruments and expensive machines. These myths were eternally driven into the minds of the majority of Americans, both black and white, until nearly every black child in the land was afflicted with a feeling of inferiority almost impossible to overcome . . . those were the days when the black man at times could be crushed and utterly silenced by such derisive terms as "nigger," "coon," "shine," and the like.[9]

The middle-class young man from Topeka experienced some of the hardships of the new black proletariat that was taking shape in the cities of the North. His memory of labor in the factory would remain with

him throughout his life, influencing his artistic work and political sensibilities.

Though his stay in Detroit was brief—perhaps two months—Douglas wasted no time. When not working at the foundry, he spent his free time at the Detroit Museum of Art. Evening classes were offered free of charge to anyone who wished to use the facilities. He purchased paper and charcoal and attended the classes for the duration of his stay in Detroit, usually two to three times per week. This was Douglas's first formal training after high school.

In July 1917 Douglas received word from his friend Foster that he had arranged work for both of them in a factory in Dunkirk, New York. Douglas moved to Dunkirk, hoping to save enough money to pay for a semester's tuition in college.

> This proved a bit difficult even for a close-fisted fellow like me. Having no skills whatever, I was obliged as usual to take the first jobs offered. It was always my luck to get the roughest and poorest paying job wherever I was hired. My job in Dunkirk proved no exception. I had the task of sweeping broken bits of glass from the floor of the Essex glass factory and piling up broken bottles, sand and soda ash to be shoveled into the furnace from which it emerged finally as molten glass. . . . In spite of the tension and anxiety of the first few weeks away from home, I found some moments of this period as delightful as any that I have ever experienced before or since.[10]

Douglas returned to Topeka late in 1917 with three hundred dollars saved and new clothes suitable for wearing to college. It had been a successful adventure, and it whetted his appetite for more.

Douglas spent a month in Topeka and then left for Lincoln and the University of Nebraska, which had very few black students. Although he was determined to receive an education, Douglas had little understanding of the rules or format of a university education. He arrived ten days into the term, unaware what day classes began. Not only was he late, but he had not brought his high school diploma, transcripts, or any recommendations from his teachers at Topeka High School. But in a pattern he would repeat in the future, Douglas found support from those who saw in the earnest young man the spark of creativity and imagination. The chairman of the Fine Arts Department decided to accept Douglas conditionally upon receipt of his high school transcripts. Although he had to work long hours as a busboy to pay for his

education, Douglas soon became, in his own words, "the fair-haired boy" of the Fine Arts Department when he received first prize for drawing.[11] Douglas did his first serious painting during the first or second year of college as part of a rigorous course in the drawing of plaster casts. This practice soon became outdated, but he felt that it gave him facility and skill in drawing and helped him develop as an artist.[12]

Douglas's studies were interrupted at the end of the first semester by World War I. Anticipating the draft, he joined the regular army under a congressional provision that allowed men between the ages of eighteen and forty-five with high school diplomas to volunteer. This unit was known as the Student Army Training Corps (SATC). Douglas looked forward "with much satisfaction to the prospects of proudly drilling through the streets of Lincoln." After he had been active in the Nebraska unit for several weeks, he was called to the office of the commander of the regiment and informed that he would not be required to participate further in the activities of the unit. Suspecting that racial prejudice lurked behind this decision, Douglas found this to be a "deeply humiliating experience."[13] But he swallowed his pride and presented himself for military service in a different state where there might be less prejudice against blacks. After working for the summer at the Minneapolis Steel Machinery Company, Douglas volunteered for the SATC and entered the University of Minnesota, where he remained until the armistice was signed.

Douglas's experience was not unusual, and his patriotism was not unique. As he put it, "Patriotism was as Afro-American as religion."[14] W. E. B. Du Bois, the great black leader and historian who would play an important role in Douglas's career, urged blacks to "close ranks" with whites and serve in the military, hoping that such a demonstration of patriotism would lead to an end to discrimination at home.[15] His critics charged that Du Bois "had embraced the hope of full citizenship through carnage."[16] These hopes would be disappointed, and black soldiers often were subjected to separate and unequal treatment. Despite hopes that black soldiers might be led by black officers, black leaders were outraged to find that the War Department had chosen to train black soldiers at a segregated camp in Des Moines, Iowa. Their anger was not just a matter of dignity but a fear that this second-rate operation would turn out less than professional soldiers and therefore that serving would do little to help the race. African-American leaders

had hoped that upon their return, the troops' bravery would be re-
warded. They hoped for an end to lynching, an increased right to vote,
and better employment opportunities.

Despite the disappointment of larger hopes, Douglas's experience
during World War I proved to be positive. At the University of Minne-
sota he was assigned to a unit of about two thousand men, in which he
was one of about six blacks. Douglas's commanding officer was a stern
young lieutenant who treated him with respect. Douglas was in charge
of the distribution of equipment and materials and was made a corporal
over an eight-man outfit. He later admitted he knew little about the
military and made many mistakes, but his squad was understanding and
accepting of him. While in Minneapolis, he visited the Walker Muse-
um whenever possible to study form, technique, and proportions in the
works in its collections and library, including the Leonardo da Vinci
drawings. When the armistice was signed, Douglas returned to the
University of Nebraska.

Back in Lincoln, Douglas read further in the writings of W. E. B.
Du Bois and began to ponder the larger dimensions of the nation's
racial situation. By 1921 he was a "constant reader" of *Crisis* "and later
of the *Opportunity* magazines": "The poems and stories, and to a lesser
degree the pictures and illustrations were different. The poems and
other creative works were *by* Negroes and *about* Negroes. And in the
case of one poet, Langston Hughes, they seemed to have been created
in a form and technique that was in some way consonant or harmo-
nious with the ebb and flow of Negro life."[17] He also continued to read
the progressive black press from his hometown of Topeka, which fol-
lowed Du Bois closely.

After four years of hard work, Douglas received the bachelor of fine
arts degree from the University of Nebraska in 1922. He worked at
various jobs throughout college, including heavy physical labor. He
came to regard the drudgery as simply one more dimension of his
artistic preparation: "Fortunately, this experience proved to be the best
possible training and orientation for the creation and interpretation of
the life that I was later called on to depict."[18] Douglas always sympa-
thized with, and even romanticized, the common laborer, whose expe-
rience he had briefly shared.

Douglas hoped to go on for a master's degree in fine arts, but no such
program existed at Nebraska. During the summer of 1923, he waited
on tables on the Short Line of the Union Pacific Railroad and in the fall

secured a job teaching art at Lincoln High School in Kansas City, Missouri. Douglas had tried to survive on odd jobs to allow more time to paint in his studio in the year following his graduation, but he found that "the joy of sitting around with an empty stomach in a studio filled with unpurchased pictures had little glamour and no satisfaction."[19]

His teaching experience in Kansas City provided more than a secure income. Douglas experienced a small-scale enlightenment when he met William L. Dawson, a black musician, and the two formed a lifelong friendship.[20] This seemed to be more than just a chance meeting of two ambitious young artists of "like mind and purpose." For Douglas, it was like an "embryo, or first step" of a renaissance or revival. Finding a friend of the same racial and cultural background, who lived and worked "in the same milieu," raised Douglas from the isolation he later called "the cross the Black artist had to bear, who was often isolated physically, as well as in time, interest and outlook."[21] His decision to go to Harlem would be precipitated by this desire to overcome isolation.

While Douglas was in Kansas City, he worked diligently to improve his craft, although the resources to do so were limited. He discussed his dreams and hopes in letters to Alta Sawyer, his high school sweetheart and future wife. At the time, Sawyer was trapped in an unhappy marriage and contemplating divorce. For two years they wrote faithfully and met on rare occasions.[22] Early in their correspondence, Douglas told Alta that he had signed up for a commercial art course, putting down $10 toward the total cost of $150.00. A correspondence course may have been the only way a black man could receive training in art in Kansas City, and Douglas took it very seriously. He thought it promised "excellent but remote returns." Douglas wrote to Alta of his efforts in the course and studying on his own. His drive and ambition are immediately evident:

> I have been working and reading furiously. I have sent lesson six. It went yesterday. I am doing some work in ornament and design, a very tedious and laborious task. I am still getting up at 4 and 4:30. Sweetheart, you have aroused again in me that passion for work and study that deep seated ambition to push to the top. It is that same passion and that same ambition which alone carried me through all my school life.[23]

His reading included Sheldon Cheney's *Primer of Modern Art*, Charles Marriott's *Modern Movements in Painting*, and Henry R. Poore's *Concep-*

tion of Art and the Reason of Design,[24] all of which focused on trends in modernism. Cheney's *Primer* discussed the historical and theoretical background of modern art, as well as such movements as cubism and German expressionism. Along with Picasso's works, the book included reproductions from less famous movements such as vorticism, a British style that featured works in black and white not unlike Douglas's own early work. Charles Marriott's book discusses modern movements beginning with impressionism and including cubism and Picasso. The Poore book contains a few cubist reproductions, including Picasso's *A Woman*. Poore discusses the new movements, in particular artists Picasso and Matisse, by reviewing the writings of four advocates of modernism. (Douglas may also have seen the catalogs or exhibitions of the Société Anonyme and works such as Albert Gleizes's *Paysage*, ca. 1914, and Sandor Bortnyik's *Red Locomotive*, ca. 1918–19.)

Douglas could be extremely critical of what he read, exhibiting those qualities that would make him innovative and pioneering in his work:

> I have another [book] by Ruskin, *Ten Lectures in Art*. Just why I bought this book anyway I don't understand. Ruskin's aesthetics are 50 years behind, a hardened modernist would say a thousand. I just now opened the book at random and found this sentence which is the very antithesis of what the modernists are after. I'll quote it, "You are, in drawing, to try only to represent the appearances of things, never what you know the things to be." Could anything be more mischievous and misleading?[25]

When searching for early influences on the development of Aaron Douglas's paintings, it is difficult to find evidence of black artists, except for Henry O. Tanner.[26] If Douglas was influenced by black teachers or obscure black artists, apparently he did not recall them. Few black artists were known, and almost none were painting black themes. Among the few who chose black subject matter in the nineteenth and early twentieth centuries were Joshua Johnson (sometimes referred to as Joshua Johnston, a relatively unknown painter who was not rediscovered until the 1930s), who painted at least one portrait of a black man around 1805–10, and Edward Bannister, who painted *Newspaper Boy* in 1869 and was equally obscure. Edmonia Lewis, the famed half-black, half-Chippewa Indian sculptor, expressed issues of oppression and slavery in her art, as in the 1867 *Forever Free*, and Meta Vaux

Warrick Fuller, a sculptor who worked in Paris under Rodin, returned to America in 1905 to create such works as *The Awakening of Ethiopia* in 1914. There is no evidence that any of these artists directly influenced Douglas's early development. He would forge a new tradition depicting black subject matter.

At the end of his second year of teaching, Douglas found that he had again reached a dead end, or at least a fork in the road. The ambitious young artist realized that there was "a vast difference between my actual situation at that time and the goals I had previously set for myself."[27] Later in his life he would say that hunger of the spirit was more painful than hunger of the stomach and, despite the security of teaching, he wanted to take more risks.

Shortly after the school year of 1925 ended, Aaron Douglas quit his teaching job in Kansas City and made his way eastward. His exhilaration over taking this decisive step, as well as his self-confidence and love for Alta, are evident in a letter he wrote her en route: "Well, I have really begun a campaign which will land me either success or failure. In case of failure I have this consolation, my failure has been a conspicuous one. But I really don't think I shall fail. On the contrary, I think I shall succeed. I feel that your faith and confidence in me will be the keystone of my success."[28] Douglas originally planned to stop only briefly in Harlem before going to Paris to study. He thought that every painter should visit Paris. As he later recalled, the history of art pointed to the value of a form of artistic exile:

> One thinks of at once the Dumas, the Pushkins, and Coleridge-Taylor, none of who lived and worked in the same country. In our country there were H. T. Burleigh, Nathaniel Dett, Paul Laurence Dunbar, Charles Chesnutt and William Stanley Braithwaite—contemporaries all, but isolated. In the plastic arts there were Tanner, Bannister, Edmonia Lewis and Duncanson among others. Again, we find all of these artists working in isolation, and, with the exception of Bannister, all with their centers of gravity, so to speak, outside of their native land.

Harlem seemed like a natural stop on the way to the capital of the art world, Paris: "After I reached New York, in spite of the urgent pleadings of friends, my mind was set on a plan calling for at least a year of study in Paris. Where else but to Paris would the artist go who wished really to learn his craft and eventually succeed in the art of painting?"[29]

A former art teacher who had worked and painted in Paris wrote to
Douglas urging him not to go to Paris but to create a place for himself
in Harlem. Eric Walrond, a noted black writer, also encouraged Doug-
las to stay in Harlem. Walrond convinced Douglas that New York was
"where the action was" for a young black artist.[30] Ethel Ray Nance,
secretary for the National Urban League in Kansas City who was then
in Harlem, also played a key role in Douglas's decision to forego Paris.
She had met Douglas in Kansas City, and she encouraged him to come
to Harlem. When he arrived, she introduced him to Urban League
officials, who helped him obtain work. He later recalled: "I had hardly
reached the city before I was called upon to prepare cover designs and
drawings and sketches to be used for illustrating texts of various kinds
for both the *Crisis* and *Opportunity* magazines. This work soon con-
vinced me that it was unnecessary to go all the way to Paris to master
the fundamentals of the art of painting and that a more reasonable
course was to remain in America, and particularly New York, and carry
on my work."[31]

Harlem itself played an important role in Douglas's decision to stay.
In moving to the largest black city in the world, Douglas sought to end
the isolation that had hindered his artistic growth. His first reaction was
to feel overwhelmed and excited to be amid the action:

> My first impression of Harlem was that of an enormous outdoor stage
> swarming with humanity and spreading roughly from 116th Street on
> the South to about 143rd Street on the North, and from 5th Avenue on
> the East to St. Nicholas Avenue on the West. Here life moved across
> this vast stage without a halt from morning until night and from dusk
> to dawn. Here one found a kaleidoscope of rapidly changing colors,
> sounds, movements—rising, falling, swelling, contracting, now hurry-
> ing, now dragging along without end and often without apparent pur-
> pose. And yet, beneath the surface of this chaotic incoherent activity one
> sensed an inner harmony, one felt the presence of a mysterious hand
> fitting all of these disparate elements into a whole to be realized, to be
> understood only in time and from a great distance.[32]

Perhaps the most important influence on Douglas's decision to stay
in Harlem was the fortuitous appearance of an extraordinary publica-
tion. For several years Douglas had been following the young leaders of
what Alain Locke would call the "New Negro" movement, a precursor
of the Harlem Renaissance. He read a "remarkable body" of poems,

short stories, and essays in the *Crisis*, *Opportunity*, and *Messenger* magazines, which he felt indicated "a serious effort on the part of the young Negro writers to express in artistic language their reactions to life's hopes and joys, victories and defeats, which had for so long remained unspoken."[33]

While still in Kansas City, Douglas received a letter from a friend in Harlem urging him to enter his work in a competition sponsored by *Survey Graphic* for a special issue it planned on Negro life in Harlem. Douglas's friend thought "Negro life in Harlem would not be totally unlike Negro life anywhere else" and suggested that Douglas enter the competition for both "the experience and as part of your debut."[34] But Douglas decided not to enter the competition, perhaps on some level because he was aware that "Negro life in Harlem" was very different from Negro life in the rest of America.

As it turned out, Douglas was profoundly impressed by the "spectacular issue" of *Survey Graphic* magazine (1925), the magazine that would later be expanded to become Alain Locke's book *The New Negro*. *Survey Graphic* was, Douglas explained, "the most cogent single factor that eventually turned my face to New York,"[35] and *The New Negro* "eventually proved to be one of the most extraordinary books of the period and more clearly than any other single publication reflects the nature and extent of this unique movement."[36] *Survey Graphic* provided a fascinating yet complex view of Harlem, a thriving and vibrant city in which Aaron Douglas would make his most important artistic contributions.

TWO

The Pulse
of the Negro World

As early as 1917, a new "white curiosity" about the culture and characteristics of black America appeared in the United States, especially in the center of culture, New York City.[1] After World War I this interest grew, and whites were increasingly attracted to Harlem. Some blacks had misgivings, but leaders such as the writer James Weldon Johnson and Charles Johnson, the head of the National Urban League, regarded white interest as a positive development. Charles Johnson in particular hoped that white interest in black arts would lead to public exposure and more professional opportunities for Negro painters and sculptors. This desire did not take long to materialize. In March 1924 Harlem leaders held a dinner attended by influential figures in the New York cultural community and young black artists. The guest speaker was W. E. B. Du Bois, who explained that although his generation had been denied its true voice, the time had come for the end of the "literature of apology." In particular Du Bois praised James Weldon Johnson for providing an inspiration to young black artists. By the end of the evening, Du Bois's message moved one of the white participants, Paul Kellog, to make a unique offer. Addressing Charles Johnson, Kellog, the editor of *Survey Graphic*, offered to devote an entire issue of his "mainstream cultural magazine" to the new black artists, an offer Johnson gladly accepted.[2]

Why would such a magazine wish to do a special issue on Harlem? The offer was unprecedented but not as unusual as it might seem. The magazine *Survey* appeared twice a month, a "graphic" issue on the first, with a decorated cover, and a "midmonthly" issue on the fifteenth, printed on lighter stock and unbound. Although the magazine's subscribers were predominantly white, its editors were open to the forces of change they saw sweeping the world. Comparing the cultural development of black America with newly independent Ireland and revolutionary Russia and Mexico, the editors sought

> month by month and year by year to follow the subtle traces of race growth and interaction through the shifting outline of social organization and by the flickering light of individual achievement. There are times when these forces that work so slowly and so delicately seem suddenly to flower—and we become aware that the curtain has lifted on a new act in the drama of part or all of us. . . . If The Survey reads the signs right, such a dramatic flowering of a new race-spirit is taking place close at home—among American Negroes, and the stage of that new episode is Harlem.[3]

The special issue of *Survey Graphic*, with Alain Locke as chief editor, appeared in March 1925. It was titled "Harlem: Mecca of the New Negro."

Survey Graphic had an extraordinary impact on Aaron Douglas. In later interviews, he always insisted that one of the main reasons he came to Harlem was the inspiration he derived from this one magazine. What could an issue of *Survey Graphic* possibly contain that would make Harlem seem so inviting and interesting, so open to a young artist? It was the first comprehensive study devoted entirely to Harlem, and it contained the viewpoints of blacks and whites, women and men, scholars, sociologists, civil leaders, and poets. It explored every aspect of life there, including the opportunities and excitement and the disappointments and problems.

More important, this issue of *Survey Graphic* offers an extraordinary look into the cultural milieu in which Aaron Douglas would work and provides detail on some of the important influences on his work. In four important areas—the discussion of the New Negro, the problems and opportunities of the city of Harlem, the importance of Africa for

the black artist, and the highlighting of the work of Winold Reiss—
Survey Graphic merits special attention.

The New Negro was a product of a world created in the aftermath of
World War I, when a host of new nations replaced former empires and
kingdoms. At the Versailles Peace Conference, President Woodrow
Wilson had proclaimed America's support for the principle of self-
determination for colonial peoples, and although the United States did
not join the new League of Nations, Americans were sympathetic
observers of the movements for independence around the world. In
many of these new states, leaders faced the problem of instilling a
separate and distinct national identity among predominantly rural and
peasant populations. Artists and intellectuals played key roles in the
creation of these nationalist movements, emphasizing culture and lan-
guage to strengthen national identity and liberate their peoples from
the psychology of colonial dependency. Irish writers and poets were
important leaders in the independence movement and the revival of the
Gaelic language, while in Czechoslovakia and Poland, a new genera-
tion of intellectuals broke away from the dominant German cultural
traditions.

The concepts of self-determination, separatism, and cultural identity
influenced American black leaders during the 1920s, although they
adapted them to their particular circumstances. The urbanization of
blacks during World War I, along with their participation in the war
and their disappointment with its results, encouraged a greater spirit of
independence, while at the same time many American blacks de-
manded recognition from white society. One of the foremost spokes-
men for these ideas was Alain Locke, and his writings clearly had a great
impact on Douglas's perception of the role of an artist in the black
community. Locke was identified by the magazine's editors as a fore-
most example of the "Talented Tenth," the leaders who African-
Americans were hoping could improve the image and estimation of the
race in the eyes of the uninformed and frequently indifferent white
public. They praised him as a graduate of Harvard, Oxford, and Berlin
Universities, now a professor of philosophy at Howard University, "and
himself a brilliant exemplar of that poise and insight which are happy
omens for the Negro's future."[4] Locke was determined to bring to the
public eye black poetry, music, art, and literature, and he encouraged
artists to explore their African heritage through the arts. He became a

spokesman for these artists. In Locke's essay "The Legacy of the Ancestral Arts" in *The New Negro*, he argued that the black artist lacked a mature tradition and might consider the newfound African arts as his real and exploitable heritage. He stated: "There is a real and vital connection between this new artistic respect for African idiom and the natural ambition of Negro artists for a racial idiom in their art expression. . . . The Negro physiognomy must be freshly and objectively conceived on its own patterns if it is ever to be seriously and importantly interpreted. . . . We ought and must have a school of Negro art, a local and racially representative tradition."[5]

In the opening essay of the 1925 special issue of *Survey Graphic*, Locke equated Harlem's role for the American Negro with Dublin's for the new Ireland or Prague's for the new Czechoslovakia. Locke coined the term "New Negro," praising the younger generation of blacks as a vibrant group with a new psychology and a new spirit. Locke argued that sociologists, philanthropists, and race leaders could not account for the emergence of the New Negro. For generations, in the mind of America, the Negro had been "more of a formula than a human being—a something to be argued about, condemned or defended, to be 'kept down,' or 'in his place,' or 'helped up,' to be worried with or worried over, harassed or patronized, a social bogey or a social burden." Locke proclaimed that a sudden reorientation was necessary, a spiritual emancipation. A renewed self-respect and self-dependence had arisen in Harlem. These life attitudes appeared in the "self-expression of the Young Negro, in his poetry, his art, his education and his new outlook . . . poise and greater certainty of knowing what it is all about."[6] Locke placed the future of the New Negro movement in the new generation, the young Negro, the artist. The artist would communicate the ideals of the movement to the masses. (Such an opportunity for artistic expression must have been a primary lure for Douglas.) Locke proclaimed that the Negro problem was no longer exclusively or predominantly southern.[7]

The massive migration from the South to the urban North and Midwest had brought racial unrest to these areas as well. Yet Locke believed that problems which rural blacks faced in adjusting to their new urban environments were not particularly racial and were similar to those faced by Eastern and Southern European immigrants. The Negro had too often unnecessarily excused himself because of the way

he had been treated. The intelligent Negro of today resolved not to make discrimination an excuse for his shortcomings in performance, individual or collective. "We rejoice and pray to be delivered both from self-pity and condescension."[8]

In Locke's view, a new philosophy, a social effort based on cooperation between both races, was needed to supplant long-distance philanthropy. The Negro was being carefully studied. In art and letters, instead of being wholly caricatured, he was being seriously portrayed and painted. Locke insisted that this movement not be run by whites but through biracial cooperation in which blacks and whites cultivated mutual respect. Locke rejoiced at the coming of a new mentality for the American Negro, the development of a more positive self-image and self-reliance, the repudiation of social dependence, and finally the rise from social disillusionment to race pride: "Therefore the Negro today wishes to be known for what he is, even in his faults and shortcomings, and scorns a craven and precarious survival at the price of seeming to be what he is not. He resents being spoken for as a social ward or minor . . . regarded as a chronic patient . . . the sick man of American Democracy."[9]

Religion, freedom, education, and money were still desirable, but the Negro did not believe blindly that these would solve his life problems. Only collective effort and race cooperation would do this. Locke consistently referred throughout his writings to a collective effort by the Negro community and to the need for both races to work together. Politically, Locke recognized that the "thinking Negro" was moving toward the left with the world trend and that radical and liberal movements were growing within the Negro race. But he saw the Negro as fundamentally conservative in most matters, radical only on race, a "forced radical" rather than a genuine radical. Locke saw the prevailing Negro mind as standing between cynicism and hope, between defiance and appeal, as exemplified in James Weldon Johnson's "To America," which Locke included in his essay:

> How would you have us, as we are?
> Or sinking 'neath the load we bear,
> Our eyes fixed forward on a star,
> Or gazing empty at despair?
> Rising or falling? Men or things?

With dragging pace or footsteps fleet?
Strong, willing sinews in your wings,
Or tightening chains about your feet?[10]

The Negro had a new dual role in society, that of acting as the advance guard of the African peoples in their contact with twentieth-century civilization, while also rehabilitating the race in world esteem from that loss of prestige for which fate and the conditions of slavery had been largely responsible. In an allusion to the contemporary movement of Jews for a separate homeland, Locke proclaimed that Harlem was "the home of the Negro's 'Zionism.'"

Locke believed that the most immediate hope for the future rested in the reevaluation of the Negro by whites and blacks alike based on his artistic endowments and cultural contributions, past and prospective: "It must be increasingly recognized that the Negro has already made very substantial contributions not only in his folk-art, music especially, which has always found appreciation, but in larger, though humbler and less acknowledged ways."[11] For generations the Negro had been the "peasant matrix" of the section of America that had most undervalued him, the South, where despite pressure blacks had made economic and spiritual contributions. The Negro was now a conscious collaborator and participant in American civilization. The present generation had added the motives of self-expression and spiritual development to the old and still unfinished task of making progress. Locke believed no one who understood the present situation could be entirely without hope. Even if the Negro could not yet celebrate his full initiation into American democracy, he could at least, Locke promised, celebrate the attainment of a significant and satisfying new phase of group development and with it a spiritual coming of age. The center of this development, of spiritual and artistic growth, was Harlem. (A reproduction of a lithograph of a young black boy, thoughtful and proud, by Walter von Ruckteschell, appeared at the bottom of Locke's essay, a reminder of the artist's role in this new consciousness.)

Locke further elaborated this theme in his essay entitled "Youth Speaks," which discussed the possibilities for a new generation of artists in Harlem. The Negro youth, according to Locke, was able to foretell in the mirror of art what Americans would see and recognize in the streets of reality tomorrow. The Negro artist, out of the depths of his

group and personal experience, had at his hand almost the conditions to produce classical art. "Negro genius today relies upon the race-gift as a vast spiritual endowment from which our best developments have come and must come."[12] Poets no longer spoke for the Negro, they spoke *as* Negroes. They spoke to their own and tried to express the essence of Negro life and spirit. Race added enriching adventure and discipline, giving subtler overtones to life, making it more beautiful and interesting, even if more poignant.

To Locke, race was now a source of inspiration for black artists. Being black helped the artist to express both joy and suffering more poignantly. Locke agreed with Du Bois that blacks were innately and permanently different from whites and that color consciousness needed to be promoted, developed, and refined, even in the arts.[13] The artist's struggle had not been so much to acquire an outer mastery of form and technique as to achieve an inner mastery of mood and spirit. The artists of the New Negro movement were particularly fortunate because they had predecessors who helped lay the groundwork for them, a generation of "creative workmen who have been pioneers and path-breakers," such as sociologist and *Crisis* editor Du Bois, poet Paul Laurence Dunbar, and writer James Weldon Johnson; in painting, Henry Tanner and William Scott; in sculpture, Meta Warrick and May Jackson; and in acting, Paul Robeson. Locke regarded the youngest generation, which included writers Jessie Fauset, Claude McKay, and Jean Toomer and poets Langston Hughes and Countee Cullen, as the legitimate heirs to a tradition that was ready to acquire new energy. These people constituted a new generation not because of their youth but because of their new aesthetic and philosophy of life. They had gained more recognition from literary circles and the general public than Negro creative artists had ever before received in an entire working lifetime. It was a time of spiritual quickening, when "the heart beats a little differently." "There is in it all the marriage of a fresh emotional endowment with the finest niceties of art."[14]

Locke discussed a new poetry of social protest and a fiction of calm, dispassionate social analysis. Instead of the wail and appeal, there was challenge and indictment. The new artists had an "instinctive love and pride of race . . . and ardent respect and love for Africa, the motherland." The brands and wounds of social persecution were becoming the proud stigmata of spiritual immunity and moral victory. Locke closed

the essay with the poignant words, "Indeed, by the evidence and prom-
ise of the cultured few, we are at last spiritually free, and offer through
art an emancipating vision to America."[15]

Intimately connected with the theme of the New Negro was the
concept of Harlem as a "race capital," the largest black city in the
world. Locke explained the significance of this development. He pro-
claimed Harlem as the "new race capital," where "the pulse of the
Negro world has begun to beat. . . . A Negro newspaper, carrying the
news material in English, French and Spanish, gathered from all quar-
ters of America, the West Indies and Africa has maintained itself in
Harlem for over two years."[16] Locke compared Harlem's meaning for
blacks to that of the Statue of Liberty for European immigrants. The
volume of migration to Harlem had made it "the greatest Negro com-
munity the world has known" without counterpart in the South or in
Africa. Harlem also represented the Negro's latest thrust toward de-
mocracy. White New Yorkers, according to Locke, thought of Harlem
merely as a rough rectangle of commonplace city blocks, unaccounta-
bly full of Negroes. A few saw Harlem as a place to savor for its racy
music and racier dancing, of cabarets notorious for their amusements,
of abandon and sophistication. This Harlem drew in both the enter-
tainment connoisseur and the undiscriminating sightseer. This was the
"shufflin'" and "rollin'" and "runnin' wild" Harlem on the exotic
fringe of the metropolis. There was also the Harlem of the newspapers,
a Harlem of monster parades and political flummery, swept by revolu-
tionary oratory and flashy black millionaires.

In the final analysis, Locke saw Harlem not as a slum, ghetto, resort,
or colony, but rather as place that was, or promised to be, "a race
capital."[17] Locke explained that the tide of Negro migration could not
be adequately interpreted as a blind flood started by the demands of war
industry coupled with the shutting off of foreign migration or by the
pressure of poor crops. Neither labor demand, the boll weevil, nor the
Ku Klux Klan was a determining factor. This migration northward
represented a new vision of opportunity, of social and economic free-
dom, of a spirit to seize, despite an extortionate and heavy toll, a
chance to improve conditions. With each wave, the Negro migrants
became more and more like the European waves at their crests, moving
toward the democratic chance, a deliberate flight from medieval Amer-
ica to modern.[18]

Not only was Harlem the largest Negro community in the world, but it was also the first concentration of so many diverse elements of Negro life. It attracted the African, the West Indian, the Negro American, the northerner and southerner, the man from city, town, and village. Harlem had become home to the peasant, the student, the businessman, the professional man, the artist, poet, musician, adventurer, and social outcast. The greatest experience of all had been finding one another. This was a laboratory of a great race welding: "Hitherto, it must be admitted that American Negroes have been a race more in name than in fact . . . more in sentiment than in experience. The chief bond between them has been that of a common condition rather than a common consciousness. . . . In Harlem, Negro life is seizing upon its first chances for group expression and self-determination."[19]

Locke and many of his colleagues saw the positive in Harlem more than the negative. Subsequent historical treatments tended to stress the negative dimensions of Harlem's emergence as an all-black community, focusing on the creation of slum conditions and a ghetto pathology. Harlem became a slum in the 1920s because of the high cost of rent, poor employment possibilities, poor salaries, congestion, substandard health care, crime, and poor sanitation. Why would Locke and others have viewed Harlem in such a positive light, largely ignoring its troubles?

Locke and the artists he worked with were not average migrants. They were educated, they were united as a group in search of opportunities, and many of them were backed by the wealth of white patrons. Locke was discussing the opportunities available, and there were many, for the artists of the New Negro movement. It was the first time such artists had come together in an urban center, no longer isolated in rural communities as a peasant class. Harlem offered them tremendous opportunities just as American cities had attracted European immigrants despite the negative aspects of urban life. The members of the Renaissance accentuated the positive because much of their personal experience was more positive than was the average Harlemite's. Their experience in Harlem was also frequently a vast improvement over that in their places of origin. They believed that problems of race could be solved through art and cultural acceptance. Artists like Douglas were looking for different things in Harlem than the average laborer who migrated to the area.

For Locke, a new order had been created, and Harlem voiced these new aspirations of a people, the new condition, new relationships, a stage of the pageant of contemporary Negro life. Although Locke's view of Harlem was clearly skewed, his words of encouragement were inspirational. To Locke, Harlem was the center of a new cultural revolution for the Negro, a place open to new leaders, new ideas, and, most important, new artistic talent.

One of Douglas's primary reasons for moving to Harlem was to find other artists who shared the race consciousness he was developing. Douglas had met only one person in Kansas City to whom he could relate, and he felt isolated and longed to be part of a community. James Weldon Johnson's article "The Making of Harlem" showed men and women like Douglas, who were often isolated, well-educated blacks, that such a community of support existed. Johnson was listed in the beginning of the issue as a journalist, editor, poet, and executive secretary of the National Association for the Advancement of Colored People (NAACP), as well as editor of the *Book of American Negro Poetry* and author of *Fifty Years and After* and *The Autobiography of an Ex-Coloured Man*. Johnson described Harlem as the Negro metropolis, the mecca for the sightseer, the pleasure seeker, the curious, the adventurous, the enterprising, the ambitious, and the talented of the Negro world. Harlem was a city within a city, one of the most beautiful and healthy sections of the city, with its own churches, social and civic centers, shops, theaters, and other places of amusement. It contained more Negroes per square mile than any other place on earth, beginning on 125th Street and covering twenty-five solid blocks. The Harlem of 1925, wrote Johnson, was practically a development of the past decade, although there had always been colored people in New York. Entertainment spots famous for showcasing Negro talent appeared in Harlem, such as the Marshall Hotel, where actors, musicians, composers, writers, singers, dancers, and vaudevillians gathered. Famed actors such as Paul Robeson frequented the Marshall when visiting New York. (This kind of Harlem establishment would become a source of inspiration for the visual imagery in Douglas's works.) Again, Johnson saw the positive side of Harlem, emphasizing the positive and excluding certain glaring realities. Like Locke, Johnson saw Harlem as a land of opportunity.

In Johnson's view, Harlem was becoming more and more a self-supporting community, where blacks were able to branch out steadily into new businesses and enterprises. Negroes were experiencing a constant growth of group consciousness, the sense of community that Aaron Douglas was searching for. It had movement, color, gaiety, singing, dancing, boisterous laughter and loud talk, and outstanding brass band parades. Harlem was not a mere quarter in New York City, for several reasons Johnson listed. First, the language of Harlem was not a foreign tongue, it was English. Second, Harlem was not physically a quarter, but rather a zone through which four main arteries of the city ran. Third, because there was little or no gang labor, Negroes could lose their former identity and quickly assimilate: "A thousand Negroes from Mississippi put to work as a gang in a Pittsburgh steel mill will for a long time remain a thousand Negroes from Mississippi. Under the conditions that prevail in New York they would all within six months become New Yorkers. The rapidity with which Negroes become good New Yorkers is one of the marvels to observers." Optimistically—and somewhat naively—Johnson thought there was little chance that Harlem would ever be a point of race friction in New York. Old white residents lived peacefully side by side with black tenants, and he could see no reason why problems would arise, especially with the large proportion of Negro police on duty. To Johnson, Harlem was more than just a Negro community: "It is a large scale laboratory experiment in the race problem."[20]

Although Johnson admitted that the Negro still met with discrimination in Harlem, it was more important to recognize that blacks possessed basic civil rights and could be confident that discrimination would eventually be abolished. Johnson ended his essay with the following statement: "I believe that the Negro's advantages and opportunities are greater in Harlem than in any other place in the country, and that Harlem will become the intellectual, the cultural and the financial center for Negroes of the United States, and will exert a vital influence upon all Negro peoples."[21] An opportunity to combine the tasks of self-fulfillment and race betterment was what Aaron Douglas sought, and Harlem seemed qualified on both counts.

The anthropologist Melville Herskovits's essay, "The Dilemma of Social Pattern," in the same *Survey Graphic* issue, described Negro newspapers, intellectuals, churches, and social groups. Harlem offered a

busy, whirring cycle of life, with doctors, lawyers, teachers, nurses, student waiters, and more. It was the same pattern found in any community in America, only a different shade![22] It was a community that a white would find familiar, with vitality and opportunities; the only difference was the skin color of its members. Herskovits applauded the vigor of Harlem and all it had to offer men like Aaron Douglas.

For all of its problems, Harlem was the first American city that blacks could claim as their own. Even though it was located within the larger political entity of New York, it encouraged among blacks a sense of power and possibilities, providing the opportunity to forge a new sense of identity. If the move to Harlem led to poverty and hardship for many blacks, it also provided a much-needed sense of community and support for those like Aaron Douglas who sought to forge a new racial identity. His creativity and innovation cannot be understood apart from the dynamic community that was Harlem in the 1920s.

One of the most distinctive aspects of Aaron Douglas's work would be his attempt to draw upon the African heritage of American blacks. *Survey Graphic* helped stimulate his interest in this subject. Alain Locke discussed the importance of African art, paying tribute to the Barnes Foundation's collection of African art. Locke noted the influence of African art on modernist art in both France and Germany, including the works of Matisse, Picasso, Amedeo Modigliani, Alexander Archipenko, Jacques Lipchitz, Wilhelm Lehmbruck, and others, centering in Paris around the pioneer exponent, Paul Guillaume. Thus far, the Negro in his American environment had turned predominantly to the arts of music, dance, and poetry, and the influence of African culture was either unconscious or indirect. Locke hoped that the "plastic arts" would allow Africa a more direct influence on the artistic development of the American Negro, an influence that had already manifested itself in modern European art: "It [African Art] may very well be taken as the basis for a characteristic school of expression in the plastic and pictorial arts, and give to us again a renewed mastery of them . . . and a lesson in simplicity and originality of expression. Surely this art, once known and appreciated, can scarcely have less influence upon the blood descendants than upon those who inherit by tradition only."[23]

Locke wanted to emphasize that the Negro was not a cultural foundling without an inheritance. His essay was accompanied by reproductions of four African sculptures, three masks and one male figure.

(Other African art pieces from the Barnes Foundation collection were included in the issue to accompany poems such as Countee Cullen's on the African heritage.[24]) The need for the Negro to go back to his own unique heritage, a heritage others had tried to claim, was repeated throughout the *Survey Graphic* issue.

The Harlem of the 1920s was also home to other pan-African sentiments. The pan-African movement, which attempted to unite African-origin blacks worldwide, was a growing phenomenon, part of a new internationalism that aspired to reestablish contact among the scattered peoples of Africa. Marcus Garvey, a West Indian insurgent, was perhaps the most flamboyant spokesman for the pan-African cause, though in 1923 he was convicted of mail fraud, jailed, and later deported. Not surprisingly, Locke referred to Garvey's Universal Negro Improvement Association movement in a less than flattering manner, but he agreed with Garvey that the American Negro needed to be involved in the future development of Africa. Such involvement would give the Negro valuable prestige at home and abroad.

Before he came to Harlem, race had not been a part of Douglas's artistic work. Although his pre-Harlem paintings no longer exist, he does refer to them in his letters as traditional studies of human anatomy, not based on racial issues or stylistically influenced by modernist trends. Nor does it appear that there were any significant visual artists in Harlem before Douglas who were incorporating African ideas in their work. In this area Douglas was clearly an innovator, and he was quick to seize upon this challenge after his arrival in Harlem. (Indeed, Locke called Douglas, who illustrated some chapters of *The New Negro* in 1925, "a pioneering Africanist.") With Douglas's arrival in Harlem, a whole new chapter of Africanism in African-American art was opened. It comes as no surprise that Douglas would earn the title of "the father of Black American art."[25]

The final aspect of *Survey Graphic* that affected Aaron Douglas was the artwork and style of Winold Reiss. The very first illustration was Reiss's portrait of Roland Hayes, "whose achievement as a singer symbolizes the promise of the younger generation." Drawn in a straightforward, realistic manner, with Hayes's head floating on a plain white page, it shows no neck or body. This was the "splendid portrait of a Black man by the famous German artist Fritz Winold Reiss" that Douglas referred to when discussing the impact *Survey Graphic* had on

him.[26] Hayes is looking off to the side thoughtfully and seriously. Reiss had proudly displayed Hayes's African traits, including a full nose and lips (Figure 1).

The magazine also contained a brief discussion of the significance of Reiss's work, probably written by Locke. The author asserted that conventions stood doubly in the way of the artistic portrayal of Negro folk: certain narrow, arbitrary conventions of physical beauty and "that inevitable inscrutability of things seen but not understood." Caricature had put upon the countenance of the Negro the mask of the comic and the grotesque, whereas in actuality, based on life experience, the very opposite should have been included, namely, the serious, the tragic, the wistful. The Negro artist was still confronting his own material timidly. His best development, according to the essayist, would most likely come in the pictorial arts, "for his capacity to express beauty depends vitally upon the capacity to see it in his own life and to generate it out of his own experience."[27] Using one's own life experiences and heritage as a source of inspiration for creating art was the credo of Winold Reiss, with whom Aaron Douglas would study for two years and find encouragement to paint things African and explore a vein of artistic experience that was uniquely his.

Winold Reiss was born in 1886 in Karlsruhe in southwestern Germany, the son of a Bavarian landscape painter.[28] He studied at the Kunstgewerbe Schule in Munich under Franz von Stuck, as well as under the direction of his father, respected artist Fritz Mahler Reiss. The elder Reiss had trained at the Düsseldorf Academy, studying natural history, German landscape, and peasant portraiture, and he passed these traditions down to his son. Reiss's teacher Franz von Stuck, master at the Munich Academy, exposed him to the modern art movements of fauvism and cubism and eventually encouraged him to enroll at the School of Applied Arts, where he would study commercial design and poster design under Julius Diez. Reiss painted folk groups in Sweden, Holland, and Germany before his immigration to the United States in 1913. He probably became aware of cubism and African art at least by 1913, when he most likely saw an exhibition of Picasso's African-inspired cubist works in Munich. Von Stuck also introduced Reiss to *Jugendstil* (youth style), the German decorative arts movement which was rooted in France's Art Nouveau. Reiss had worked as a designer in Munich and would take these talents to New York, where

he worked as an illustrator for magazines, books, and advertising, using his commercial and poster art training. Reiss was also no doubt familiar with the German folk art technique *Scherenschnitt,* which influenced his simple black and white designs and often resembled cutouts or collages.

Reiss, along with other Munich modernists, was attracted to ethnography. He was aware of the 1912 Blaue Reiter almanac, which contained numerous photographs of the art of the Cameroons, Egypt, and Japan, as well as Bavarian and Russian folk art. Reiss therefore developed an interest in both ancient and modern art and an awareness of contemporary experiments of modern artists.

Before becoming a premier artist in Harlem, Reiss spent a great deal of time traveling in the American West, Canada, and Mexico, as well as in Central America, painting Indians and aspects of Indian life. He was particularly fascinated by the Blackfoot Indians, the Pueblo people, Mexicans, and the American Negro. Reiss had always been interested in documenting various racial groups "as a means to illuminate the distinctions and integrity of different ethnic groups." Reiss went to communities that were undergoing dramatic social changes, visiting the heirs of the Aztecs in Mexico in 1921 and the last survivors of the intertribal wars of the nineteenth century in Browning, Montana. Harlem provided similar opportunities for documentation, a community that author Jeffrey Stewart states Reiss "stumbled onto," finding it "brimming with racial consciousness and a desire for dignified self-representation."[29]

Reiss's art owed its success "as much to the philosophy of his approach as to his technical skill."

> He is a folk-lorist of the brush and palette, seeking always the folk character back of the individual, the psychology behind the physiognomy. In design also he looks not merely for decorative elements, but for the pattern of the culture from which it sprang. Without loss of naturalistic accuracy and individuality, he somehow subtly expresses the type, and without being any the less human, captures the racial and local.[30]

To Locke, Reiss's attention to American blacks was particularly welcome: "What Gauguin and his followers have done for the Far East, and the work of Ufer and Blumenschein and the Taos school for the Pueblo and Indian, seems about to become for the Negro and Africa: in short, painting, the most local of arts, in terms of its own limitations

even, is achieving universality."[31] For Reiss, the Negro, without humor or caricature, was an acceptable subject.

The drawings that surrounded the essay about Reiss consisted first of a young, somber mother with clear, straightforward black facial features including a prominent, wide nose and full lips, holding a young girl perhaps two years old, with loose, kinky, natural hair. The original drawings were done in pastel crayon and charcoal, with very little paint added to just a few of the garments. The young girl bears only the slightest smile. Most of Reiss's drawings showed serious and thoughtful facial expressions. The next page contained three more portraits, *A Boy Scout* in profile, *A woman lawyer*, and *Girl in the white blouse*. All of Reiss's portraits show detail in the face and hands, and in the originals color pastel crayons are used for the face and hands. The clothing and bodies are not detailed and are almost sketches, further emphasizing the sensitive, serious, and dignified nature of the sitter. There is no effort to caricature or overemphasize black features, nor is there an attempt to hide features particular to African-Americans. Reiss's work provided a source of pride and inspiration for the black artist, who often in this time period did not choose to paint black subject matter. Reiss's final portrait in this section of *Survey Graphic* was *A college lad*, clad in a fine suit and tie, intelligent, thoughtful, handsome, and dignified.

Reiss influenced Douglas not only in his eventual turn to his black heritage and Africanism but also in stylistic ways. Reiss's illustration *Dawn in Harlem* (Figure 2) shows modern skyscrapers, à la Charles Sheeler or Joseph Stella, without the same strong influence of cubism. Progress in 1925 is depicted by skyscrapers towering over the city, most of them topped by smokestacks, some illuminated by the morning sun, others hidden in shadow. The sun is rising along the horizon, surrounded by concentric circles of energy. Douglas would use a very similar, clear style in his works, undoubtedly under the influence of Reiss's tutelage, including skyscrapers, smokestacks, and concentric circles, a motif he would take much further.

An article by J. A. Rogers, "Jazz at Home," provided the opportunity for more of Reiss's illustrations. Rogers, the author of *From Superman to Man*, reviewed the history of jazz, calling it one part American, three parts Negro, a spirit that could express itself in almost any way. It was joyous revolt, the revolt of the emotions against repres-

sion.[32] His article was accompanied by two of Reiss's drawings, *Interpretations of Harlem Jazz* (Figure 3). One drawing included a Negro dancer in a cabaret, dancing with a young woman, their faces accented only by thick, overaccentuated lips, their bodies flat silhouettes. The piece has the stylized qualities of Art Deco, Egyptian art, and a touch of cubism, all of which would influence Douglas. An African mask, a booze bottle, and another dancer's leg appear in the background. All of the black silhouette figures are accentuated by thick features, slightly slanted eyes (reminiscent of Dan sculpture of the Ivory Coast of Africa), thick lips, and black faces. Here Reiss uses flat patterns and silhouettes of figures in black and white, giving the illusion of a cutout work similar to *Scherenschnitt*, or scissors-cut images. This was the folk art silhouette technique of black cutouts, with no depth or perspective. This technique was also used in Germany with marionettes and puppet theater, employing cutout forms behind a transparent screen. This technique may have influenced Reiss, who in turn taught Douglas. Again, Douglas's stylistic connection to Reiss is particularly clear in these drawings. Douglas would turn to jazz and cabaret life as a source of inspiration in his works, including book illustrations and murals.

In a series of moving portraits titled *Four Portraits of Negro Women*, Reiss used the same style, with a clearly drawn, detailed, realistic face and sketchier body, which in some cases consisted of only a few simple black lines. These are titled *The Librarian*, *Two Public School Teachers*, and *Elise Johnson McDougald* (Figures 4, 5, 6). All of the portraits are extremely thoughtful, indeed almost solemn, with the trademark dignity Reiss gave his sitters.

Survey Graphic offered the reader a remarkable insight into Harlem as a place of opportunity, of educated leaders of the arts and letters, of race betterment. It also depicted the less attractive side of Harlem as a place of exploitation and disappointments. Overall, the issue left a distinctly positive view of Harlem and its environs. It provided a lure for many young, striving blacks like Aaron Douglas to come and participate in this new movement with all the great leaders of the time. Douglas would become close friends with many of the issue's contributors and would study under Winold Reiss. The issue was eventually expanded into the volume *The New Negro* edited by Alain Locke, to which Douglas would contribute, later that same year. Both the magazine and the book would announce to the world the new self-awareness, artistic consciousness, and race pride of the Negro of the Renaissance. Like

Survey Graphic, The New Negro focused on Harlem as the symbol of a new chapter in the history of the black race, "the laboratory of a great race-welding."[33]

Douglas wrote Locke upon his arrival in New York City. He told of his personal background and training, explaining:

> There isn't much romance there. No, but under it all there is a great deal of pathos. Now, why do I speak of pathos as if it were a point of great merit; as if it were an exception; as if black America has known ought but pathos; as if pathos is not now one of the most vital elements in the genius of the race. Yes, and we must let down our buckets into our own souls where joy and pain, mirth and sadness, still flows swift and deep and free, and drink until we are drunk as with an overpowering desire for expression.
>
> If you should find it possible to use one of my drawings I am flattered beyond measure. I am sure they merit no such distinction.[34]

Douglas would find abundant opportunities to express "the joy and pain, mirth and sadness" of black life, shortly after his arrival in Harlem.

Three

An Artist Concerned
with Black Life

Survey *Graphic*'s dynamic portrayal of Harlem and the cultural ferment there helped lure Aaron Douglas from Kansas. The magazine's appearance in March 1925, along with the publication a few months later of the "bible" of the black avant-garde, Alain Locke's *New Negro*, marks the beginning of the Harlem Renaissance. Both works reflect this movement's governing intellectual and aesthetic assumptions, proclaiming the rebirth of a distinct African-American culture.

The Harlem Renaissance occurred in the context of the mass emigration of blacks from the South and their urbanization in the North during the second decade of the twentieth century. This population transfer coincided with the worldwide movement toward self-determination and independence sparked by World War I and encouraged by the tenets espoused by Woodrow Wilson. The leaders of the Renaissance compared their efforts with those of leaders of newly independent states such as Ireland and Czechoslovakia that were trying to forge new and separate cultural identities. As Nathan Huggins, one of the most important African-American historians of the Renaissance, has pointed out, it was commonly accepted in the decades after World War I that "culture"—literature, art, and music—was the true measure of a civilization.[1] Harlem's new intellectual class self-consciously be-

lieved that they were witnessing a renaissance, or rebirth, of African-American culture. Poetry, prose, the visual arts, theater, dance, and music were all integral to their vision of that rebirth. Their efforts to promote these activities created an aura of excitement and promise that Douglas spoke of years later:

> The world was shocked and amazed at the spectacle of an economically depressed and culturally retarded group of people giving voice in artistic forms to their deepest spiritual yearning, as well as to their social, economic and political concerns. This movement is called the Renaissance because of its sudden appearance, its vigor, its wide scope and its nearly exclusive concern with the creative arts. The names of singers, sculptors, composers, painters and architects were heralded to the nation, often before they were known in their own communities.[2]

Not all chroniclers of the period, however, have been as impressed by the Renaissance and its achievements. Many find it hard to separate the Renaissance from the hostile racial climate of the 1920s, when the Ku Klux Klan was revived. As Houston Baker, Jr., argued in *Modernism and the Harlem Renaissance*, it was "difficult to conceive of the horribleness of the American scene for black people during the era in which Locke produced his classic collection [*The New Negro*]."[3] To these writers, the optimism of Harlem's intellectual elite was at odds with the reality of the black experience in America.

Other critics of the Renaissance have offered an even more searing indictment. Nathan Huggins, writing during the turbulent 1960s with both the civil rights struggle and the black power movement in mind, blasted the Renaissance for its dependence on whites for ideas, inspiration, and, perhaps most important, financing. Although Huggins praised some of the cultural output of the era, he believed the Renaissance depended on and answered the needs of whites rather than blacks. As Huggins put it, "Black Harlem was as much a white creation as it was black."[4] Huggins challenged the authenticity of the Renaissance as a black cultural movement. He asked rhetorically: "Whose sensibilities, tastes and interests were being served by such art, the patron or the patronized?"[5] He suggested that whites dictated the interest of blacks in such movements as primitivism, which reflected white America's view of the Negro. Huggins also criticized the movement's leaders for their emphasis on high culture and their disdain toward such genuine expres-

sions of black culture as jazz. To Huggins, much of the Renaissance's artistic work was provincial, and he described Alain Locke as "an anxious parent" who seized upon "every suspicion of talent as if it were the bloom of genius."[6] The emphasis of Locke and others on Africa struck Huggins as superficial and without enduring importance. Huggins also argued that the Renaissance's emphasis on a group identity and consciousness undermined the opportunity for individual black artists to realize the American Dream. The Renaissance, in Huggins's view, merely aped European and white standards of culture. Its self-consciously nonpolitical character ignored many of the very real problems facing blacks.

Huggins's critique has not gone unchallenged. In *When Harlem Was in Vogue*, David Levering Lewis paints a more balanced picture of the Renaissance and argues that blacks were instrumental in shaping the movement. Although Lewis criticizes the elitism of the movement, his assessment is more positive. Neither Huggins nor Lewis, however, completely captures the essence of the Renaissance, the special quality that Douglas once described:

> It was a cultural experience; in a sense, a sort of spiritual experience. Actually it was difficult to put your hands on it, because it wasn't something that the people actually understood as really a thing of great importance; they had the feeling that something was going on and we acknowledged that this perhaps was something unique and destined in American black-white relationships, this touched upon the experience of black people in America, but to get hold of anything particular is difficult to realize, to achieve.[7]

Douglas's perspective as a contemporary and a participant and as one of the Renaissance's few visual artists is useful in examining some of the more critical views of the Harlem Renaissance, although there are problems with using one individual's viewpoint to assess an entire cultural movement. The Harlem Renaissance concentrated mainly on literature. Although African-American music was viewed mostly as folk art, it was a far more accepted form of expression than the visual arts. Douglas acknowledged this contrast:

> The example I am trying to say is the sort of things that a singer, a musician or musical thing was that far back. They were beginning to— they were coming to grips with that thing musically, but we didn't—

painters—there was no such thing as a painter at that time. You could sing, and we did, create those marvelous spirituals. You could dance, but you didn't have any tools and any paper and that sort of thing, instructions and so on for doing things. They danced, and created dances that have lived and come right on up to this time. But, for this business of art, we had nothing to go on.[8]

The visual arts required a pioneer for whom the Renaissance would be a starting point in creating a tradition in African-American culture. Because he was such a pioneer, the experience of Aaron Douglas—particularly with regard to the issues of patronage, primitivism, and group identity—provides unique insight into the achievements and limitations of the Harlem Renaissance.

There is no denying the importance of white patronage in the Harlem Renaissance. There were few wealthy blacks, and the arts were still relatively new to the emerging black middle class. Prominent and wealthy whites such as Paul Kellog, the editor of *Survey Graphic*, and Carl Van Vechten, the "uncrowned prince" of Harlem, were actively involved in the movement, and they influenced black artists. The effect of white patronage on the cultural product of the Renaissance becomes clear in the reflections of the writer Langston Hughes. Hughes had a particularly troublesome relationship with Charlotte Mason, known during the Renaissance as the "Godmother." The elderly Mason was a wealthy Park Avenue matron who played an active role in the Renaissance, supporting not only Hughes but also Zora Neale Hurston and Louise Thompson. Mason had paid many of Hughes's college expenses as well as supporting him for a summer spent working on a novel. She continued to provide funds after he left school, but the arrangement made the writer increasingly uncomfortable. Hughes felt a genuine warmth toward Mason, whom he described as gentle and caring, but he became frustrated by her expectations and strong opinions. (Observing their relationship, Douglas felt sorry for Hughes and commented that he looked like a "terrier" on Mason's arm when he attended concerts with her.[9]) Hughes found he could no longer please Mason by writing about the "mystery and mysticism and spontaneity" of Harlem's blacks when he was observing their poverty, misery, and hunger.[10] He asked to be released from their arrangement, which Mason granted, but not without berating him in brutally humiliating terms. Hughes later explained: "She wanted me to be primitive and know and

feel the intuitions of the primitive. But, unfortunately, I did not feel the rhythms of the primitive surging through me, and so I could not live and write as though I did. I was only an American Negro—who had loved the surface of Africa and the rhythms of Africa—but I was not Africa. I was Chicago and Kansas City and Broadway and Harlem."[11] The final break between the two occurred when Hughes wrote a "socialist" poem criticizing the opening of a luxury hotel amid starving people.

Hughes's experience with Mason underlines the power of white patrons in the Renaissance. Mason's insistence that Hughes's writing reflect her view of blacks' "primitivism" seems to support Huggins's contention that black artists had little choice but to "serve a white dream and fancy" in their work.[12] Other black artists felt the same pressure. Paul Laurence Dunbar also believed that to get anyone to listen to him, he had to write in a primitive manner, to create dialect poetry. Dunbar related the Negro's need to please his audience in "We Wear the Mask."[13] The Negro smiled and performed, hiding his tears and frustration. Another example can be found in black theater, where minstrelsy remained dominant. Minstrels had taken on a white theater tradition that satirized and mocked their own race. Whites' patronage of minstrelsy in Harlem and elsewhere made it a commercial success.[14]

All black artists, however, were not simply victims of the white patronage system, as Douglas's own experience with the Godmother indicates. Before Hughes broke with Charlotte Mason, he and Alain Locke wanted Aaron Douglas to meet her, hoping some of her largesse might go to the struggling artist. At the time Douglas was trying to finish a mural at the Club Ebony so he could begin a fellowship at the prestigious Barnes Foundation. When Mason arrived at the club, Douglas was immediately called from the scaffold to make an appointment with her. Although resentful of being summoned like an errand boy, Douglas acquiesced. He was impressed by her wealth.

> She lived down on Park Avenue in one of these fabulous places, for us, from our standpoint, fabulous. It must have been about ten or twelve rooms in this apartment. Unthinkable as far as we were concerned. And when you go down there, get off the, (your eyes get like that) and get off the elevator and you are right in there, in the apartment, which we had never seen anything like that. Well, Godmother, I went down this day to see her and carry this little package of things and she looked at the

drawings, she liked them and she decided that she would take one of these drawings. Well, she took this drawing and gave me $125 for this drawing. Oh, terrific I thought. She had me right then.

The money thrilled Douglas, but he remained surprisingly impervious to Mason's influence. Despite her insistence that he turn down the Barnes Foundation fellowship, he "brushed that off" and took it anyway. Patronizing and persistent, she came personally to Philadelphia to harangue Douglas into returning to Harlem. Rather than confront her directly—it is clear he was in awe of her power and wealth—he avoided a direct answer:

> She was with her governess, or whatever it is, I don't know what you call it, but anyway an attendant. . . . Anyway, she came in this place, what we call a Black neighborhood, nice place, but, here is this old lady with a car as long as this place here you know and so with this person, she talked with me for an hour trying to persuade me to give up this thing, and also persuade me to give up this book that I had accepted. I couldn't do anything like that, but I finally, I must have said that I would consider it, or something, but anyway I got her off my neck in that way. I went right on with this—never gave it another thought, as far as giving it up was concerned.[15]

When Douglas went to the Barnes Foundation, Mason told Alain Locke that the artist was stuck in "Barnes's Vacuum."[16] Mason also convinced Douglas not to do a cover for a book that eventually became a Book-of-the-Month Club selection and advised him not to accept the Knopf commission to illustrate *Nigger Heaven*. As a result, Douglas provided only the advertisements for Carl Van Vechten's book, and his friendship with the author deteriorated. Douglas's relationship with Mason continued after the Renaissance. She disapproved when he took a teaching position at Fisk but insisted that he write her daily from Nashville, an onerous task he refused to do. Mason then dropped Douglas "like a brick," a separation that was perfectly acceptable to him.[17] Douglas thought Mason was always more fond of Alta than of him, primarily because he refused to follow her advice blindly.

Douglas's experience with the Godmother emphasizes the limits to Huggins's argument. Scholars have often failed to understand the basic issues surrounding patronage. Art has always benefited from patronage in some form. Artists today of any race, like the black artists of the

Harlem Renaissance, are forced to create works in response to the tastes of those who are able to pay for their work and support them financially. As was the case in Harlem, the result often is works that are created to please the tastes of the public (sometimes as guided or dictated by dealers and critics) as well as more personal works that reflect the needs and expressions of the individual artists. The real issue is whether the patron's influence is so overbearing that it prevents an artist from achieving any real autonomy or creativity in his or her work. Langston Hughes believed that his financial—and perhaps also psychological—dependence on Mason led him to write only what she wanted to read, not what he wanted to write. Hughes thus made the painful decision to break from her. For his part, Douglas was obviously impressed by Mason's wealth and pleased that she would purchase his work. But the Godmother's influence did not distort his artistic work or career.

This is not to say that Douglas was unaffected by patronage. His relationship with Carl Van Vechten, whom Huggins calls the undisputed "prince" of Harlem, also demonstrated Douglas's appreciation of the importance of a powerful patron. Douglas described Van Vechten's help in a 1971 interview:

> Well, Carl Van Vechten on occasion . . . was capable of giving financial aid. . . . I don't know of any particular thing that Carl did for me except for . . . I'm sure he must have inspired Johnson to ask me to do *Trombones*. I'm sure that I did once a little mural in his house in his bathroom . . . painted around the frieze of the bathroom. Some other things he wanted me to do that I couldn't. I was in no position. I was doing something else and we never got around to doing it. But he sent me to Frank Crowinshield, the editor of *Vanity Fair*, and he took some of these drawings I had, some of them I brought from Kansas City.

Douglas remembered Van Vechten far more fondly than he did the Godmother. Van Vechten "helped me in getting myself set in New York." Van Vechten "knew everybody in Harlem, the good people and the bad," and if an artist showed promise, everyone asked, "Are you going through Carl, Carl Van Vechten?"[18]

Although Van Vechten helped Douglas get started, the two men's personalities were markedly different. Douglas was as shy and introverted as Van Vechten was flamboyant, or as Douglas described him, "a

lively sort of person." The two men had a falling-out when Douglas did an "off-hand" job on a bookplate Van Vechten wanted. Douglas admitted that his effort was something that he would have been "ashamed of myself," if he had really cared about it, but he didn't. Douglas's indifference offended the imperious Van Vechten, who was unaccustomed to such an attitude from those for whom he served as a patron. This affair led to a final rift between the two men.[19]

White patronage was expressed not only through the preferences of powerful individuals such as Charlotte Mason and Carl Van Vechten. It also took shape in the creation of private foundations, most notably the Harmon Foundation, established in 1922 by William E. Harmon, a self-made real estate tycoon. The foundation contributed to such typical charitable causes as playgrounds across the country, tuition assistance and vocational guidance for students, and educational programs for nurses. But Harmon, who from his boyhood had a "great love for and admiration of the Negro people and their aspirations," was especially interested in finding methods for encouraging initiative and sustained efforts by groups or individuals who had not previously had any offers of assistance or reward. His "sympathy for the colored people" and his desire to stimulate creative work found expression in the Negro Awards program. With assistance from the Commission on the Church and Race Relations of the Federal Council of Churches, the Harmon Foundation provided awards to honor "constructive achievement among Negroes." Initiated for a five-year trial period, the program gave awards in education, fine arts, literature, music, industry (including business), science (including invention), religion, and for the greatest improvement of race relations between "the white and Negro people in America." The first seven awards were $400 each, the last $500, and they were open to "all Negroes of American residence of both sexes." Five judges (at least one judge in each category was black) determined the recipients for each award, who were prominently announced in the *Crisis* and *Opportunity* magazines.[20]

Douglas did not receive a fine arts award from the Harmon Foundation. Palmer Hayden, a Harmon Foundation janitor, won in 1926, the first year the awards were given, and Hale Woodruff won in 1927. *Opportunity* lauded Hayden for working in "uninteresting drudgery which meant money for room, board, paints and canvases, nothing more," and his ability to rise above his financial limitations to create

works with "real artistic vision."[21] (The white press seemed more interested in stressing Hayden's background as a janitor.) Although Douglas did participate in the Harmon Foundation's 1928 traveling exhibition, "Contemporary Negro Art," which was organized with the College Art Association, he was critical of the foundation's efforts. Some of his criticism might be considered sour grapes because he was never chosen to receive a Harmon medal, but his claim that the Harmon awards encouraged mediocrity was not without grounds. Douglas argued that the Harmon Foundation rushed artists, heaping notoriety on them before they were adequately trained or prepared for such attention. As he put it:

> Harlem was sifted. Neither streets, homes nor public institutions escaped. When unsuspecting Negroes were found with a brush in their hands they were immediately hauled away and held for interpretation. They were given places of honour and bowed to with much ceremony. Every effort to protest their innocence was drowned out with big-mouthed praise. A number escaped and returned to a more reasonable existence. Many fell in with the game and went along making hollow and meaningless gestures with brush and palette. But . . . the Negro artists have emerged.[22]

Others have made similar criticisms of the Harmon Foundation's exhibitions. The art historian James Porter explained that the work offered in the Harmon exhibitions was not technically or subjectively homogeneous. Pieces Porter called "competently mature" were hung alongside the naive and experimental. Porter contended that the exhibits displayed from 1927 to 1933 showed too liberal a taste in subject matter and too little concern for execution. Porter argued that there was always an ample section of popular painting of the kind that unpleasantly suggests tawdry calendar landscapes and portraits, although, like Douglas, he conceded that the Harmon exhibitions were among the greatest stimuli to the artists of the New Negro movement.[23]

Douglas well understood the artist's need for a patron, telling one interviewer that "the economic thing is always behind us," and "we follow the man that pays us." He recognized that white patrons want "certain kinds of art from black people."[24] Nevertheless, Douglas's behavior during the Harlem Renaissance resembles that of Langston Hughes, who, despite his relationship with the Godmother, encour-

aged blacks not merely to respond to white patrons but to explore their blackness. In a 1926 *Crisis* essay Hughes declared:

> I am ashamed for the black poet who says, "I want to be a poet, not a Negro poet," as though his own racial world were not as interesting as any other world. I am ashamed too, for the colored artist who runs from the painting of Negro faces to the painting of sunsets after the manner of the academicians because he fears the strange unwhiteness of his own features. An artist must be free to choose what he does, certainly, but he must also never be afraid to do what he might choose.[25]

Douglas emphatically rejected the argument that the artists of the Renaissance were manipulated by their white patrons. He acknowledged that "there were certain white people at that time that came in contact with blacks and helped make it possible for them to reach a level from which they could create." But Douglas insisted that this "was not something dictated by white culture. It stemmed from Black culture. We were constantly working on this innate blackness at that time that made this whole thing important and unique." Despite the financial support of patrons, Douglas believed that black artists made the ultimate decision about their work. Douglas was convinced that the patron's requests and the artist's creative process could be reconciled. Asked if black leaders like Alain Locke tried to direct the artists, Douglas replied, "They were handling it, looking at it, seeing this thing going on there, but *we* were the ones that were creating this."[26]

That Douglas maintained his artistic integrity despite the influence of white patrons and black leaders is clear in the themes he selected for his work. Although, as Huggins argues, the black leaders of the Harlem Renaissance did not consider jazz an important aspect of African-American culture, this was not the case with Douglas. Douglas employed jazz themes as a background in many of his paintings and often used the cabaret as a source of inspiration. Jazz provided a backdrop in his illustrations for James Weldon Johnson's *God's Trombones*, his mural for the Sherman Hotel, and his mural *Music* at Fisk University in 1931.

Douglas rarely included images of whites in his works, not because of any "animosity or any antagonism" but simply because his art was concerned with "black life and as such [whites] wouldn't appear." Douglas painted as a black artist whose reputation grew on the basis of his racial work. He was the first black artist to give his work "something

of a Negro content. . . . [Blacks] had the feeling this isn't something that was done by a caucasian person. This is a black person. Here at last it is a black person doing this thing. He isn't criticizing his people; he isn't placing them in a situation that they would not normally have; he isn't trying to exalt them and you would see that in many of these things."[27] Langston Hughes commented on the racial significance of Douglas's work, adding a note of defiance to both the black middle class and the white patrons of the Renaissance:

> Aaron Douglas drawing strange black fantasies causes the smug Negro middle class to turn from their white, respectable, ordinary books and papers to catch a glimmer of their own beauty. We younger Negro artists who create now intend to express our individual dark-skinned selves without fear or shame. If white people are pleased, we are glad. If they are not, it doesn't matter. We know we are beautiful. And ugly, too. The tom-tom cries and the tom-tom laughs. If colored people are pleased we are glad. If they are not, their displeasure doesn't matter either. We build our temples for tomorrow, strong as we know how, and we stand on top of the mountain, free within ourselves.[28]

Few African-American artists were trying to depict black life with the cultural authenticity to which Douglas aspired. Most black artists, Douglas recalled, "were occupied with . . . representing [blacks] as white. Physically and culturally . . . we didn't recognize our cultural contributions . . . they didn't know what they were."[29]

Douglas's desire to reach the "common man" during the Renaissance and to use him for inspiration also reflects his artistic independence. His attention to the black working class prefigured Douglas's own radicalization in the 1930s, when he would join the American Communist Party. Reflecting the tendency of artists to romanticize the working class, as well as his own inclination toward mysticism, Douglas argued that although the average black worker was unaware of the Renaissance, he was critical to its success:

> He did not actually, consciously make a contribution; he made his contribution in an unconscious way. He was the thing on which and around which this whole idea was developed. And from that standpoint it seems to me his contribution is greater than if he had attempted consciously to make a contribution. The inner thing that came from him that some were able to understand and some of us, I believe con-

sciously understood, (we who understand that sort of thing), and that's the thing that made it unique, in my estimation.

Aaron Douglas described his depictions of the working class as the essence of the "Negro thing." The men and women in his art were not Harlem's new aspiring middle and upper classes but the "humble working person."

> So I tried to keep it there with simple devices, such as giving the clothing, any clothing, giving—sometimes giving it ragged edges, you know, as to keep the thing realistic . . . I was picking their pockets, sort of speaking. That's what it was. And it was a unifying thing, doing that. I felt that this is the basis of the [Harlem Renaissance]. . . . Yes, we have higher, we have lower and so on, but here is the base of the thing. We all understood that. We all were only one jump ahead of this person that I was trying to set forth here.[30]

Douglas's desire to reach the common man also drew him toward African art. Africa was the common thread for blacks of all nationalities. It provided a unity that cut across the many divisions among African-Americans, including those of class and skin color. The leaders of the Renaissance promoted this interest in the African heritage of American blacks, hoping that it would lead to a new race consciousness and racial pride. Langston Hughes tried to capture this longing for a connection to Africa in the following poem:

Afro-American Fragment

So long,
So far away
Is Africa
Not even memories alive
Save those that history books create

Save those that songs
Beat back into the blood—
Beat out of blood with words sad-sung
In strange un-Negro tongue—
So long,
So far away
Is Africa.

Subdued and time-lost
Are the drums—and yet
Through some vast mist of race
There comes this song
I do not understand,
This song of atavistic land,
Of bitter yearnings lost
Without a place—
So long,
So far away
Is Africa's
Dark face.[31]

For black Americans, Africa was largely distant, unknown, and foreign. Although Africa had a strong tradition of visual arts, middle-class black Americans failed to recognize it in the folk art of slaves and their descendants. In fact, African art's influences are evident in the crafts of American slaves, including wood sculpture, basketry, and ceramic sculptured forms whose patterns of iconic intensity may have been derived from the Congo-Angola section of Africa.[32] But as Douglas discovered, it was difficult to educate oneself on the traditions of Africa. Asked in later years about his title as the "first of the Africanists," he replied:

> I wished I had been. I could have made it more specific, but I didn't know how to then. I tried to read and get up on this thing, but there wasn't much that you could get a hold of. Of course, there were certain things. For instance, if I had known of Du Bois's book published in 1912, I think it was of the Negro, it would have helped. What I was interested in was the contribution of black people throughout the world. I never could get quite clear, and I went back and read *Islam, Christianity and the Negro Race* by Willmot Blyden. I got *Timbuctoo the Mysterious* by Felix Du Bois, but I didn't get quite enough.[33]

Douglas's challenge was to incorporate an African folk aesthetic within the established conventions of formal Western painting.

Douglas came to believe that the spiritual essence of the black man could be understood by going back to his African roots, and he often included African imagery, masks, dances, and rituals, if not scenes of Africa itself in his works. These thematic tendencies prove that Huggins's claim that African art had "little lasting influence on Douglas" is

without foundation, and his contention that the Renaissance's interest in Africa was superficial needs to be qualified.[34] Douglas initially learned about African art from Winold Reiss and continued to study it throughout his lifetime. He studied private collections such as Alain Locke's and spent a one-year internship at the Barnes Foundation's African art collection. He was also most likely familiar with Paul Guillaume and Thomas Munro's *Primitive Negro Sculpture*, published by Harcourt Brace in 1926 and illustrated with works in the Barnes Foundation. African art heavily influenced his work after 1926, with the exception of portraiture, which was his weakest venue. African idols appeared in the mural series at Fisk University executed in 1930-31. His faces often conveyed an African feeling, particularly the eyes, which resemble those of African masks of the Ivory Coast. Black artists Meta Vaux Warrick Fuller and Sargeant Johnson attempted to incorporate African motifs into their works, but only after Aaron Douglas emerged in the mid-1920s did Africanism have a major impact on African-American artists.

Although white patrons helped Douglas, they did not control or manipulate the main body of his artistic work. In his selection of themes, his interest in racial questions, and the influence of African art on his work, Douglas followed his own artistic path.

The question of primitivism, although linked to patronage in Huggins's critique of the Renaissance, deserves separate treatment. Huggins contends that black artists' primitivism reflected a preference of white patrons, betraying their racial prejudice and patronizing attitude toward African-Americans. It is undeniable that white Americans developed an interest in the Negro "primitive," a subject explored by white writers such as e. e. cummings with his character Jean Le Negre in 1922. Claude McKay's novel *Home to Harlem* was successful because it conformed to the sensationalism demanded by the white vogue for black primitivism. This vogue brought work to black writers, who were encouraged by the white commercial presses. Countee Cullen was also a proponent of primitivism and believed the true Negro spirit could be found in the African heritage. The romantic primitivism of Cullen and McKay rested on a superficial knowledge of African life. They pictured an ethnic identity which Huggins believes was rooted in male fantasy. Charlotte Mason was particularly fascinated with primitivism and urged artists to employ it in their works. She wrote to Alain

Locke: "We have trampled every primitive instinct in the heart of man to dust, and today there is not recognition of vision, or a divine will among us." She urged Locke to show a film on Africa to American Negroes and explained: "To enlighten and educate, Primitive life must be attractive. The film must make them thoughtful that they are the brown children of the world."[35]

Huggins believes that had black artists been free to choose their themes, their work would have been substantially different. Without minimizing the importance of patronage or the persistence of white prejudice, it is still necessary to qualify Huggins's argument through Douglas's own experience. Primitivism was a broad movement within the arts during this era, affecting both European and American artists. Indeed, there is a long history of the veneration of primitive art and artists by Western cultures. Europeans have been perceived as different than primitive artists because the primitive qualities in their art were seen as intentional, whereas primitive cultures were perceived as creating their work spontaneously, less reflectively, with less artistic intentionality. Westerners also deemed primitive artists anonymous, thus freeing themselves from the task of trying to determine the individual authorship of particular pieces. It was not until the 1920s that visual artists would incorporate full-fledged primitivism in their works instead of responding more narrowly to the inspiration of African sculpture, as Picasso, Braque, and others had done.[36]

Primitivism was popular not merely on racial grounds, and Douglas seems to have chosen freely to develop this style. His training in primitivism came from his white European art teacher, Winold Reiss, but his use of this method was encouraged by black leaders. Douglas kept working toward achieving this new style. He later recalled:

> I wanted to do something else, but gradually, they insisted so vehemently that I finally thought that maybe there is something to this thing. This primitive thing. What I was up against was trying to put myself back in, say, 1830, 1840, 1850, 1860. And try to see the world as a Black artist would have seen it during that time. And, without the facilities, without the training and education which that person would have had, or that person had. How did he see the world?[37]

Douglas described his views on primitivism similarly in a 1927 newspaper interview. He accepted some of the ideas of primitivism but

argued that it allowed American blacks to make a unique cultural contribution. As he put it: "The American Negro is peculiarly situated. His race is in the midst of a highly cultured people who have lost a certain amount of primitive impulses, and who respond to very intense exaggerated impressions. The Negro has greater rhythm and flexibility than his white brother and in such an environment his artistic contributions are neither like the farm hand nor the man on Fifth Avenue." Douglas went on to say that although it would be "absurd to take African sculpture and literally transplant it and inject it into Negro American life, we can go to African life and get a certain amount of understanding, form and color and use this knowledge in development of an expression which interprets our life."[38] For Douglas, Africa was a source of inspiration, not an escape.

Huggins argued that the ultimate irony of the primitives was that they were forsaking their actual past, denying their unique American heritage for a vague and distant myth. Dissatisfied with themselves, they sought to escape in the exotica of primitive Africa. It is ironically true that some black artists of this period neglected their own American heritage and turned to unknown Africa, but this is not an unusual reaction. White America had denied African-Americans a dignified past and had belittled or disallowed any cultural tradition that survived at the folk level. It was hardly surprising that a people denied expression of their immediate past might turn to a more remote heritage that had gained a degree of respect and legitimacy in the eyes of European artists.

The vogue of primitivism was a source of controversy within the black community, as captured in the debate over Carl Van Vechten's book *Nigger Heaven*, published in 1926. Van Vechten, an important and influential figure in Harlem, asserted that the Negro was a natural primitive who civilized himself at a great cost, losing some of his purity in the process. The book stirred immediate controversy and evoked a scathing review by W. E. B. Du Bois in the *Crisis*. Du Bois contended that *Nigger Heaven* was "an affront to the hospitality of black folk and to the intelligence of white." In Du Bois's view, Van Vechten depicted Harlem as a "nasty, sordid corner into which black folk are herded, and yet a place which they in crass ignorance are fools enough to enjoy. Harlem is no such place as that, and no one knows this better than Carl van Vechten." Du Bois found the novel neither truthful nor artistic. He

was concerned that instead of showing African-Americans as a distinct and dignified race, Van Vechten portrayed them as wild, barbaric, drunken participants in the white-financed cabaret scene. Primitivism and the true African-American heritage needed to be separated. Noting the difference between Langston Hughes's portrayal of Harlem life and that of Van Vechten, Du Bois wrote that "both Langston Hughes and Carl Van Vechten know Harlem cabarets; but it is Hughes who whispers, 'One said he heard the jazz band sob, When the little dawn was grey.' Van Vechten never heard a sob in a cabaret. All he hears is noise and brawling."[39]

James Weldon Johnson, whom Du Bois had once promoted to head the NAACP, by contrast, considered *Nigger Heaven* a well-written novel that accurately depicted life in Harlem. Johnson believed that the story "comprehends nearly every phase of life in the Negro metropolis. It draws on the components of that life from the dregs to the froth." His only regret, as a "Negro reviewer," was "the wish that a colored novelist had been the first to take this material and write a book of equal significance and power." Johnson praised Van Vechten for not being "too heavy, for not moralizing," and for covering every phase of the race question from Jim Crow discrimination to miscegenation. Ignoring Van Vechten's belief in the essential primitivism of blacks, Johnson believed that the book depicted blacks as just like white people, with the same virtues and faults.[40]

Primitivism was clearly a divisive issue for the black leadership of Harlem. Aaron Douglas had his own views about *Nigger Heaven* and illustrated two advertisements for it, even though he claimed never to have read it. "If I had read it, I think, at that time, I would have gone along with it." When asked if the title was offensive, Douglas replied:

> Yes, for the most part, and the life too. He . . . described that sort of, what shall I say, cabaret life. And most of us are church going people, and we didn't, couldn't go along with that sort of thing. But I suppose I thought of myself as being sophisticated at that time and therefore I would have gone along with it. But now I—it's a different thing, I would not, I am free from that kind and I see life differently now, and I don't think that was any help to us, that kind of thing. And yet, much of what was written [was] much like that.[41]

Douglas's retrospective distaste for the picture of Harlem life presented in *Nigger Heaven* is understandable. During the 1920s, many

whites sought escape in Harlem, which became part of the entertainment world's calculus of supply and demand. After World War I, America's moral code had begun to change, particularly in urban centers with their crowded and impersonal life-style. The roaring twenties, flappers, and all manner of excesses were in vogue as whites looked for a place to escape, to let loose, to indulge.[42] Harlem's clubs and cabarets provided a unique form of escape, a place where complete abandon was possible. The elegant sophistication of African culture that Europeans had discovered twenty years before in France was rediscovered by whites in Harlem as a chance to participate in what they saw as simplicity in its purest form. To the cabaret visitor, Harlem's blacks seemed to live an honest, free life. Of course, cabaret visitors at three in the morning had a completely different view of Harlem than they would find in the light of day. Whiskey, sex, and cocaine were readily and anonymously available to white visitors in Harlem. Harlem could provide everything a person (especially a man) might want. Although Douglas found Van Vechten's description of Harlem distasteful, he did see something positive in the race relations of that time, claiming that "I saw no fights or even quarrels between blacks and whites that were not immediately stopped by alert and determined bouncers. In fact, the Renaissance period was the heyday of peaceful relations between the races in New York City."[43]

As controversial as primitivism was, and as prejudicial as were its connotations, it can also be considered in a comparative context in American history. The interest of American blacks in primitivism parallels that of other newly urbanized American ethnic groups, who searched for their "roots" in an often distant and usually mythologized past. What Huggins regards as a "fanciful notion"—the attempt by black intellectuals to identify with Africa—can also be seen as an inevitable aspect of the economic and social development of a modern African-American community. Although most individuals had only remote connections with Africa, their wish to forge a cultural link with the African past reflected an impulse common to many immigrant groups whose tangible ties to a homeland are lost but later resurrected during an epoch of reawakened group identity. Unavoidably, any effort to reclaim an ethnic or national heritage lost through assimilation or acculturation involves distortion, if only because the parent culture is being rationally chosen rather than unconsciously "received."

Although the black search for roots parallels that of white ethnic

groups, it did have unique aspects. Slavery and the "middle passage" constituted a far more complete break with the African past than that experienced by European immigrants. Many African-Americans were aware of a handed-down folk culture, including music and storytelling, but during the early twentieth century the heritage of slavery caused more embarrassment than pride among most blacks. Douglas felt that the loss of a sense of culture, the "great loss of creative expression which culminates in the formation of original styles in buildings, paintings and sculpture," was underemphasized. He believed that one could "only speculate on the number and talents of the [black] architects, painters and sculptors, who were miscast as musicians, poets and actors."[44] The interest in primitivism provided American blacks with a way to overcome this deeply felt sense of cultural loss and permitted African-American artists to express a unique cultural heritage of their own, a heritage influenced and tied to white culture yet unique in its own right.

In considering the group identity of the artists of the Harlem Renaissance, Douglas's experience is an important corrective to the less favorable picture presented by Huggins. As in the case of primitivism, the group identity was one Douglas chose, and it had both good and bad consequences. The painters, sculptors, poets, writers, theater performers, musicians, and dancers of the Renaissance relied heavily on each other for artistic inspiration, as well as opportunities and connections in the black and white communities. There is little evidence that an inward group focus denied the artists opportunities and indeed more evidence that such a group consciousness actually expanded their potential.

From both an aesthetic and a financial standpoint, group solidarity was a sine qua non of the Harlem movement. Alain Locke wrote that "in Harlem, Negro life is seizing upon its first chances for group expression and self-determination. It is—or promises at least to be—a race capital."[45] The group was necessary as an entity from which individuals could draw on the talents and ideas of other members who banded together, creating opportunities and assisting each other in a multitude of ways. Locke did not see this as a small group movement but as one that had potential to influence African-Americans on a national and international scale—pan-Africanism writ small.

Aaron Douglas profited greatly from his connections with W. E. B. Du Bois and Charles Johnson, especially in receiving magazine com-

missions and being introduced to the artist Winold Reiss. But the group identity provided a spirit of camaraderie that kept him going. Douglas explained: "We were consciously making art. We were constantly involved in the process of turning this thing of concerned Blacks meeting in this place and telling jokes of all sort lightheartedly. Turning this into art of some sort. . . . This togetherness was the thing that created the Renaissance that made it sort of special and sort of monumental in a certain sense.[46] The group itself was the essence of the Renaissance. Had Douglas labored in Harlem deprived of kindred spirits with whom to share and collaborate, his art would not have developed as it did, as he freely attested:

> This great upsurge, this enormous ground swell of self-identification might have eventually subsided into forgetfulness, but for this small group of merry [participants] who decided to fix the event on the conscience of our times by raising their united voices in a single creative expression through music, poetry, the novel, the essay, sculpture and painting. . . . I had the good fortune to be one of a small group of eight, ten perhaps a dozen young men and women who met in the streets, the libraries, the churches and the cabarets of Harlem, which was at that time the Mecca, the intellectual and artistic focal point of the black world of the twenties.

Douglas recognized, with both pride and astonishment, how much the members of the group reinforced each other's convictions and determination. Aaron and Alta Douglas's home served as a central meeting place for artists. "At the time no one stopped to think how absurd, illogical, incongruous it was that a few young, black, inexperienced writers, artists and scholars, coming for the most part from lowly backgrounds such as ours should ever aspire to the eminence that comes to mind when you think of the great Renaissance of 15th and 16th Century Italy."[47]

Douglas's experience makes it clear that at this early stage of active black cultural expression, the artists needed to have each other to turn to for ideas, encouragement, and inspiration. The creation of the magazine *Fire!!* was the epitome of collaboration in the Harlem Renaissance, a group effort that paid rich dividends to its members. Langston Hughes, Zora Neale Hurston, and Wallace Thurman served as editors. John P. Davis acted as business manager, and Richard Bruce Nugent was in charge of distribution. Gwendolyn Bennett and Aaron Douglas

assisted in other ways, Douglas providing illustrations. Many leading Renaissance artists participated, including Countee Cullen and Arna Bontemps. Without white direction or help from the main black leaders of the time, these artists published, albeit for only one issue, a magazine devoted to young black artists, relying heavily on the group to make the issue successful.

The group character of the Renaissance had other consequences as well. It brought Douglas into contact with one of the few wealthy black patrons of the time, A'Lelia Walker. Walker was the daughter of the first black woman millionaire, Sarah Breedlove, who had made her fortune by developing a hair-straightening tonic. Walker controlled more than two million dollars of inherited investments and constantly entertained the black elite, as well as many whites, at one of her three homes. The parties were lavish and exciting; all of the great intellectuals of the Renaissance attended.

In 1928 she opened what was to become known as the Dark Tower, a salon at her 136th Street home, where she entertained her friends. Later the Dark Tower was turned into a nightclub. At one point she approached Aaron Douglas about frescoeing the walls in her apartment—he never did—and Langston Hughes about placing poetry on them. Douglas recalled that when he arrived in New York, "that Dark Tower business was going." To Douglas, Walker's Saturday afternoon dances were "wonderful," the only place where you could "meet all the people, all the people in the North so to speak, . . . white and black." Even though Walker had another place on Edgecomb at St. Nicholas Place, nothing ever had "the glamour of this Dark Tower."[48]

The camaraderie of the young black artists would have other consequences as well. Douglas mixed socially with other artists on a regular basis. His acquaintances included Langston Hughes, Harold Jackman, Bruce Nugent, Wallace Thurman, Countee Cullen, and Jessie Fauset, an intimate friend of Du Bois's. It was through Fauset that Douglas met Jean Toomer, whom he described as quiet, amiable, unassuming, and nontheatrical. Toomer was the author of the lyrical novel *Cane*, and he introduced Douglas and the other young artists of the Renaissance to the teachings of the French mystic George Ivanovitch Gurdjieff.[49] Toomer served as an unofficial leader of a group of Harlemites who studied Gurdjieff's philosophy, a mix of Christianity, mysticism, and what one might term today consciousness-raising. Gurdjieff's philoso-

phy demanded that his disciples practice a regimen of "inner exercises" and "sacred gymnastics," promising them release from the "mechanical plane" and knowledge of the lost truths of the East.[50] (It also included a fascination with paranormal phenomena such as mesmerism and hypnotism, an obsession with secrecy, and such supposedly profound expressions as "Man Must Live Till He Dies."[51]) Gurdjieff made his first visit to the United States in early 1924, staying mainly in New York and giving a series of public performances of his work on sacred dances.

Toomer, as the leader of Gurdjieff's black American disciples, drew in such figures as novelist Arna Bontemps and Wallace Thurman. He also provoked Douglas's interest in Gurdjieff. Douglas wrote to Alta that "every Friday night Jean Toomer is giving a series of philosophic lectures, in which he is teaching a new type of psycho-philosophy the essential element of which is self realization, self-consciousness." Douglas went on to explain his own understanding of Gurdjieff's philosophy, as expressed by Toomer:

> He claims that we all have the potentialities of intellectual, artistic giants if we could only get to the bottom of our real selves. He claims that back deep in our natures there is a mine of unused power, a source, a hitherto little known faculty which is neither body, emotion or intellect, but is equal to the combined power of all. The key to this source is self-observation. The ultimate goal is free will. It is tremendously interesting. I have had more interesting experiences in its practice.[52]

Douglas told Alta of going to Brooklyn one Saturday night and finding that there was a ten dollar fee just for the "privilege of hearing the book." Douglas managed to avoid the fee and entered free.

Douglas later claimed that his interest in Gurdjieff did not affect his art in any major way and that he did not use his art as propaganda for Gurdjieff as Toomer did.[53] This recollection is not wholly accurate. The appeal of Gurdjieff's ideas to Douglas must take into account their transmission through Toomer, a friend and important influence on Douglas. Gurdjieff's ideas also appealed to Douglas's own interest in mysticism and group identity. One can see some of this mysticism in Douglas's conviction that the "common man" influenced the Renaissance:

> He was a participant. He didn't, he didn't make, he didn't put his hands on anything. He didn't mold anything, excepting the thing was being

emitted, something was coming out of him which the various artists answered (responded to), could get hold of and make something that was later known as the Harlem Renaissance.[54]

Douglas was in search of what Huggins called "the spiritual identity of the Negro people," a soul that would unite all black people. He wanted to create universal objects that would have meaning to any black man, simple symbols in his art that would be recognizable, to unite the race. Art could bridge the gaps between all people, Douglas believed, and through Gurdjieff's teachings he looked for the primitive soul to make universal statements.[55]

The Harlem Renaissance achieved more than could initially have been thought possible for the time period. It provided a beginning, an intellectual and social initiation for the black movement, and its importance cannot be underemphasized. The leaders of the movement have been criticized for their interest in traditional standards of culture, but these traditional standards provided a starting point for developing a unique form of cultural expression. Critics also underestimate the degree to which the Renaissance prepared the way for later advances in the 1930s, when individual achievement loomed larger than in the period of the Harlem Renaissance. In the visual arts, especially, artists such as sculptor Richmond Barthé flourished in the 1930s. From the perspective of its leading visual artist, the Harlem Renaissance emerges quite differently than the account written by Nathan Huggins. Huggins denied the very authenticity of the Renaissance for African-American history. Aaron Douglas's experience gives little evidence for this conclusion. White patronage did not cripple Douglas's artistic creativity or compel him to create work that catered to white prejudice. Douglas believed the Harlem group members relied on each other in a positive way and created many original works of art. They were positively influenced by a new discovery of African culture, however remote their knowledge was and however naively they depicted Africa. It is thus ironic that Huggins's book features a cover illustration by Douglas. This illustration was solicited by the author, for which the seventy-one-year-old Douglas was paid two hundred dollars. Douglas did not see the book until it had been published, but his writings and interviews indicate that his view of the Harlem Renaissance was entirely different from that of Nathan Huggins.

Four

A Visual Artist
with an Authentic Voice

For Aaron Douglas, Harlem was different from anything he had ever seen before, and he wished to experience it immediately. In one of his first letters from New York, written only two weeks after he arrived, Douglas told Alta that "it is now time that I pick out a course of some sort." He had been waiting for a "happy accident" to suggest what he should do, but now, in a fit of youthful impatience, he was determined to begin an "active effort."[1]

In beginning this "active effort," Douglas had to rely on his own intrinsic talent and creativity. But although these attributes best explain his success, his career advanced as quickly and dramatically as it did because three men—Charles S. Johnson, Winold Reiss, and W. E. B. Du Bois—different in personality as well as race and even nationality, provided him with the opportunities, training, and inspiration to become the most innovative visual artist of the Harlem Renaissance and a significant figure in early twentieth-century American art.

In 1924, at an Urban League convention in Kansas City, Aaron Douglas was introduced to Charles S. Johnson. Johnson, a trained sociologist, was the editor of *Opportunity* magazine, the official journal of the Urban League. In the civil rights world of the early twentieth century, the Urban League was a relatively conservative organization,

providing business networking and research for the still relatively small black professional and entrepreneurial classes. Despite its business orientation, Johnson was determined that *Opportunity* would display the work of black artists and writers. The Harlem Renaissance needed illustrators, and Johnson had been told that Douglas was well trained and showed more promise than most African-American artists of the time. He began a campaign to convince Douglas to come to Harlem, through his secretary, Ethel Ray, later Ethel Ray Nance, with whom Douglas was fairly well acquainted, and on whose friendship and wide range of contacts within Harlem Douglas drew "rather heavily."[2] Conveying Johnson's sentiments as well as her own, Ray told Douglas that it was "better to be a dishwasher in New York than to be head of a high school in Kansas City."[3] Along with the timely appearance of *Survey Graphic*, Johnson's tactics worked. For some time after he arrived in Harlem, Douglas was a guest in Ethel Ray Nance's home, a gathering spot for many of Harlem's new black elite.

Douglas's connection with Charles S. Johnson would prove to be very important to his future in Harlem. Johnson would not only provide opportunities and contacts but serve as a social mentor to Douglas, helping him learn how to conduct himself within Harlem's elite society.

> I got to know Dr. Johnson quite closely, quite intimately. And . . . on occasions of going to certain social things, certain parties, and so on when I might not have had exactly the right things, I'd borrow things from *him*, you see. And that sort of relationship—he understood really what was going on, to add his strength to, to promote. Now, we see it as one of the greatest things that existed at that time and he promoted almost every young person at that time who had any talent whatsoever: these young people could be encouraged and could be pushed along by Dr. Johnson.

Johnson could spot talent and promote it, helping artists get started. As Douglas stated, Johnson "understood how to make the way, how to set the next step, how to indicate the next step for many of these young people at that time and make it possible for them to go on to other things." Through Johnson, Douglas made important contacts, including Carl Van Vechten and Dorothy Barnes of the Barnes Foundation. Douglas gave Johnson an enormous amount of credit for the success that he and many others experienced, saying that Johnson's influence was "so massive that many people, many people, took credit for the

things that he really had done and that were really Johnson's. Certain people say that his influence was so broad that it was hard to do anything that he hadn't created, thought out and . . . engineered."[4]

Johnson's influence on Douglas was multifaceted. Along with the contacts he facilitated, Johnson provided Douglas with commissions to illustrate in *Opportunity* magazine. These created an almost immediate demand for Douglas's work, and Johnson served as the intermediary. Douglas wrote Alta:

> Mr. Johnson, editor of *Opportunity*, has had three letters asking specifically about Aaron Douglas the artist. One letter came from Gwendolyn Bennett who is studying in Paris. One came from someone at Hampton Institute. The other came from a Professor Punkett of Western Reserve University, Cleveland. Mr. Johnson is selling Professor Punkett the original cut of one of the drawings. Don't know what I'm getting for it. I told Mr. Johnson to make it light. Eugene Kinkle Jones [executive secretary of the Urban League] asked about me. I met R. K. Bruce several days ago. Bruce also said that he had heard so much about me that he was especially pleased to meet me.[5]

Johnson nominated Douglas for a Harmon Foundation award in 1926, declaring that during the past year, Douglas had produced the most significant creative work of any Negro in the field of fine arts. Such an award would bring the needed encouragement and stimulation to an artist who has "been faithful to his art in the face of many discouragements. He bids fair to become, within a few years, the most outstanding artist of the Negro race."[6]

Johnson proved equally helpful in Douglas's personal life. Although Douglas came to Harlem alone, his love affair with Alta remained passionate. He turned to Johnson for help in bringing her to Harlem. Johnson agreed to interview Alta, and Douglas was confident that he would be able to find her a position. He wrote Alta to suggest that she read up on current sociological theories for her interview with Johnson: "Mr. Johnson is in close touch with the type of work of which you speak, and has wide influence. He would be glad to help me as they feel rather indebted to me."[7] Johnson was impressed with Alta and found her a position with the Urban League's Morristown project. This job, organizing boards and committees for Johnson, required only an hour's commute from Harlem and enabled Aaron and Alta to be together for the first time in their relationship.

Douglas's relationship with Johnson did have problems, though they resulted from Douglas's success. The young artist felt a certain amount of pressure from Johnson, who wanted to be the one to introduce him to the important people of Harlem. Although the Urban League and the NAACP shared the same goal of civil rights for blacks, the organizations and their respective magazines—*Opportunity* for the Urban League and *Crisis* for the NAACP—were rivals for influence and power within the black community. Douglas soon realized that balancing social obligations was a touchy subject and tried to keep members of both organizations happy. This was not always possible; he wrote to Alta of an uncomfortable encounter with Johnson about meeting the artist Miguel Covarrubias:

> Lines have already begun to draw in around me. You see I'm between two rival factions. The Urban League and the NAACP. I walked into Johnson's office a few days ago, and he said, "sit down, I've got something to tell you." He was furious. And all because Walter White had sent for me a few days prior to that and asked me if I had met Covarrubias yet. I told him no, where upon he proceeded to plan for us to meet. . . . Covarrubias is mad over my cover design for Opportunity for this month and has asked everybody how he could meet me. He said the cover was perfect and expressed a wish that he himself had made it. What made Johnson sore was the patronizing attitude that Walter White took in the matter. Johnson had planned for Covarrubias and I to meet at the Urban League Party, but Miguel failed to get his notice. Can you beat it, fussing about who shall introduce me to people?[8]

Despite occasional tensions, Douglas's relationship with Johnson remained close. Johnson provided Douglas with the encouragement and strong support to sustain his artistic ideals, visions, and hopes for his career. Specifically, Johnson encouraged Douglas's desire to continue his artistic education, avoid commercial work, and plan a trip to Paris. After arriving in Harlem, Douglas continued reading books on the history of painting, which he found "nearly as fascinating as a novel." He saw himself as "changing very much every day." Douglas was "pleased and surprised with my recognition" but needed to try "to get away from people in order to get ready for the grand push. My plan is to study two years more here and finish with a year in Europe. I'll be ready then to slap them dead." To carry out his plan, Douglas wanted to avoid becoming involved in too many commercial ventures. "I've

been considerably upset this week," he wrote Alta. "I have been duck-
ing these commercial people. Literally running from money. There's
good and bad money. The situation is this, if these fellows should give
me work it would be the sort they don't want or can't do. I'm sharpen-
ing my teeth for the meat, not scraps and bones."[9]

When Charles Johnson recommended Douglas again for a Harmon
Foundation award in 1927, he mentioned these important qualities. He
stated that Douglas "distinguishes himself from the majority of Negro
artists by refusing to admit that his art education is complete . . .
foregoing a comfortable position as art teacher in the high school in
Kansas City to continue his studies, and sacrificing other comforts
rather than prostitute his abilities in hack commercial work. He, almost
alone among the Negro artists, has remained true to his art."[10] Johnson
endorsed Douglas because he believed he was the most creative of the
Negro artists, making a genuine contribution to modern art through
his recreations based on African motifs. He also hoped that a Harmon
award would enable Douglas to study in France, as the artist Palmer
Hayden had done with his award money.

Despite Johnson's influence, his recommendation did not secure
Douglas the Harmon award. But Douglas's relationship with Johnson
remained strong, and Douglas eventually went to Fisk University
in Nashville after Johnson became president of that institution.
But perhaps most important among Johnson's various contributions
to Douglas's career was the introduction he provided to an extra-
ordinary Bavarian artist, the "Holbein of the Humble," Winold
Reiss.[11]

The relationship between Winold Reiss and Aaron Douglas is one of
the best examples of the positive interaction of whites and blacks dur-
ing the Harlem Renaissance. Even before Douglas was introduced to
Reiss he considered the Bavarian's work inspirational, particularly his
contribution to *Survey Graphic*. Reiss was still relatively unknown when
the magazine appeared, but after five thousand copies were sold and his
show of black portraits opened at the 135th Street Library in March
1925, he became a celebrity among Harlem Renaissance leaders. Har-
lem notables including Jean Toomer, Countee Cullen, Paul Robeson,
Roland Hayes, W. E. B. Du Bois, and Alain Locke all wanted their
portraits done by Reiss.

Through Charles Johnson and *Opportunity*, Douglas received an invi-

tation to meet with Reiss. Reiss was everything Douglas had hoped he would be, and his influence led Douglas to change his artistic course:

> I met Winold Reiss yesterday. He is a wonderful fellow. He is also very handsome. I was at his studio and saw the originals of the drawings we saw in *Survey*. The originals are superbly beautiful. . . . I can't say yet sweetheart what I shall do. . . . My first reaction has been to destroy all my existing work. I shall also avoid cheap and premature notoriety. I have set in for solid attainment. That takes time.[12]

Douglas later described Reiss as "a very interesting person, very stern. . . . What we think of as a typical German. He was a very fine person. He saw what I was doing with the little schooling that I had in art out to Nebraska which wasn't very much at all in relation to what you should have had."[13] After meeting Douglas and viewing his work, Winold Reiss was clearly impressed with the young black artist. He offered Douglas a two-year scholarship to study with him, as well as the opportunity to meet with him informally throughout the summer of 1925 while Reiss was in New York. Douglas was very pleased. The contact with Reiss helped him get started even before classes commenced at the Reiss studio in the fall.

> I was down to Reiss's studio yesterday. I had a very interesting and inspiring talk with him. He is great. I shall study with him in the Fall. In the meantime I shall receive weekly criticism from him. He has no classes now. I have been drawing all day. I already feel that I am improving. By the way I am going to work Monday at the Faculty Club. . . . My problem is to get on. Not wait. The world doesn't wait. Opportunities are on the move and one must get on the move to get them. I'm going to make it—don't forget that.[14]

One of those opportunities would prove special to Douglas because it related to the inspiring issue of *Survey Graphic*. Reiss was asked to illustrate Alain Locke's *New Negro* and chose to include some drawings by his new prodigy, Aaron Douglas.

For *The New Negro*, Reiss contributed portrait sketches as well as African-looking symbolic designs. Douglas's work followed the same basic patterns. In the preface to the 1968 edition of *The New Negro*, Robert Hayden described Reiss's and Douglas's involvement in the volume:

One of its most exciting and unusual features was the work of the Austrian artist Winold Reiss and the rising young Negro artist Aaron Douglas. Their illustrations, portraits of racial types, and African-inspired decorative motifs constituted a fresh and original approach to materials hitherto little explored. Together with the photographs of African sculpture also included, the work of these artists added considerably to the total effect of the volume as testimonial to Negro beauty, dignity, and creativity.[15]

Some African-Americans, conditioned by generations of prejudice and racism, were not ready for Reiss's honest, dignified portraits that were so different from the typical stereotype or caricature. Douglas was not among them. Reiss painted blacks as blacks, which Douglas, in a letter to Alta, considered significant for the black struggle for dignity:

> I have seen Reiss's drawings for the New Negro. They are marvelous. Many colored people don't like Reiss's drawings. We are possessed, you know, with the idea that it is necessary to be white, to be beautiful. Nine times out of ten it is just the reverse. It takes lots of training or a tremendous effort to down the idea that thin lips and straight nose is the apogee of beauty. But once free you can look back with a sigh of relief and wonder how anyone could be so deluded.

In the same letter, Douglas discussed the relationship between art and beauty, berating those critics of modern art who disliked its method of representing people and nature:

> Beauty for most people is synonymous with desire. If the picture is of a so called beautiful face we desire to possess or emulate it. If it be a landscape we desire to roam about in its fields and woods. If it is of fruit we desire to eat it. And so our pleasure in the picture is contingent upon its being as nearly like nature as possible. Our pleasure in pictures is seldom derived from that goal of art in my mind, should not be to represent the spiritual by means of material imperfection. Life is the manifestation of spirit. I have no objection to a pretty face else how could I love you as I do. But I do object to people holding up pretty faces as the acme of beauty, and then saying that the business of art is to depict beauty. It is revolting. So when you see these pictures by Reiss please don't look for so called beauty. It ain't there. But there is a powerful lot of art.[16]

Reiss encouraged Douglas to explore modern art while reviving African and other premodern, non-Western design forms. Reiss also

urged him to explore Egyptian art but to include American Negro spirituals, dance, and folklore as symbolic motifs in his visual designs. He hoped that Douglas would develop African-American designs and portraits without stereotyping African designs. Though some have suggested that Reiss himself had grown tired of this work and wanted to pass it along to another, it seems more likely that Reiss took Douglas on as a pupil because of his genuine interest in portraying African-American subjects accurately and with dignity.[17] Douglas believed that Reiss wanted him to arrive "at something of a style in art that would reflect my background. . . . What kind of picture, what kind of world does a black artist see, and transcribe, must be responsible for transcribing? That wasn't easy. That was a terrific problem." As "wonderful as he was as an artist," Douglas thought, Reiss knew he could not see the world as a black artist would. "I had to do this," Douglas concluded.[18]

Douglas was particularly impressed with Reiss's training "in the thorough and exacting craftsmanship of the art schools of pre-war Europe." Reiss's work, particularly in design, clearly showed his sympathy for and appreciation of the contribution of African art to the modern world. His influence was exactly what the young and still artistically immature Douglas needed at this time.

> I clearly recall his impatience as he sought to urge me beyond my doubts and fears that seemed to loom so large in the presence of the terrifying specters moving beneath the surface of every African masque and fetish. At last I began little by little to get the point and to take a few halting, timorous steps forward into (what was for me) the unknown. I shall not attempt to describe my feelings as I first tried to objectify with paint and brush what I thought to be the visual emanations or expressions that came into view with the sounds produced by the old black song makers of antebellum days, when they first began to put together snatches and bits from Protestant hymns, along with half remembered tribal chants, lullabies, and work songs. These later became the early outlines of our spirituals, sorrow songs and blues.[19]

Reiss was a demanding teacher, and Douglas wanted his approval. For a time, meeting Reiss's standards was all that mattered to Douglas. He wrote Alta: "I don't feel so good today. My drawing for the drop failed. That is, Reiss didn't think it so good. I have spent about three weeks on the thing. Pretty rotten." Reiss challenged the young artist to expand his intellectual horizons as well, encouraging him to read books

such as Henri Bergson's *Creative Evolution*, which Douglas considered "the greatest thing that I have ever read. It's going to be the bible of my aesthetics from now on." He knew how fortunate he was to have the opportunity to study with Reiss because his was "the most expensive art school in New York," costing more than five hundred dollars in tuition alone. Although Reiss's approval was still elusive, Douglas knew he was making progress. "One fellow said to me," he wrote Alta, " 'My God, how do you get so much done, I can't get started.' Of course, there is no virtue in speed. Neither is there advantage in quantity. But I do feel elated to know that I can do a drawing in fifteen minutes and almost as well this week that required an hour to do last week."[20]

Reiss encouraged Douglas to continue to draw to improve his technique, and his training had a profound influence on Douglas. Douglas developed a flat, stylized signature method that closely resembled Reiss's. Reiss's insistence that Douglas turn to his black heritage and that he have proper training from live models greatly improved Douglas's work. Douglas saw that he was progressing under his teacher's direction but began as well to see his own work as becoming independent of Reiss. He wrote Alta that "Reiss was pleased with my drawing. I was pleased from the start, but I felt his approval necessary, in that I was working in an advanced medium, and without his recommendation. When I showed it to him he started, recovered, gave me a crushing slap on the back and said fine, wonderful, keep after it." Douglas went on to tell Alta that although there were similarities between his style and that of Reiss, "on close observation differences in style are obvious. In fact one of the students suggested that it looked very much like a particular drawing that hangs in the studio." Douglas was becoming more confident in the value of his work. He was jubilant when he recounted to Alta a gesture of this self-confident independence:

> At twelve o'clock when the regular model ceases to pose we have someone from the class to pose for half an hour. A colored chap posed today. I made a complete pencil sketch of the head. I was so elated over my success with my other drawings that I took my work home and completed it in crayon without the model. Oh babe, I wish you could see it. It looks exactly as if it had been carved out of wood. It is beautiful. The beauty of it is in its originality. It will be a crusher when I show it in the studio tomorrow, because no one would dream that the thing could be carried out without the model. I didn't know it myself until I did it.[21]

In describing the work as almost "carved out of wood," Douglas was referring to his effort to make his works more purely primitive and based on African sculpture. This was an original idea; no other black artist was doing the same kind of work. And though at first glance Douglas's style seems extremely close to Reiss's, the two were actually quite different. Douglas's drawings have a much sharper, harder line and silhouette, and in their simplicity they are more dramatic. These qualities would lead Douglas to surpass his teacher and develop as a characteristic a very strong, hard line in his silhouettes.

Reiss also served as professor of mural painting at New York University. He painted murals in railroad stations, hotels, restaurants, and theaters, often using ethnic groups as his main subject. Although Douglas never mentioned having training in mural painting, Reiss's work likely had a great influence on the murals he did in the future. Douglas completed numerous murals, including those at Fisk, Bennett College, Club Ebony, the College Inn, the YMCA, and the Countee Cullen Library.

Despite Reiss's importance for Douglas, their relationship was not without tensions brought on by race. Douglas felt he knew a great deal about art but had to keep silent. He wrote Alta that he felt he, as an African-American, needed to display caution when speaking with Reiss:

> [Reiss] told me that when his classes began work we would make some studies from the model, etc. Did you get the *we*. You see, sweet, I'm having to put myself in the back. While everything is going nicely one must not forget to be careful . . . to keep their acquaintances separate and in line. You must let your right hand know what's going on in your left. My tactics are these, assume a look of dumbness graduated to the occasion, keep eyes and ears open and say as little as possible. No one knows better than a Negro the real power of a smile. It seems to be instinctive for one man to want to teach the other man something. What a real disappointment it is to find that the other fellow knows what we are about to tell him.[22]

But though Douglas felt he had to "play the game" to benefit from his time with Reiss, he did develop a genuine respect for Reiss as a man and an artist. Reiss, in turn, became one of Douglas's strongest supporters, an important reference in his nominations for fellowships, and an artist whose approval brought Douglas to the attention of the most impressive black intellectual leader of the era, W. E. B. Du Bois.

By 1916, after the death of Booker T. Washington, W. E. B. Du Bois had emerged as the most prominent African-American leader in the United States.[23] His book *Souls of Black Folk* signaled the break from Washington's supporters and made the quest for political and social rights the order of the day for the New Negro movement. As editor of the NAACP's magazine the *Crisis*, published in New York City, Du Bois helped establish Harlem as the center of Negro protest. Du Bois used the magazine, which had a circulation of almost forty thousand, both as a forum for his political views and to crusade against racial injustice, especially lynching. The *Crisis* told its readers of every gruesome aspect of lynching, complete with shocking statistics, graphic descriptions, and photographs.

As a counterweight to racial violence, Du Bois advocated that blacks pursue political power. He wanted his race to be independent from major political parties and yet to achieve political clout. He continually struggled with these goals in the *Crisis*. Political strength would be difficult to achieve when no political candidate was particularly interested in obtaining the Negro vote. Black leaders had little power and a limited following. No leader was capable of uniting blacks on a national level. Without mass support, even the best leadership could not make changes.[24]

Du Bois was a towering intellectual figure, an aloof thinker with an extraordinarily incisive mind and a combative, arrogant personality. As David Levering Lewis writes, "Ego and obduracy were integral to Du Bois's makeup," and at times, he was "touched with a sense of infallibility."[25] Although he was not easy to love, his courage and convictions won him respect. His brilliant writings and attacks on racial prejudice and inequality were an inspiration to African-Americans across the United States. Douglas read Du Bois's editorials when he was still in high school, considering them "beautiful things . . . the inspiration from those things was enough to make me realize the importance of any kind of association with this man."[26] From the pages of the *Crisis*, Douglas learned of political issues, the arts, social affairs, and Du Bois's opinions on the issues of the day. (Du Bois's support for the involvement of black soldiers in World War I was one reason why Douglas became an enthusiastic participant.)

Not surprisingly, Du Bois had strong views about African-Americans and art. In his speech "Criteria of Negro Art," delivered at the 1926 Chicago Conference of the NAACP, Du Bois posed the question, What do blacks and slaves have to do with art? He answered by encour-

aging the "colored artist" to create, recognizing that his work was not inferior, as the white man would suggest. Whites might want blacks to create because it would stop "agitation of the Negro question." He declared it "the bounden duty of black America to begin this great work of the creation of Beauty, of the preservation of Beauty, of the realization of Beauty." The artist should strive for Truth, Goodness and Beauty. Du Bois also argued that art was propaganda, and should be, to gain the right of black folk to love and enjoy. Negro art should carry a message. In words that read like an endorsement of the social realist school of the 1930s, Du Bois declared: "I do not care a damn for any art that is not used for propaganda. But I do care when propaganda is confined to one side while the other is stripped and silent." Whites might encourage blacks to create works that deliberately distorted the black condition. Blacks needed to learn to determine on their own which black art was of high quality, rather than relying on the judgment of white publishers and critics. "Until the art of the black folk compels recognition, they will not be rated as human."27

To some extent, the relationship between Du Bois and Douglas reflected Du Bois's desire that blacks determine their own artistic forms of expression. Du Bois helped Douglas solve one of the most basic problems that any artist faces—how to make a living while trying to find the time to create. Not long after he arrived in Harlem, Douglas wrote of the difficulty of making ends meet. For a time he worked in a batik factory, dyeing fabric by covering parts of it with removable wax, and also waited tables in an apartment hotel where he was the only waiter. This job was particularly difficult because the hotel was run by Eastern European immigrants and Douglas could not understand them. He explained to Alta that he quit the jobs when he realized that "my purpose here above all things is to study and unless I am studying I might as well be back out West where I could make a living decently."28 The solution finally came after Douglas was introduced to Du Bois, who, on Reiss's recommendation, took an interest in the struggling artist. Du Bois encouraged Douglas to pursue his art and include an African vein. Most important, Du Bois offered Douglas a job in the mail room at the *Crisis*, allowing him to take classes in the morning and work in the afternoon. The job was ideal. He was elated when he wrote Alta about the opportunity, although he realized that it would not go down well with his friends in the Urban League:

> Now to cap the climax. The great Du Bois wrote me that their shipping
> clerk had left and that if I was at all interested he would like to talk with
> me about it. He thought that he could arrange the job to meet my
> convenience. Isn't that wonderful? My *Opportunity* friends are going to
> be sick. I'm sorry, but I must live and the *Crisis* has offered to solve a
> very real and withal a very pressing problem. Sentiment must be put
> aside. Besides the *Crisis* can publish my drawings as well as *Opportunity*.
> And besides I can draw for both.

Douglas privately hoped the situation would be temporary, telling Alta
that although he was grateful for the sixty dollars a month, "I hope in a
few months to be able to spit on that $60."[29] The job enabled him to
pay his rent and to continue taking classes with Winold Reiss. It was a
lifesaver for the young artist.

In his letters to Alta, Douglas described his new routine, courtesy of
Du Bois's patronage. "My day is something like this," he wrote. "Class
9 to 12:45. No lunch. Work 1 to 5. Dinner. Hours work. . . . I'm
doing a very interesting drawing. Probably the best thing that I've ever
done. Everybody is raving about it."[30] As favorable an arrangement as
it was for the young artist, Du Bois's patronage exacted a price. In 1925,
Du Bois had founded the Little Theatre Movement in Harlem with his
Krigwa Players group. He "requested" that Douglas help with the set
designs, a task that clearly annoyed Douglas. He was surprised when
Du Bois attached his name to the organizing committee of the Players,
puzzled as to what role he would have. "Oh! yes, stage decorations," he
angrily wrote Alta. "I have attended five meetings. The so called cabi-
net got together under the dictatorship of Du Bois and appointed the
committees. If it wasn't so absolutely ridiculous I would consider my-
self insulted [to be working under one particular woman artist]. But it's
too funny."[31] Douglas met regularly with Du Bois, often unsure of
what they would discuss but certain that he would be doing most of the
listening. The young artist took to referring to the black leader in his
letters as "the great Du Bois," indicating the aloof and condescending
manner with which Du Bois treated many of his associates.[32]

Despite Douglas's mixed feelings, the "great Du Bois" would open
many doors for the artist. Slowly his relationship with the formidable
Du Bois warmed up, especially after the highly respected Winold Reiss
praised the young artist's work.

> Dr. Du Bois's little curt smile and stiff handshake have turned to an ear
> to ear grin and warm and sincere grip. I admit my confusion. . . . And

all because Winold Reiss has given me his unqualified stamp of approval. It all happened like this. Dr. Du Bois phoned Reiss asking him to judge the art section of their contest. When Reiss looked at the drawings he said many things and withheld a few. Dr. Du Bois told Miss Ray and she told me. Reiss told me everything himself yesterday morning some of which I censor. It amounted to this, that my work was far superior to anything in the exhibition and that in the next contest they would do well to have me entered. He was very enthusiastic over my last efforts. Between you and I dear, I have started them to talking about me.[33]

Du Bois quickly began using Douglas's work on the pages of the *Crisis*. His first drawings appeared in the February 1926 issue with his Little Krigwa Players poster and his drawing *Invincible Music, the Spirit of Africa*.

Later in life, Douglas looked back on this time in his career with a mix of amazement and wonder at the speed with which his work was accepted. Noting that his early work could hardly be called "masterful," Douglas recognized that his quick acceptance reflected the need felt by black leaders such as Du Bois and Johnson for visual art that reflected an authentic black voice. His art, Douglas recalled in a later speech, was a "heaven-sent answer to some deeply felt need for this kind of visual imagery. As a result, I became a kind of fair-haired boy and was treated in some ways like a prodigal son. I began to feel like the missing piece that all had been looking for to complete or round out the idea of the Renaissance."[34] (Douglas originally added the words "in the souls of black men" after "deeply felt need" but crossed them out before delivering the speech.) Douglas knew that his immediate success reflected not only the quality of his work but the needs of the newly urbanized, newly politicized African-American community.

As an artist drawing for both of the leading black journals of the time, Douglas increasingly felt the competition between Du Bois's *Crisis* and Johnson's *Opportunity*. He was uncomfortable being stuck between the two factions but felt that there was enough of him and his work to go around. He decided to illustrate only for these two magazines and not for lesser publications, believing that his career would progress better if his work appeared in the best magazines. In a letter to Alta, he reveled in his success with a mixture of arrogance and humor:

> I'm becoming awfully egotistic. Things have broken and are braking so beautifully for me that I can't help patting myself on the back. *Vanity Fair* has one of my drawings and *Theatre Arts* will publish some of my

work before long; but I don't want any more recognition of that sort. I shall submit nothing more to magazines excepting *Opportunity* and the *Crisis*. I want to keep away from publicity. It's bad. At present. Distracts my plans. Distorts and forces my development. I should like to remain obscure for two years longer. At my present rate of progress I'll be a giant in two years. I want to be frightful to look at. A veritable black terror.[35]

Du Bois did try to tie Douglas more closely to the *Crisis*. The March 1927 issue listed Douglas as art editor and included a brief biography, mentioning the first prize Douglas received for his drawing *The African Chieftain* in the *Crisis* contest for 1926. (Douglas received seventy-five dollars for the prize.)[36] The role of art editor required no particular duties or tasks, and Douglas recognized that Du Bois gave it to him to encourage him to stay with the *Crisis* in a more professional position. He was grateful for his acceptance into the magazine's inner circle, wanting to "be worthy of the distinction that Dr. Du Bois conferred upon me."[37] Douglas was listed as art editor only through December 1927, four months after he resigned. In his letter of resignation, Douglas thanked Du Bois for his assistance but wrote that "my art work has grown to such an extent that I shall find it necessary to give all of my time to it." He assured Du Bois, however, that he would "be quite glad to give whatever assistance possible in the field of art."[38] At this time Douglas was also commuting to the Barnes Foundation in Merion, Pennsylvania, for his one-year fellowship, and that may have also played a part in his decision to resign from the *Crisis*.

Even after his resignation, Douglas remained close to Du Bois, accepting criticism from the black leader and responding to his suggestions of political angles that the young artist could emphasize graphically. Du Bois continued to patronize Douglas, both literally and figuratively. In 1931 Du Bois asked Douglas for a "replica" of the Fisk murals for his own collection and suggested that he name his price for the work. Douglas wrote back, thanking Du Bois for reproducing the frescoes in the *Crisis* and telling him to set the price. With the classic deference of the student to his feared but respected teacher, Douglas wrote, "I shan't have quite as much time as I have had, and I could never decide the matter of a price. You know best what you could expend for such a thing. I leave that to you."[39] Du Bois's scolding reply was also characteristic: "You are headed straight for bankruptcy if you

allow your clients to set their own prices. What I am really able to afford to spend for art just now is exactly nothing but what I was trying to find out was what you could really afford to make a replica of one of those panels for? This only you can really decide."[40]

Du Bois, like Johnson and Reiss, played a crucial role in enabling Douglas to become the most significant visual artist of the Harlem Renaissance. The magazines *Crisis* and *Opportunity* would become the showplace for Douglas's work.

Five

The Evolution
of Douglas's
Artistic Language

Aaron Douglas's magazine illustrations best exemplify his growth and experimentation as an artist. They are his most forceful and interesting works, and they demonstrate the evolution of his distinctive artistic language. They anticipate the style of his murals and yet are simpler and bolder, primarily because of the format in which they were included. The murals are more ambitious and present lessons from African and African-American history. The magazine illustrations, both covers and drawings for the insides of the issues, are usually just a few simple figures illustrating a basic idea or simply images of African-Americans. The printed illustrations are based on original drawings, most likely executed in black ink on white paper. Very few originals survive.

One of the first two Douglas drawings *Opportunity* published illustrated a poem by Georgia Douglas Johnson. Douglas originally thought his work was "pretty good" but then became dissatisfied with it. He was surprised when Johnson wrote him thanking him for the drawing. "You would think I had done something great," he wrote Alta. "As a matter of fact, I am ashamed when I look at it."[1]

The drawing illustrated the following poem:

The Black Runner

I'm awake. I'm away!
I have jewels in trust,
They are rights of the soul
That are holy and just;
There are deeds to be done,
There are goals to be won,
I am stripped for the race
In the glare of the sun
I am throbbing with faith
I can! And I must!
My forehead to God—
My feet in the dust.[2]

The drawing was of a detailed pen-and-ink figure, a muscular male, barefoot and clothed only in a wrap around his midriff, running down a path[3] (Figure 7). He is surrounded by grass and trees and followed by a cloud of dust. The rendering is realistic; the runner's head is held high, indicating a determination to achieve. It is a somewhat unusual drawing for Douglas, because he rarely drew in a realist vein. It shows no African influence. This is one of his earliest drawings published in Harlem. In the same issue Douglas presented a small self-portrait accompanied by a brief biography introducing him to the readers of the magazine[4] (Figure 8). It is executed in the style of the portraiture of Winold Reiss, with a detailed face and just the hint of shoulders and a neck.

Douglas provided the October 1925 cover of *Opportunity*, which was printed in color, entitled *Mulatto* (Figure 9). It resembles Reiss's style of portraiture in *Survey Graphic*, especially his *Four Portraits of Negro Women*. The woman's eyes are closed, she is seemingly deep in thought, and her hands folded in front of her chest. She looks very peaceful. Her face, surrounded by long black hair, is not particularly detailed, but it is far more detailed than the few simple lines of her shoulders and collar.

Sometimes Douglas's drawings did not refer to any specific point in the article but provided a general visual accompaniment. In the November 1925 issue of *Opportunity* he illustrated Alain Locke's "The Technical Study of the Spirituals—A Review." The article discusses the connections between Negro spirituals and African music but makes

no reference to Douglas's accompanying illustrations. Douglas's *Roll, Jordan, Roll* (Figure 10) is in a simple black-and-white format, with a crown in the left-hand corner (probably indicating the Kingdom of God) from which rays of light stream, foliage, a river, and a mass of African-looking people with slit eyes and extremely thick lips. It is one of his simpler pieces and resembles Reiss's style of black-and-white drawings more than the sophisticated style of Africanism that Douglas would develop in the next two years. This drawing was included in the chapter "Negro Youth Speaks" in *The New Negro*. In the same issue he contributed *I couldn't hear nobody pray* (Figure 11) to accompany Arthur Fauset's article "The Negro's Cycle of Song—a Review." This drawing shows a figure reaching up to the heavens, mouth open, toward a large head. Here is a boldly depicted God, notable because Douglas created a God with black features, with a rainbow on the left and a cabin (symbolizing the simpler life) on the right. Three crouching stylized figures holding their heads are at the bottom of the composition. This is in the simpler style and resembles some of the Reiss drawings in *Survey Graphic* as well as Douglas's works in the *Crisis,* which were influenced by Egyptian art.

The final drawing in this issue, also accompanying Fauset's article, is entitled *An' the stars began to fall.* The familiar apocalyptic image Douglas used, although not mentioned in Fauset's article, was taken from the Book of Revelations, Chapter 6, Verse 13 (Figure 12). It indicates Douglas's awareness of biblical text and his assumption that those who read the article would also be familiar with the imagery. This drawing, in the same simple style, shows the large face of God above, looking down with rays of light emanating from him. Each ray is filled with shooting stars. One sole figure blows a trumpet on figures seemingly sleeping below, who are cropped off. (This drawing was included as well in *The New Negro* at the beginning of a chapter by Alain Locke, "The Negro Spirituals.") All three of these drawings are meant to match the material reviewed, Negro songs and spirituals, and the style of drawing is accordingly simple and folklike, with an African influence.

Douglas's untitled *Opportunity* cover of December 1925 shows the profile of a black man, with a solid black face and gray and white lips, nostrils, and outlines (Figure 13). He has very strong features and is not detailed in the way Reiss executed his portraits. The background con-

sists of a rising star, with an Arab or Middle Eastern city contained in it. This cityscape is clearly not an average American city. It was probably a reference to Bethlehem or Jerusalem because this was a Christmas issue.

Douglas's commissions were sometimes rapidly executed, and he did not always have ample warning to create his covers:

> I made the cover for *Opportunity* this month under very unusual circumstances. Wednesday night I was told that this magazine needed a cover and that I was expected to do it. I then asked when it was to be done. By tomorrow, was the reply. Can you imagine that, and that wasn't all. I was left to work on the drawing while the house attended the writers guild meeting. About twelve thirty, the bunch returns. Jimmie, Countee Cullen, Eric Walrond, Charles S. Johnson, Zora Hurston and others. Countee Cullen was leaving for Howard the next day, so the crowd decided to go to a cabaret. Returned from the cabaret about 3. The drawing was finally finished.[5]

Douglas illuminated a Langston Hughes poem in the January 1926 issue of *Opportunity*. Unlike the drawings for the November 1925 issue, this work reflects the content of the poem, "To Midnight Nan at Leroy's," which describes jungle music and a young jungle lover dancing wildly in the moonlight (Figure 14). The drawing approaches what later became Douglas's signature style. In it Douglas captures the euphoria of two young dancers, kicking up their heels in total silhouette, with a man playing the banjo. Because of the musical instrument, clothing, and the rustic log cabin, it looks more like a scene in the rural South than one in Africa. Two large palm tree fronds dangle into the top of the composition, and one extra arm, indicating another dancer, is cropped off on the right. The cabin symbolizes life before urban migration.

Douglas's special cover for the industrial issue of *Opportunity* in February 1926 (Figure 15) is one of his most interesting works. It shows his awareness of cubism, with jagged, broken forms surrounding two figures hard at work, one with a blacksmith's tool in hand, the other with a mallet. The figures are in characteristic hard-lined profile, their heads turned in complete profile, their features slightly exaggerated. A small structure in the background may be a factory; smoke billowing from three smokestacks on the roof represents industry and progress. Douglas considered cubism, used in this composition, as a sign of modernism and cosmopolitanism and considered critics who did not understand it hopelessly provincial:

By attacking Cubism, he, in my mind, disqualifies himself from further or serious consideration. For Cubism no longer exists as an active artistic force. It has long since pointed its general place in the world of art where it has come to life as modern art. There are no first rate thinkers who deny the power possibilities and achievements of modern art. We Americans are so darn infantile in our art life we will never grow up it seems. Europe was quick to see the new life and force of modern art, seized upon it and applied it to their architecture, theatre, furniture, clothing, jewelry and all the crafts.[6]

Here Douglas was inspired by the early landscapes of the cubist Georges Braque. Like Braque, Douglas became known for a monochromatic palette. He limited the use of color in his illustrations, usually executing them in black and white. Like Braque, Douglas avoided strong diagonals, foreshortening, and other perspectival devices that would give clear indications of depth in the traditional way of Western painting. Douglas's industrial issue is less three-dimensional than Braque's work, but its jagged forms resemble those Braque included in his *Landscape at L'Estaque* of 1908, now in the Kunstmuseum in Basel.

Douglas considered his work on the industrial issue to be "particularly striking," noting both the cover and a drawing inside the issue dealing with farm life[7] (Figure 16). This drawing contrasts sharply in style with the modernist, cubist-inspired cover. (The style employed in the farm drawing was fully developed by Douglas in his illustrations for *Fire!!* in 1927.) It is a contour drawing, consisting of a series of uninterrupted lines, with no shadows. A figure, dressed in pants and shirt, holds a sack of vegetables (potatoes?) and looks to the side. In the background of this contemporary rural scene, perhaps meant to take place in the South, other laborers are carrying sacks of food away.

The final two drawings in this issue of *Opportunity* were reprinted from *The New Negro*. The first accompanied a Negro sermon, "The Creation," and the second, *Meditation*, accompanied a very positive review of *The New Negro*. In the book itself, the drawing accompanies "The Creation—A Negro Sermon" by James Weldon Johnson. *The Creation* (Figure 17) shows the figure of a woman, seemingly nude, walking in profile with the sun behind her and palm trees around her. She is deliberately primitive in essence, a black Eve, although the text refers only to the creation of man and does mention race. *Meditation* depicts a figure lounging against a tree, one knee bent, the other

straight, surrounded by palm fronds and trees. It was presented in *The New Negro* alone, not connected with any text. The angular forms of the figures, which seem to evoke African sculpture, and the abstracted forms of the landscape boldly suggest African roots. The review in *Opportunity* declared Douglas's drawings "powerful and effective."

The first Douglas illustration to appear in the *Crisis* was his *Invincible Music, the Spirit of Africa*, done specifically for the magazine but not accompanied by any text relating to the work or illustrating any article.[8] It was apparently included in an effort to provide illustrations by African-American artists in the *Crisis*, much as Reiss's drawings (although he was white) were included in *Survey Graphic* to enhance that issue. The drawing (Figure 18) consists of one figure, presumably a male, in silhouette, with his head raised in song to the sky, his right arm holding a mallet with which he beats a large drum. He is in a crouching position and wears only a simple wrap around his waist. His position, with his shoulders parallel to the picture plane rather than receding into space in correct perspective, as well as his hair and the entire profile or silhouette of his body, resemble those of Egyptian art, in which Douglas had a great interest. Here Egypt represents Africa. Douglas was trying to simplify the human form. Two shieldlike marquis shapes are implanted in the ground behind the figure, with a jagged design on them that resembles African-inspired patterning. The shapes represent plant life, as do three smaller versions that look like leaves and are placed in front of the figure. The top of the drawing includes two large, jagged shapes that represent forms of energy, perhaps the sun or stars, as well as a stylized stream of smoke on the right. The bottom of the drawing includes flat papyrus plants resembling tulips, which appear to be inspired by the Art Deco movement.[9]

This drawing is successful because it is very simple, with large expanses of solid black and a bright white background, highlighted by grayish outlines and details. The silhouette format makes it particularly forceful. Douglas discussed his unique style in an interview in 1971.

> Well, there's a certain artistic pattern that I follow that is to say, I try to keep the figures broad . . . the figure was done so that there was as little perspective in figure as possible. No perspective in the face. The face was turned around so you saw the flat side of the face and no face is done in front view. You kept everything side-view . . . so that you have a broad extension rather than arms being extended toward you in perspective.[10]

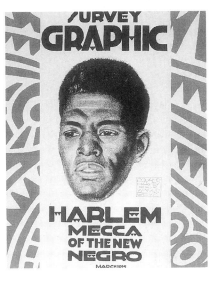

1. Winold Reiss. *Roland Hayes.* 1925
Courtesy of *Survey Graphic Magazine,* 1925

2. Reiss. *Dawn in Harlem.* 1925
Courtesy of *Survey Graphic Magazine,* 1925

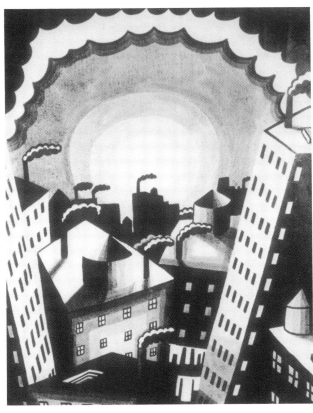

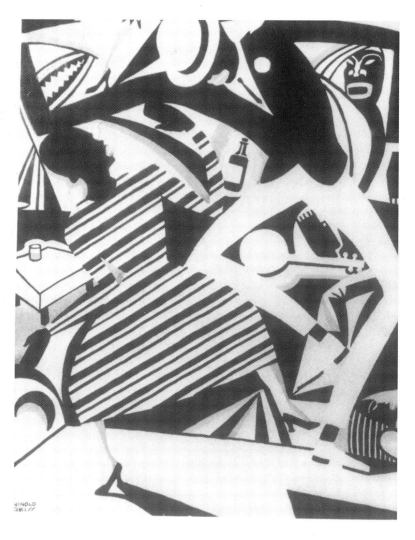

3. Reiss. *Interpretations of Harlem Jazz.* From "Jazz at Home." 1925
Courtesy of *Survey Graphic Magazine,* 1925

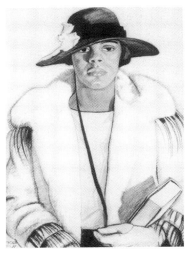

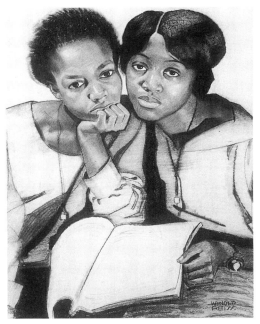

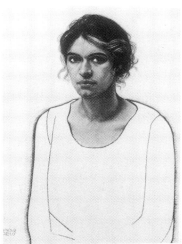

Clockwise from top left:

4. Reiss. *The Librarian.* From "Four Portraits of Negro Women." 1925

5. Reiss. *Two Public School Teachers.* From "Four Portraits of Negro Women." 1925

6. Reiss. *Elise Johnson McDougald.* From "Four Portraits of Negro Women." 1925

7. (below) Aaron Douglas.
The Black Runner.
September 1925

8. Douglas. *Self-portrait.*
September 1925

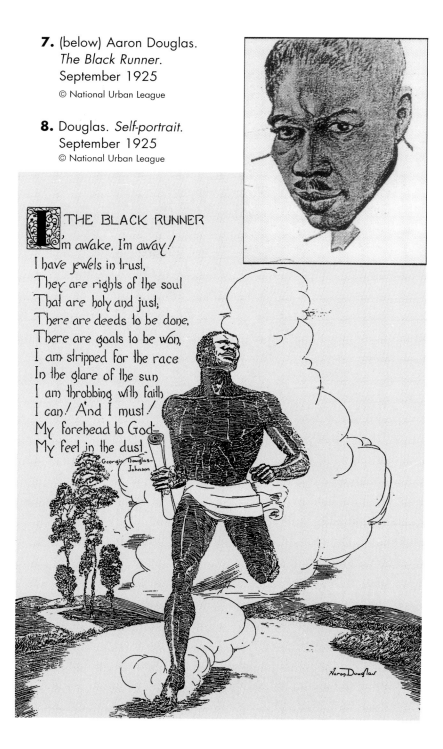

THE BLACK RUNNER

I'm awake, I'm away!
I have jewels in trust,
They are rights of the soul
That are holy and just;
There are deeds to be done,
There are goals to be won,
I am stripped for the race
In the glare of the sun
I am throbbing with faith
I can! And I must!
My forehead to God—
My feet in the dust.

Georgia Douglas-
Johnson

Aaron Douglas

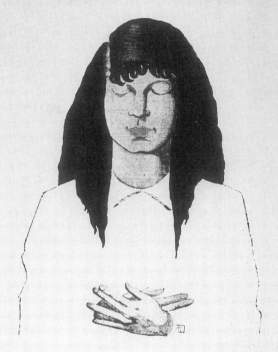

OPPORTUNITY
JOURNAL OF NEGRO LIFE

The Vanishing Mulatto The Virgin Islands
Tulsa and the Business League A Pushkin Poem

9. Douglas. *Mulatto.* October 1925
© National Urban League

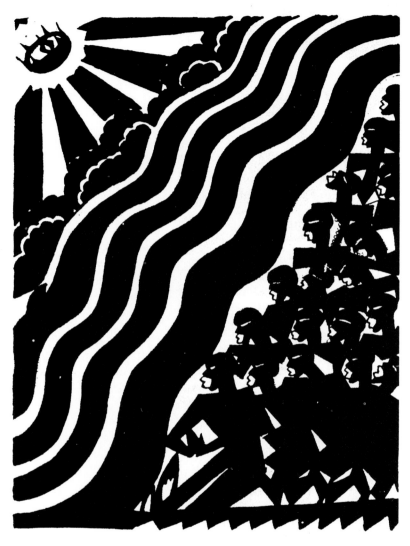

10. Douglas. *Roll, Jordan, Roll.* November 1925

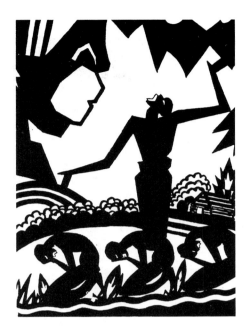

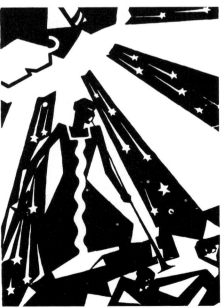

11. Douglas. *I couldn't hear nobody pray.*
November 1925
© National Urban League

12. Douglas. *An' the stars began to fall.*
November 1925
© National Urban League

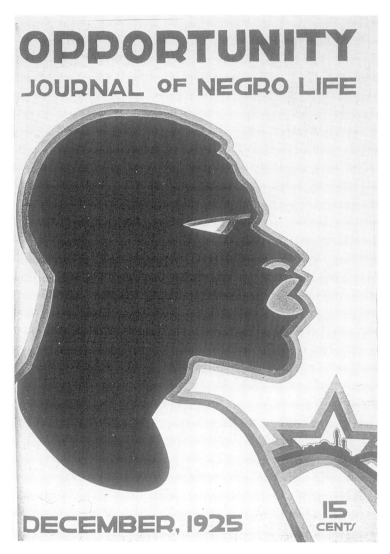

13. Douglas. *Untitled*. (Head of man with cityscape) December 1925

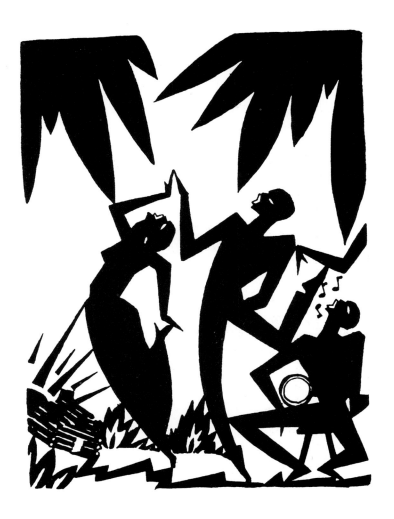

14. Douglas. *To Midnight Nan at Leroy's*. January 1926
© National Urban League

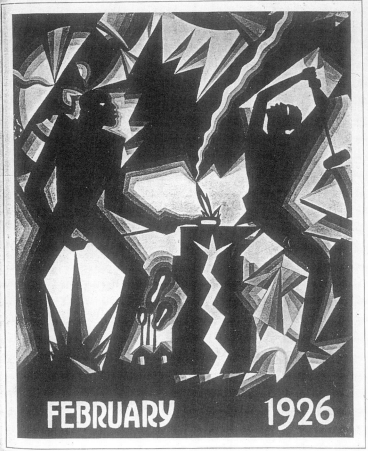

OPPORTUNITY

JOURNAL OF NEGRO LIFE

FEBRUARY 1926

INDUSTRIAL ISSUE

15. Douglas. *Untitled.* (Industrial issue) February 1926

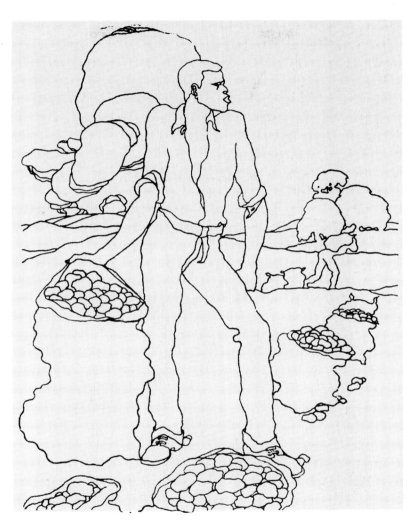

16. Douglas. *Untitled.* (Farm life) February 1926

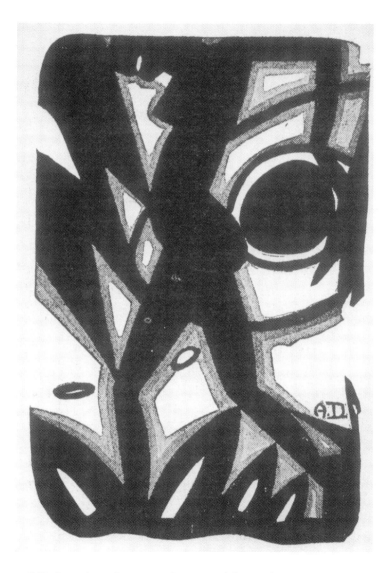

17. Douglas. *Creation*. (Reprinted from *The New Negro*)
February 1926
© National Urban League

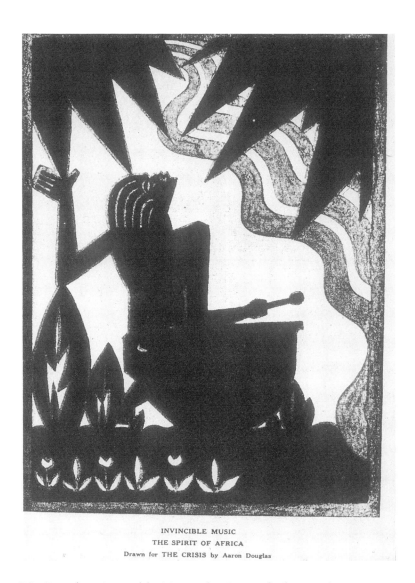

INVINCIBLE MUSIC
THE SPIRIT OF AFRICA
Drawn for THE CRISIS by Aaron Douglas

18. Douglas. *Invincible Music, the Spirit of Africa.* February 1926
Courtesy of NAACP

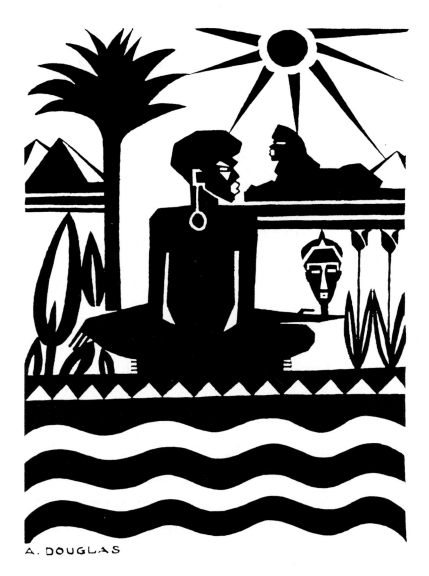

19. Douglas. *Poster of the Krigwa Players Little Negro Theatre of Harlem.* May 1926

Courtesy of NAACP

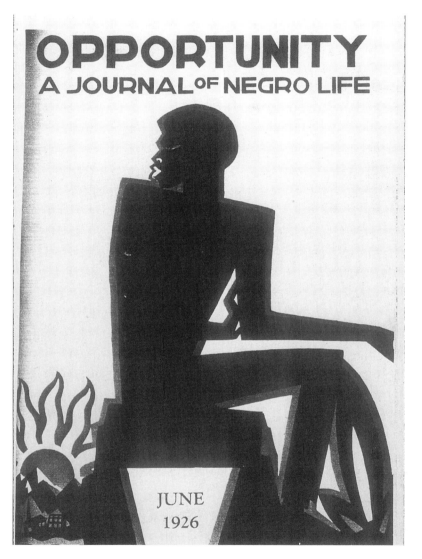

20. Douglas. *Untitled.* (Male figure) June 1926
Courtesy of NAACP

SPECIAL NUMBER

The CRISIS

THE NEGRO COMMON
SCHOOL IN GEORGIA

SEPTEMBER, 1926 15 Cents a Copy

21. Douglas. *Tut-Ankh-Amen.* September 1926
Courtesy of NAACP

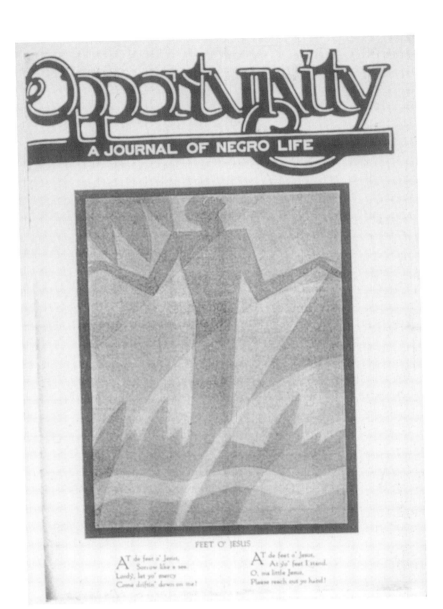

22. Douglas. *Feet O' Jesus.* October 1926

23. Douglas. *I needs a dime for a beer.* October 1926

© National Urban League

24. Douglas. *Weary as I can be.* October 1926

© National Urban League

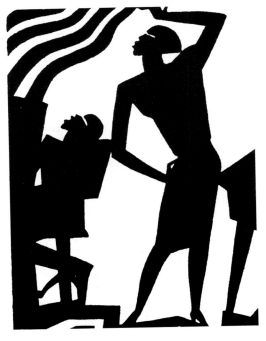

25. Douglas. *On de No'thern Road.* October 1926
© National Urban League

26. Douglas. *Play de Blues.* October 1926
© National Urban League

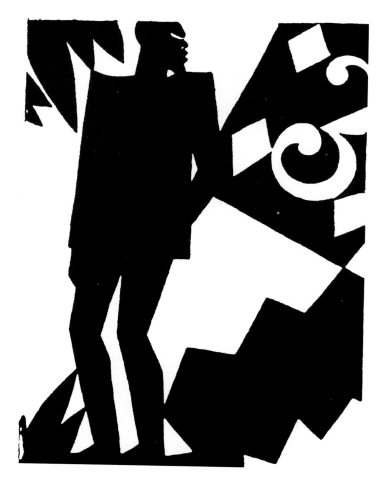

27. Douglas. *Ma bad luck card.* October 1926

The CRISIS

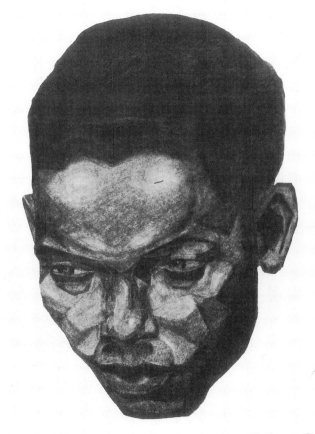

NOVEMBER, 1926 15 Cents a Copy

28. Douglas. *Untitled.* (Black portrait head) November 1926
Courtesy of NAACP

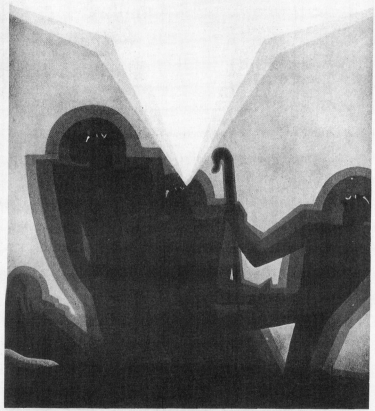

THE CRISIS
XMAS 1926

DECEMBER, 1926 — Double Number — 15 Cents a Cop

29. Douglas. *Untitled.* (Three Shepherds) December 1926
Courtesy of NAACP

THE CRISIS

Vol. 33, No. 2 DECEMBER, 1926 Whole No. 194

 OPINION of W. E. B. DU BOIS

PEACE

*A*ND there were in the same country shepherds abiding in the field, keeping watch over their flock by night— ignoi ...t, black and striving shepherds—poor silly sheep all a-crying, in the gloom; fields of harm and hunger. *And lo, the angel of the Lord,* Mahatma Gandhi, *came upon them,* brown and poor *and the glory of the Lord shone round about them and they were sore afraid.*

And the angel said unto them: Fear not: for behold I bring you good tidings of great joy which shall be to all people and nations and races and colors.

For unto you is born this day in the city of David a Saviour which is Peace.

And this shall be a sign unto you; ye shall not find Peace in the Palaces and Chancelleries, nor even in the League of Nations and last of all in the Church; but *wrapped in swaddling clothes and lying in a manger,* down among lowly black folk and brown and yellow and among the poor whites who work.

Impossible! cried the sheep and their shepherds. War was, is and ever will be; Wealth rules. God is with the big guns and the largest armies; the costliest battleships, the swiftest airplanes and the loudest boasters of superior races.

And suddenly—*and suddenly! there was with the angel*— the lone, lean, brown and conquered angel—*a multitude of the Heavenly Host praising God and saying,*

Glory to God in the highest and on earth, Peace!

30. "Opinion" to accompany Three Shepherds. December 1926
Courtesy of NAACP

31. Douglas. *Princes shall come out of Egypt: Ethiopia shall soon stretch out her hands unto God.* May 1927
Courtesy of NAACP

32. Douglas. *Mangbetu Woman.* (From *L'Exposition de la Croisiere Noire*) May 1927
© National Urban League

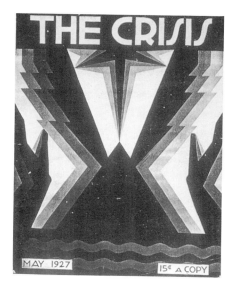

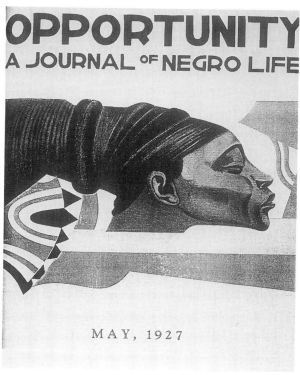

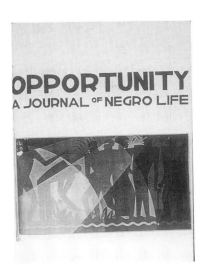

33. Douglas. *Untitled.*
(Laborers) July 1927
© National Urban League

34. Douglas. *The Burden
of Black Womanhood.*
September 1927
© National Urban League

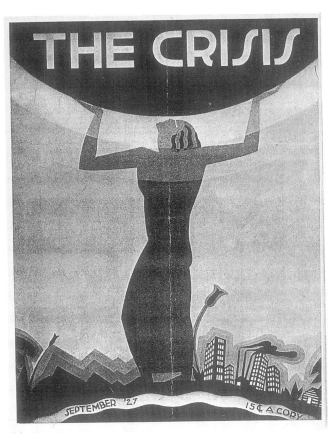

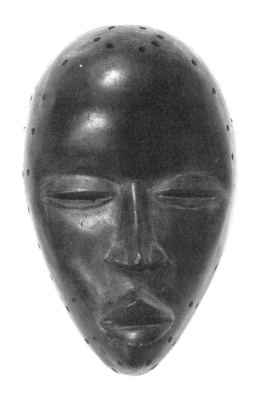

35. African Mask. Ivory Coast. ca. 1925
© Amy Kirschke

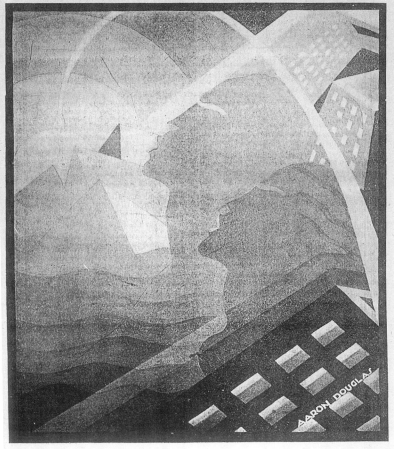

THE CRISIS

MAY, 1928 15 Cents a Copy

36. Douglas. *The Young Black Hungers.* May 1928
Courtesy of NAACP

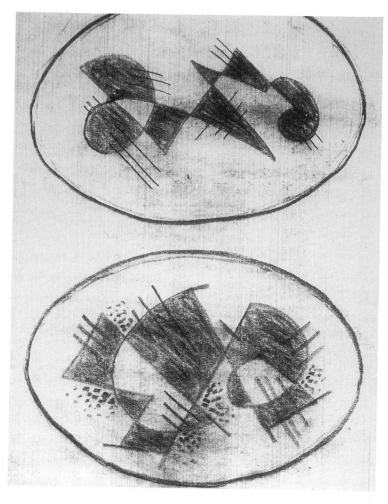

37. Douglas. *Untitled.* (Abstract drawings) n.d.
© Fisk University Special Collections

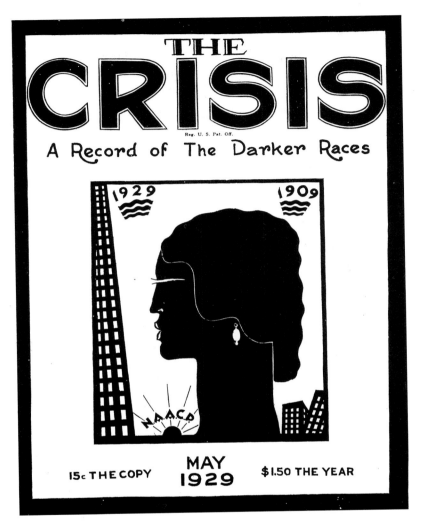

38. Douglas. *Untitled.* (NAACP Twentieth Anniversary) May 1929
Courtesy of NAACP

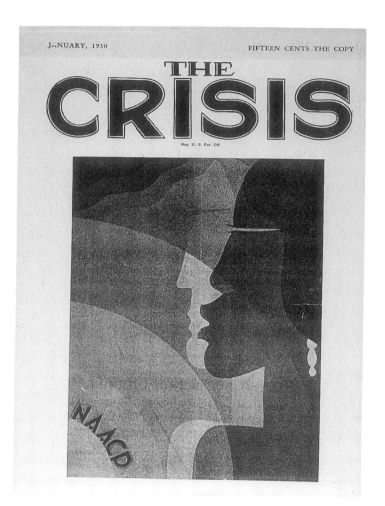

39. Douglas. *The Crisis* (NAACP Cover) January 1930
Courtesy of NAACP

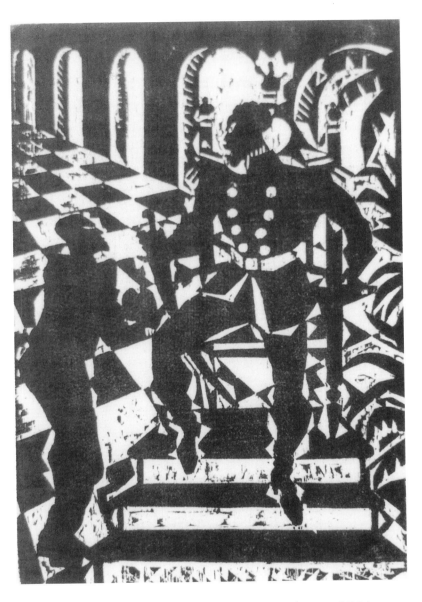

40. Douglas. *Untitled.* (Emperor Jones) February 1926
Courtesy of *Theatre Arts Monthly*

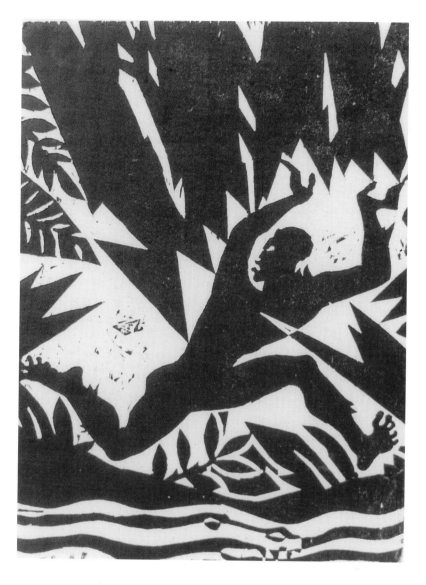

41. Douglas. *Forest Fear.* (Brutus Jones) February 1926
Courtesy of *Theatre Arts Monthly*

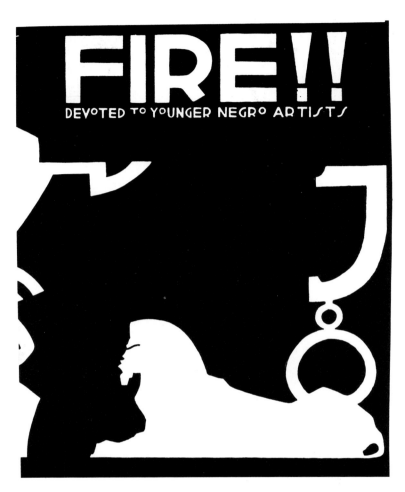

42. Douglas. *Fire!!*. Fall 1926

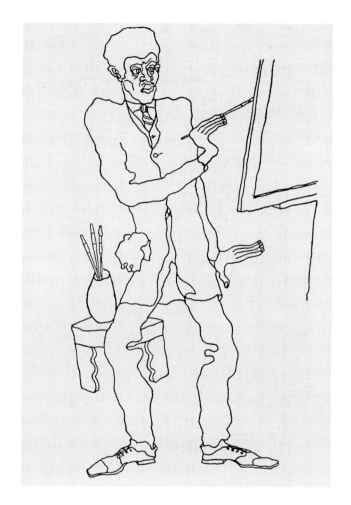

43. Douglas. *Untitled.* (Artist) Fall 1926

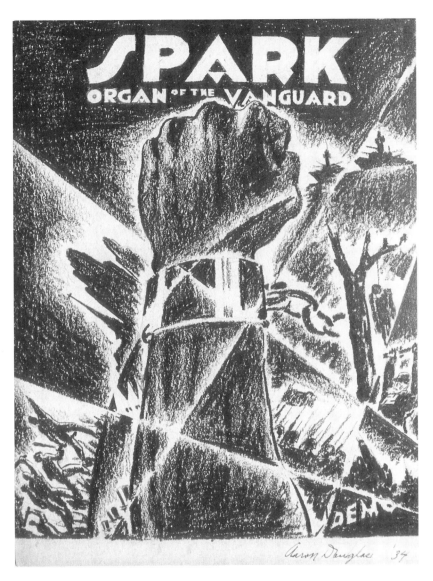

44. Douglas. *Spark.* 1934

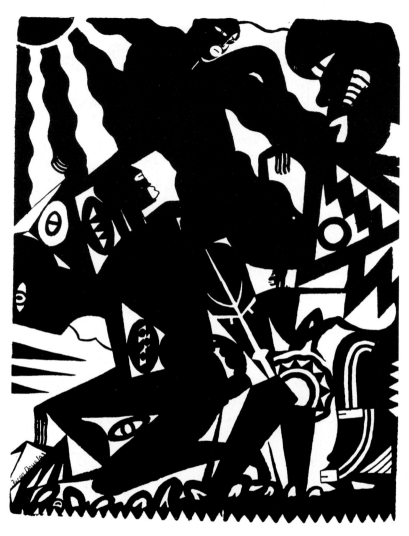

45. Douglas. *Rebirth.* 1925

Reprinted with the permission of Scribner, an imprint of Simon and Schuster. From *New Negro*.
Edited by Alain Locke. © Charles Boni, 1925

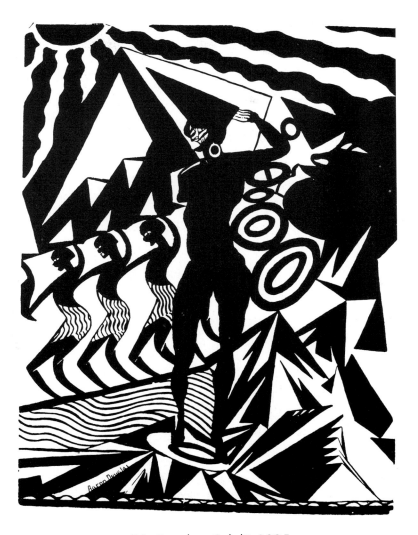

46. Douglas. *Sahdji.* 1925

Reprinted with the permission of Scribner, an imprint of Simon and Schuster. From *New Negro*.
Edited by Alain Locke. © Charles Boni, 1925

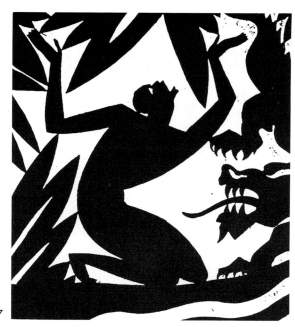

47. Douglas. *Surrender.* 1927

48. Douglas. *The Fugitive.* 1927

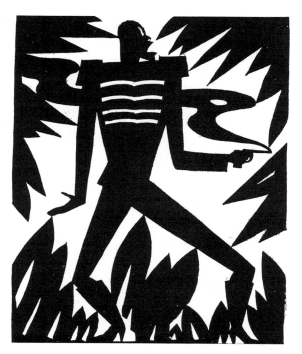

49. Douglas. *Untitled.* (Book Decorations) 1927

50. Douglas. *Untitled.*
(Advertisement for
Nigger Heaven) 1926
© James Weldon Johnson Memorial
Collection, Beinecke Rare Book and
Manuscript Library, Yale University.

51. Douglas. *Untitled.*
(Advertisement for
Nigger Heaven) 1926
© James Weldon Johnson Memorial
Collection, Beinecke Rare Book and
Manuscript Library, Yale University.

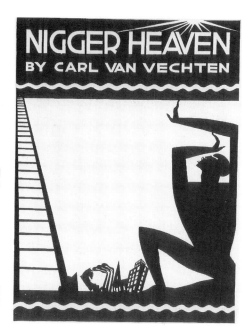

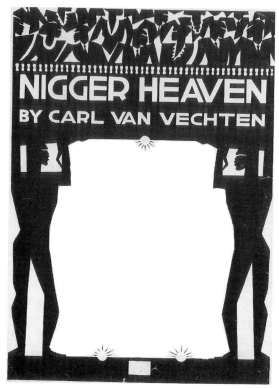

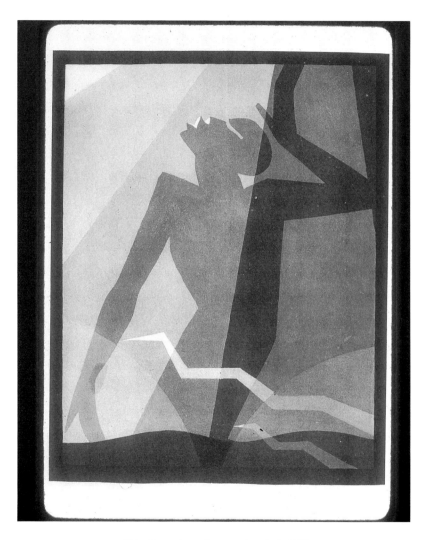

52. Douglas. *Listen, Lord.* 1927
Illustration from *God's Trombones.* By James Weldon Johnson.

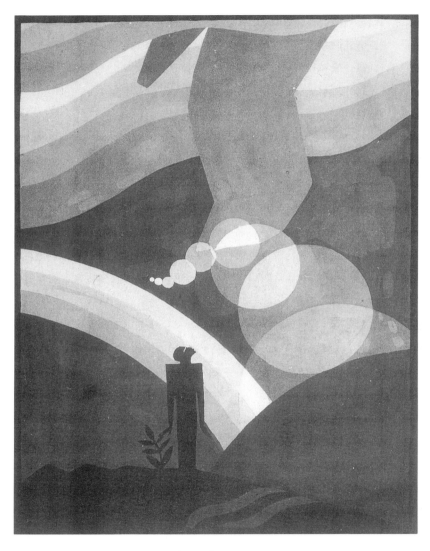

53. Douglas. *The Creation.* 1927
Illustration from *God's Trombones.* By James Weldon Johnson.

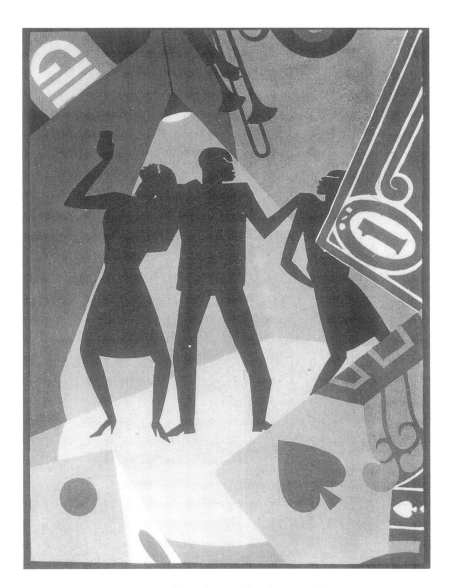

54. Douglas. *The Prodigal Son.* 1927
Illustration from *God's Trombones.* By James Weldon Johnson.

Used by permission of Viking Penguin, a division of Penguin Books USA Inc.

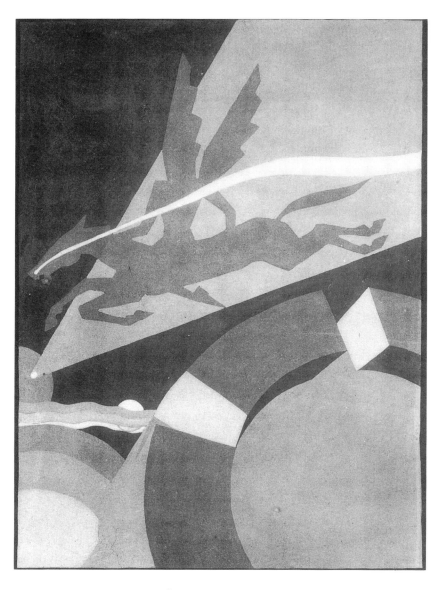

55. Douglas. *Go Down Death.* 1927
Illustration from *God's Trombones.* By James Weldon Johnson.

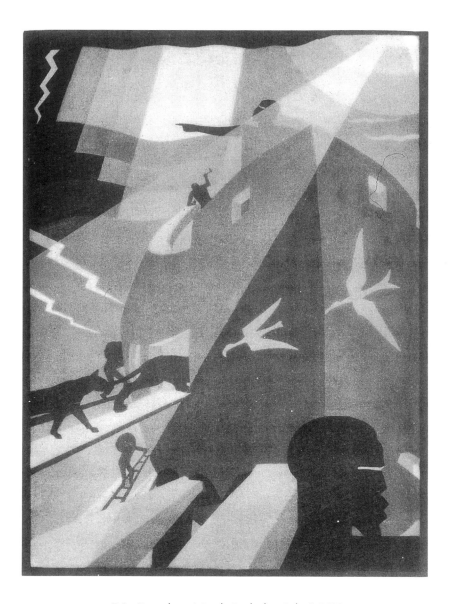

56. Douglas. *Noah Built the Ark.* 1927
Illustration from *God's Trombones.* By James Weldon Johnson.

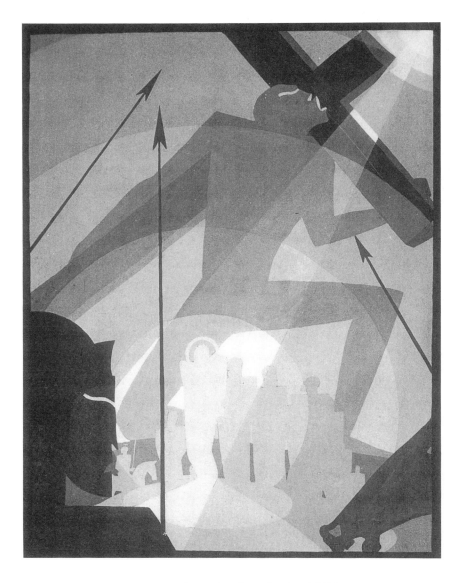

57. Douglas. *The Crucifixion.* 1927
Illustration from *God's Trombones.* By James Weldon Johnson.

Used by permission of Viking Penguin, a division of Penguin Books USA Inc.

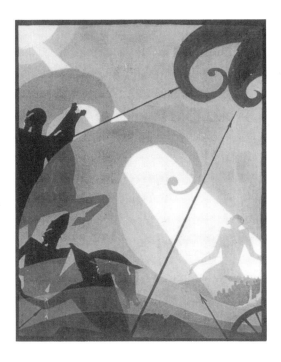

58. Douglas. *Let My People Go.* 1927 Illustration from *God's Trombones.* By James Weldon Johnson.
Used by permission of Viking Penguin, a division of Penguin Books USA Inc.

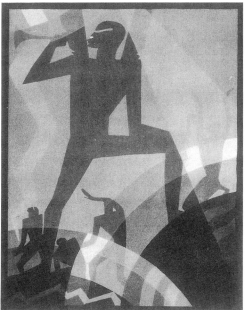

59. Douglas. *The Judgment Day.* 1927 Illustration from *God's Trombones.* By James Weldon Johnson.
Used by permission of Viking Penguin, a division of Penguin Books USA Inc.

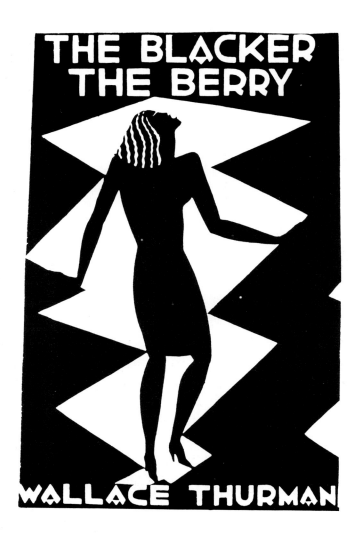

60. Douglas. *The Blacker the Berry.* 1929

Courtesy of Macaulay

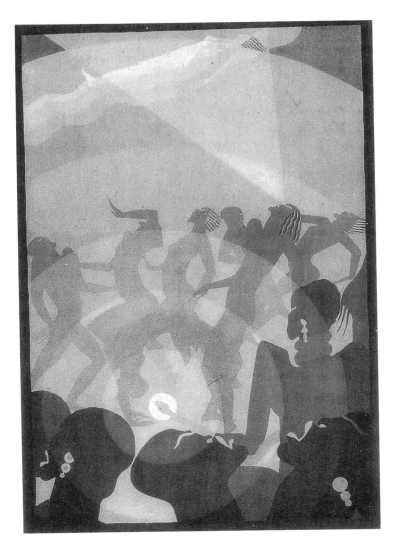

61. Douglas. *Congo.* 1929
Illustration from *Black Magic.* By Paul Morand.

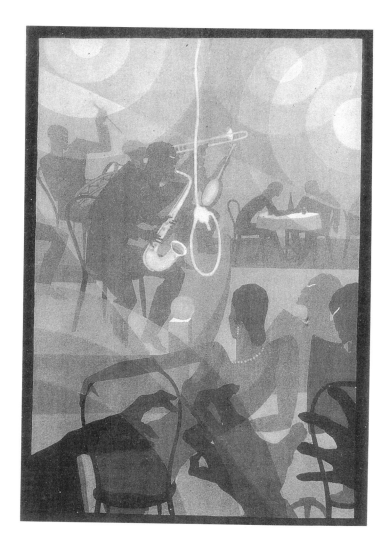

62. Douglas. *Charleston.* 1929
Illustration from *Black Magic.* By Paul Morand.
Used by permission of Viking Penguin, a division of Penguin Books USA Inc.

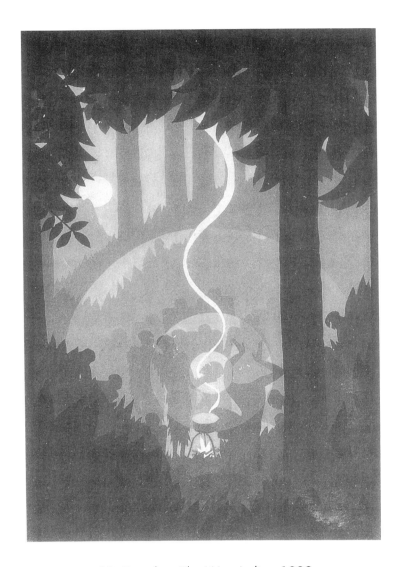

63. Douglas. *The West Indies.* 1929
Illustration from *Black Magic.* By Paul Morand.
Used by permission of Viking Penguin, a division of Penguin Books USA Inc.

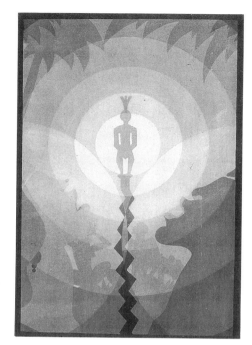

64. Douglas. *Africa.* 1929
Illustration from *Black
Magic.* By Paul Morand.
Used by permission of Viking
Penguin, a division of Penguin
Books USA Inc.

65. Douglas. *The People of
the Shooting Stars.*
1929
Illustration from *Black
Magic.* By Paul Morand.
Used by permission of Viking
Penguin, a division of Penguin
Books USA Inc.

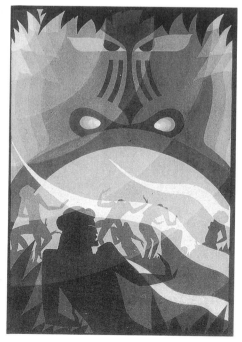

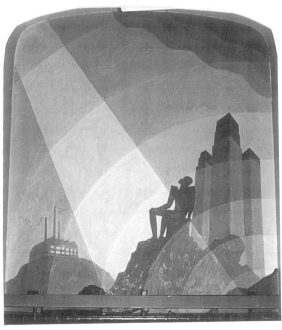

66. Douglas. *Apollo.*
1930
© Fisk University

67. Douglas.
Philosophy. 1930
© Fisk University

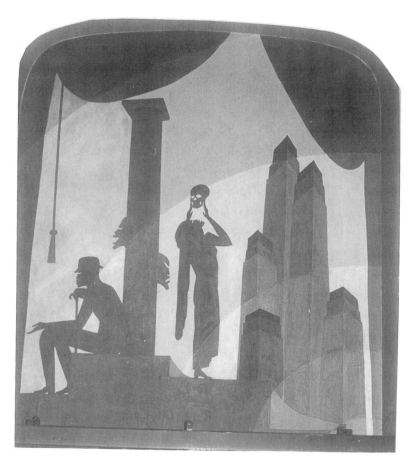

68. Douglas. *Drama.* 1930
© Fisk University

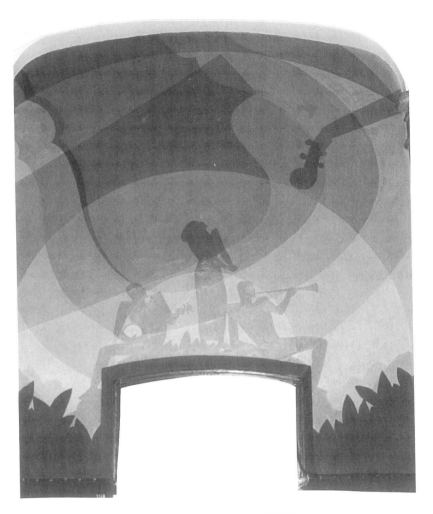

69. Douglas. *Music*. 1930

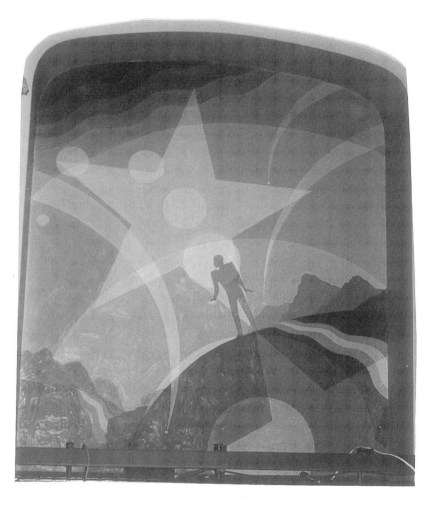

70. Douglas. *Poetry.* 1930

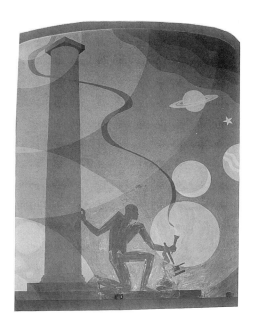

71. Douglas. *Science.* 1930

72. Douglas. *Diana.* 1930

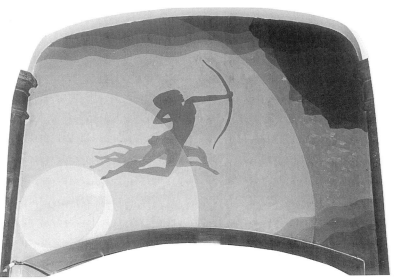

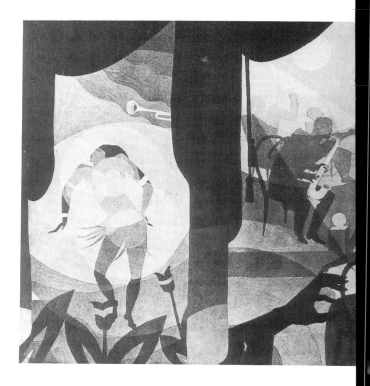

73. Douglas. *Dance Magic.* 1930-31
Courtesy of NAACP

Opposite page:

74. Douglas. *Harriet Tubman.* 1930
© Bennett College

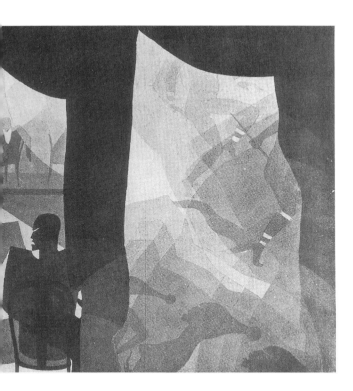

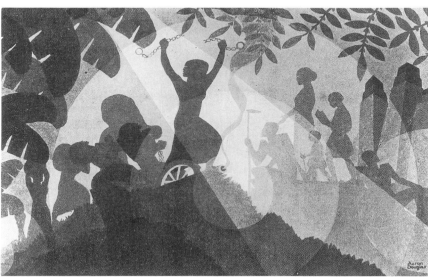

75. Academie Scandinave, Paris
© Amy Kirschke

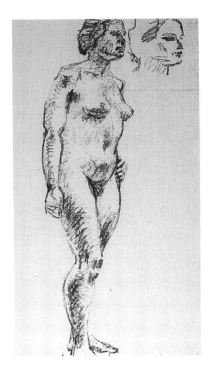

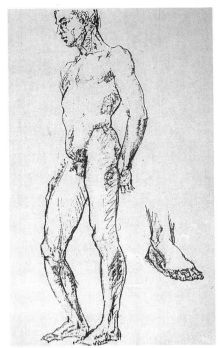

Clockwise from top left:

76. Douglas. *Untitled.*
(Female nude sketch)
ca. 1931

77. Douglas. *Untitled.*
(Male nude sketch)
ca. 1931

78. Douglas. *Untitled.*
(Cafe scene, Paris)
ca. 1931

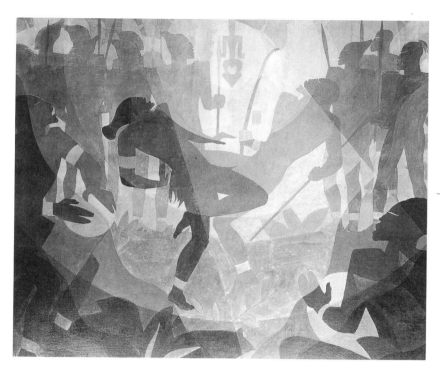

79. Douglas. *The Negro in an African Setting.* 1934
© Schomburg Center for Research in Black Culture, New York Public Library.

80. Douglas. *Slavery Through Reconstruction.* 1934
© Schomburg Center for Research in Black Culture, New York Public Library.

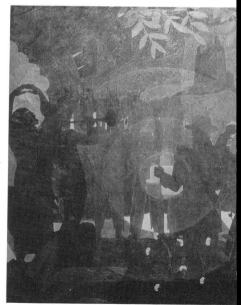

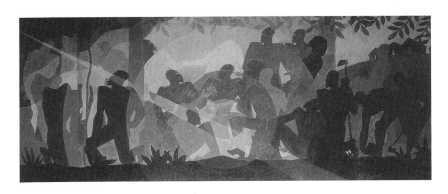

81. Douglas. *An Idyll of the Deep South.* 1934
© Schomburg Center for Research in Black Culture, New York Public Library.

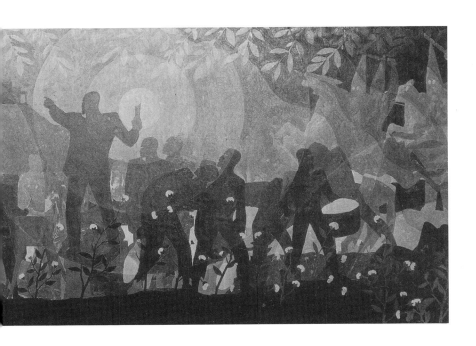

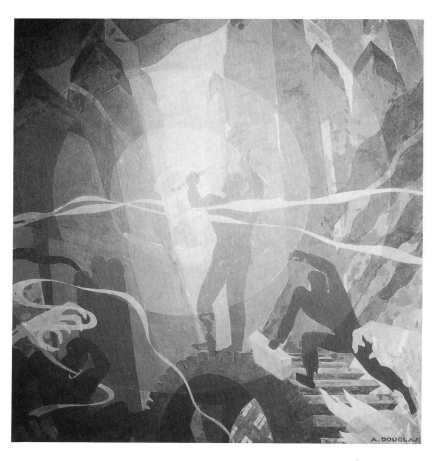

82. Douglas. *Song of the Towers.* 1934
© Schomburg Center for Research in Black Culture, New York Public Library.

Egyptians followed the most basic rule of stylizing the body by painting the figure as if it were being observed from several different viewpoints. The face was seen in profile, but the one eye shown looked straight ahead. The shoulders were shown from the front and the breast in profile, while the hips were seen from a three-quarter view. The legs were again depicted in profile.[11] Douglas explained that he "used the Egyptian form":

> The head was in perspective in a profile flat view, the body, shoulders down to the waist turned half way, the legs were done also from the side and the feet were also done in a broad . . . never toward you . . . perspective simply because at that you don't understand things, we don't view things that way. We understand if I present my hand to you that way, you wouldn't understand that that was a hand. It's only when it's done this way, when the fingers spread out that you understand. So you see that I spread the hand out with the fingers out and the hand was done in a way that I concocted. I used that hand all the time . . . got it from the Egyptians.[12]

Douglas's next illustration in the *Crisis* appeared in the May 1926 issue. Du Bois published the *Poster of the Krigwa Players Little Negro Theatre of Harlem* (Figure 19) in the issue, not attached to any particular play, but rather to advertise his theater project. This illustration is heavily influenced by Egyptian and African imagery. It is in solid black and white, very boldly executed, almost resembling a woodblock print. The poster shows a single figure, sitting in a cross-legged position, with face turned to the side in profile. The figure is very angular, a primarily rectilinear form, with exaggerated thick lips, the appearance of tribal makeup in geometric form, an Afro hair style, and a large hoop earring dangling from the only visible ear. Stylized plants and flowers, resembling both African motifs and Art Deco patterning, surround the figure, as does a palm tree.[13] The left hand holds an African mask or ancestral head. Above the figure the influence of Egypt is everywhere, with pyramids on the left, a sun form above, and a sphinx on the right. Wave patterns form the bottom one-third of the composition, perhaps representing the Nile. The obvious inspiration is from Africa, and no matter how accurately based on African imagery it is, the viewer can see the connections immediately. Du Bois wanted Douglas to remind the *Crisis* audience of their African ancestry and to inspire in them an interest in their common heritage. Egypt was the common vocabulary to achieve this goal.

Artist and art historian James Porter criticized Douglas's Africanizing style in his 1943 book *Modern Negro Art*. Porter considered Douglas's exoticism fanciful and unpredictable, a search for an "equivalent in design for the imagined exotic character of Negro life."[14]

Porter criticized Douglas's portrayal of eyes as "long slits of light," apparently unaware of a connection to the art of the Ivory Coast. He noted that Douglas rarely placed "the Negro in a normal and plausible domestic life,"[15] the figures being, "whether in Africa or America, in a tropical setting or atmosphere." Porter did not understand Douglas's desire to connect African-Americans with their rich African heritage. His criticism deeply troubled Douglas, who never forgot Porter's critical assessment of his work.

Douglas's style in the Krigwa poster is also reminiscent of Winold Reiss's, although it is bolder and more forceful with its hard-edged, woodblock-influenced style. Reiss's work is much more crowded, and the figures look more like caricatures than people with African traits. Although Reiss's compositions clearly inspired Douglas, they seem more influenced by the Art Deco style than are Douglas's works.

Douglas's untitled color cover for the June 1926 *Opportunity* shows a single male figure, sitting on a rock, in profile and executed in a hard-line style, the forms derived from Egyptian art (Figure 20). His body is echoed by an outlining shadow. In the background, we see pyramid-like mountains, a few buildings, and a church. There is no indication that this cover had any relationship to the content of the issue.

The September 1926 issue of the *Crisis* featured Douglas's first cover and was one of his more conventional efforts for that magazine. *Tut-Ankh-Amen* (Figure 21) apparently was drawn from a photograph of one of Tutankhamen's sarcophagus masks. It is no doubt related not only to the interest in North Africa by pan-Africanists such as Du Bois but to the recent discovery of Tutankhamen's tomb and was a topic of interest to the readers of the *Crisis*.

The October 1926 issue of *Opportunity* exemplified the true sense of artistic collaboration in the Harlem Renaissance, as Douglas wrote to Langston Hughes:

> Your problem, Langston, my problem, no our problem is to conceive, develop, establish an art era. Not white art painted black. . . . Let's bare our arms and plunge them deep through laughter, through pain, through sorrow, through hope, through disappointment, into the very

depths of the souls of our people and drag forth material crude, rough, neglected. Then let's sing it, dance it, write it, paint it. Let's do the impossible. Let's create something transcendentally material, mystically objective. Earthy. Spiritually earthy. Dynamic.[16]

It was a special Hughes-Douglas issue, right down to the cover[17] (Figure 22), which included a drawing contained in a heavy black-lined frame, with a figure looking up to Jesus, very angular and geometric, crossed by rays of geometric light. It is clearly influenced by cubism. The figure has the slanted eyes, broad shoulders, and no body detailing, as he looks up heavenward, characteristic of Douglas. A jagged landscape surrounds him. Below him, on the cover, Langston Hughes's "Feet o'Jesus" poem is featured.

Though Douglas defended cubism and acknowledged his debt to the movement, his work differs from Picasso's early analytical cubism. Douglas used essentially flat, angular forms, whereas Picasso and his colleagues suggested three-dimensional form through faceted-angular shapes with more depth. It is primitive yet sophisticated, lacking the harshness of the figures in Picasso's *Demoiselles d'Avignon* of 1907, executed during his now celebrated "Negro period."[18] Picasso was no doubt familiar with African and Oceanic sculpture, and most of Matisse's circle as well collected African carvings, yet Picasso denied having seen such masks until after he had completed the *Demoiselles.* Exactly when Picasso saw African masks, which were prominent in Cezanne's collection, remains a matter of controversy. Picasso's figures are harsh and ambiguous in their silhouettes, whereas Douglas's are inspired by Egyptian art, flat and clear. Douglas's faces do not have the empty-eyed, blank, masklike appearance of Picasso's in his *Demoiselles* and in his 1907 study in the Collection Berggruen, Paris. Braque, too, employed this masklike style in his *Nude* of 1907–8, now in the Galerie Alex Maguy, Paris.

The work of André Derain might also have impressed Douglas. Derain became close with Picasso as early as 1906 and was influenced by Picasso, Cezanne, and what was then known as Negro art.[19] Derain began to explore primitive art through his contact with Cezanne and his admiration for Gauguin, who also collected primitive art until his death in 1903. By 1906 tribal art was beginning to permeate Paris, and men such as Winold Reiss would have been well aware of its impact. Douglas's own early study of modernism in the works of Sheldon

Cheney, Albert Barnes and Henry Poore had acquainted him with these, too. Derain's *Last Supper* of ca. 1911–13, now in the Art Institute of Chicago, is affected both by cubism and by tribal or primitive art. It is closer in some ways to the Douglas style because it is a softer, simpler version of cubism. The faces of the apostles resemble primitive or African masks, without the extreme angularity and severity of Picasso's masks in *Demoiselles*. The floating circles, the primitive faces, and the cubist-inspired architecture of Roger de La Fresnaye, in his *La Conquête de l'Air* of 1913, now in the Museum of Modern Art, can also be tied to Douglas's modernist inclinations of the 1920s and 1930s. De La Fresnaye's work was featured in the Barnes collection. Douglas could also have seen similar modernist works in the collection of the Société Anonyme.

Inside the October 1926 issue of *Opportunity* under the heading "Two Artists," Douglas provided five drawings for Hughes's six poems. The works are simple and understated, influenced by cubism and Egyptian art. Douglas used the latter to indicate a relationship to the African continent. At times the technique may also have been dictated by the economic necessity of producing quick, dramatic, easily printable forms. They were specifically executed to illustrate the particular poems they accompany. The cutout quality may have anticipated Matisse's later technique. The whole group was executed like a cutout technique, though it was not actually done so, and it appears to be imitating the German *Scherenschnitt* technique. The poem "Down an' Out" is accompanied by Douglas's *I needs a dime for a beer* (Figure 23), showing a woman in contemporary dress and with an African hairstyle, standing in a room with a tipped perspective reminiscent of Matisse. "Lonesome Place" is accompanied by Douglas's *Weary as I can Be*, showing a single figure, reclining in profile, starkly depicted in black-and-white contrasts (Figure 24). Hughes's poem "Bound No'th Blues" is accompanied by Douglas's *On de No'thern Road* (Figure 25), which shows a man in silhouette, a long road behind him. "Misery" talks about singing the blues and is accompanied by *Play de Blues* (Figure 26). This drawing shows a young woman singing, accompanied by a pianist, in very angular silhouette, almost in the style of a cutout or a Kurt Schwitters collage. It evokes the movement and crooning of the Jazz Age, which would eventually appear in Douglas's illustrations for James Weldon Johnson's *God's Trombones* in 1927 and in his murals of the

1930s. Finally, "Hard Luck" is accompanied by *Ma Bad Luck Card*, which is referred to in the poem (Figure 27). A man in silhouette with broad shoulders turns toward the edge of a playing card. His luck has run out. In contrast, Douglas's luck was holding well. He was awarded the 1926 first prize for excellence in art by *Opportunity* magazine.[20]

For the November 1926 cover for the *Crisis*, Douglas returned to a more conventional style, featuring the head of a black man, slightly angular but realistically rendered, "floating" on a white background, with no neck, shoulders, or body (Figure 28). The man seems to be looking down in deep thought.[21] (The exact technique he employed and media he used are unknown.) The style in which the head is executed resembles that of Winold Reiss's portrait of Roland Hayes, which had greatly impressed Douglas, although Reiss's Hayes looks straight out rather than thoughtfully downward, and his head floats without neck or shoulders.

Douglas's Christmas 1926 cover illustration for the *Crisis* consists of three shepherds, one with staff in hand (Figure 29). The figures all look up toward a giant point of a star, their bodies and faces in silhouette. Their eyes are deeply slit and slanted upward and clearly resemble African masks from the Ivory Coast. The figures are all in black, although their facial features are white. They are angular and in the typical Egyptian-inspired profile. They are outlined by a grayish, hard-lined shadow which also forms a halolike aura around their heads. Inside is Du Bois's "Opinion" column entitled "Peace," with passages from the New Testament mixed with his own interpretations of peace. The Savior was peace; in a land where churches, the League of Nations, and war could not bring peace, one lone, brown conquered angel praised God and said, "Glory to God in the highest and on earth, Peace!"[22] (Figure 30).

The May 1927 Douglas cover for the *Crisis* again exhibited Du Bois's pan-Africanist leanings; the cover bears the title "Princes shall come out of Egypt; Ethiopia shall soon stretch out her hands unto God" (Figure 31). This cover is simple, angular, heavily influenced by Art Deco, and consists of two black hands, held open, with a pyramid in the center. Identical jagged forms emerge from each side of the pyramid, and there is a star in the middle. The main composition is in black, with two shadow levels in dark and medium gray. A river pattern follows the bottom of the cover, perhaps the Nile River of Africa.

Douglas obtained his May 1927 cover by copying a Mangbetu woman from *L'Exposition de la Croisiere Noire* (Figure 32). The cover is not Douglas's own design but shows his ability to render figures in a realistic although interpretive manner. The woman, in profile, is not flattened in Douglas's usual way, nor is she shown merely in solid black. She has an exaggerated oval head and an African headdress, both beautiful and exotic. Here his handling is close to the broadly faceted forms that the American artist Thomas Hart Benton began to use in the early 1920s.

Douglas won *Opportunity*'s prize in 1927 for the pictorial composition section of the magazine's art contest and had the honor of having the winning piece placed on the cover of the July 1927 issue (Figure 33). The figures in this untitled piece, laborers at work, pierced by a cubist-inspired abstract design of light rays, are done in the rectilinear, profiled, Egyptian-influenced style. Again, the impact of the *Scherenschnitt* cutout technique is evident. The figures also show the influence of modern illustrations and the sophisticated graphic arts traditions of Germany, in particular *Die Brücke* posters as well as woodblock prints, such as the works of Ernst Ludwig Kirchner, Max Pechstein, and Karl Schmidt-Rottluff. The figures have the usual frontally positioned broad shoulders and turned lower bodies, much like Egyptian reliefs. Their liveliness, however, is African-American.

Labor was a theme that interested Douglas, who often spoke of his desire to depict the common man. Both the *Crisis* and *Opportunity* also showed a strong interest in labor issues. Surprisingly, Douglas did not illustrate for the *Messenger*, Wallace Thurman's magazine that was more closely allied with the labor movement. (Douglas's main interaction with Thurman would be with the magazine *Fire!!*.) Although he was interested in labor, Douglas admitted that at the time he was "not conscious of the organized labor movement among Negroes." His work "was not that political, was not from a political standpoint." In an allusion to his Marxist-influenced work in the 1930s, Douglas confessed, "I later read it, understood it and some association from the people who were moving things from that standpoint, but at that time I didn't know it."[23]

Douglas produced one of his more interesting *Crisis* covers in September 1927, *The Burden of Black Womanhood* (Figure 34). This composition includes the figure of a woman in a long Egyptian-influenced garment, with a side view of hips and frontal body silhouette, holding

up a round shape, the world. She looks up, with face in profile and the same slit eyes that resemble African Dan masks of the Ivory Coast, a style frequently employed by Douglas (Figure 35) and which he later discussed:

> The only thing that I did that was not specifically taken from the Egyptians was an eye. I made an eye that I followed throughout instead of . . . getting behind perspective, let's say. So you saw it in three dimension. I avoided the three dimension and that's another thing that made it sort of unique artistically. It took so quickly. The artistic people understood that you never presented a thing with volume and depth. It was always flat. They reduced everything to a flat and treated it in that way.[24]

A cityscape is included below, which resembles Art Deco drawings of skyscrapers with the billowing smoke of industry behind it.[25] A simple cabin (her humble beginnings?) is on the far right. On the left are three pyramids and a palm tree, perhaps indicating her origins. Papyrus blossoms in outline, with a Deco handling, are scattered in the composition. The composition, showing a woman bearing the burdens of the world, appealed directly to the *Crisis's* female audience. Several sections of the magazine were dedicated to women's issues, and planned parenthood and birth control were discussed. The magazine emphasized the important role women played in the black community, stressing child rearing and teaching.

Douglas's May 1928 cover for the *Crisis, The Young Black Hungers,* shows the typical profile Douglas face with slanted Dan Ivory Coast eyes, the face in the foreground black, the one behind gray, looking upward (Figure 36). (The eyes could also have been inspired by a mask reproduced in *Survey Graphic,* part of the Barnes Collection, entitled "Bushongo," with the same slanted eyes.) A sun with concentric circles behind it and skyscrapers make up the background, pyramids form the middle ground, and sand dunes or river water the foreground, along with a sole corner of a skyscraper in the far right corner, where Douglas has signed his name. (Douglas's sun surrounded by circles was probably influenced by Reiss, who employed the identical technique in his *Dawn in Harlem,* which features skyscrapers and smoke pouring out of smokestacks on the roofs.) The work is executed in a style identical to the previous covers, showing the young black's roots (with Egypt repre-

senting Africa) and his or her aspirations represented by the figures looking heavenward, faces uplifted, surrounded by the skyscraper as a symbol of modern society. This proud, positive imagery was what the Harlem Renaissance movement wanted and needed in order to change the caricatures of blacks.

This drawing, like many of Douglas's pieces, is also influenced by a sophisticated form of cubism, which is also clear in some abstract cubist geometric drawings he did in his personal sketchbooks[26] (Figure 37). Douglas's use of skyscrapers shows the impact of the precisionists' unique view of the modern world. His slanted, angled rectilinear edifices in particular resemble those found in precisionist painter George Ault's *Construction Night* of 1922, in the Nancy Wechsler collection, Charles Sheeler's *Offices* of 1920–22 in the Phillips collection, and Louis Lozowick's *Pittsburgh* of 1922 in the Whitney Museum of Art's collection. Lozowick exhibited in New York regularly from 1926 on, and Douglas could have seen his work. He was also well known in Germany and may have been familiar to Winold Reiss.[27]

Douglas's cover for the *Crisis* in May 1929 was one of his least interesting, both technically and compositionally, but it addressed a particular audience (Figure 38). Douglas was asked to do a cover honoring the NAACP's twentieth anniversary, and he used a woman's head in profile. Although the woman is clearly black, her African heritage is not strongly emphasized. Her eye slits have eyelashes, and her jewelry and straightened hair are those of a contemporary urban woman. To the left and right of the woman are parts of skyscrapers, and a small sun, with the letters "NAACP" intersected by rays of light, reminds the reader that a new day is dawning for American blacks. It is interesting and rather remarkable that Douglas considered a contemporary-looking American woman to be the appropriate symbol of the NAACP's twenty years of service.

Douglas's January 1930 cover for the *Crisis,* again honoring the NAACP, resembled previous covers (Figure 39). He showed the flat profile of a woman from the shoulders up and another profile located directly behind her, with full lips and slit eyes. The background featured concentric circles, the letters "NAACP" contained in them, with a wave pattern in the upper left corner. It is similar to his May 1928 and May 1929 covers for the *Crisis*, indicating that he was beginning to recycle old images with slight alterations.

Although a few other Douglas illustrations were reprinted in *Opportunity* from other sources—for example, a drawing from *The Emperor Jones* accompanied a critique of Negro theater as too "white controlled" in the June 1928 *Opportunity*—Douglas's contributions to magazines decreased sharply after 1927. He was turning to other interests, such as the creation of the magazine *Fire!!*, spending a year at the Barnes Foundation and in Paris, and painting large-scale murals.

Douglas had two drawings in *Theatre Arts Monthly* in February 1926, illustrating *The Emperor Jones*, which starred Paul Robeson. In the accompanying article, Locke discussed the American Negro's contributions to the American stage. Heretofore these contributions had been negligible, but Locke argued that they were increasing. Dramatic spontaneity had been the Negro's strength, often in the lack of formal training. The Negro had to struggle out of the shambles of minstrelsy to show his true talents. Locke mentioned the major successes of the time, namely *The Emperor Jones*, which starred a black actor, and *All God's Chillun Got Wings*. The article discussed the strengths of the Negro actor, including pantomime and raw emotion. More and more, Locke hoped, Negro actors would seek materials in the "rich native soil of Negro life, and not in the threadbare tradition of the Caucasian stage."[28]

Douglas illustrated the article with two drawings of one of the more successful plays of the period, Eugene O'Neill's *The Emperor Jones*, brought to life by Paul Robeson. The first untitled drawing shows the signature hard-edged style of Douglas's silhouetted figure, with exaggerated lips and slanted eyes, looking off to the viewer's right, his body precariously balanced against his throne (Figure 40). The background patterning is more complex than usual for Douglas, the tiled floor providing an unusual perspective. Three arches line the background, with the soft vertical lines Douglas often employed to represent a river flowing behind the arches. Locke praised the drawing for recapturing "the dynamic quality of that tragedy of terror. There is an arbitrary contrast of black masses and white spaces; and the clash of broken line becomes highly expressive in suggesting the proximate collapse of the Emperor's throne and the fear it inspires."[29]

Douglas's drawing clearly shows an affinity with Winold Reiss's *Interpretations of Harlem Jazz* (Figure 3). Douglas based the position of the Emperor's body on the figure in *Jazz*—both are flat, angular, open

silhouettes with a patterned background. Both figures have exaggerated thick lips as well. Reiss recognized that the black experience possessed its own aesthetic, which could be translated into the visual arts. His work captured the rhythm, tension, and expressive form of black culture and Harlem itself. Reiss's *Interpretations of Harlem Jazz* emoted the tension of the rhythm and energy of black Harlem's music and dance, going beyond primitivism.[30] Douglas's version is simpler, bolder, and more forthright.

The second drawing, from the same play, shows the silhouette of a male figure lunging away from the stylized jungle that engulfs him (Figure 41). A jagged, bright opening of white frames the figure of Brutus Jones. Locke described how the "tropical jungle closing in on the defeated Brutus Jones is here suggested . . . with an utter simplicity of means, yet with no sacrifice of psychological verisimilitude. There is a sharply defined sense of dramatic design—of drama in design." To Locke, the power of Douglas's images was "one often missing among men of greater technical skill but less vivid imagination."[31] Locke explained that Negro dramatic art could not develop fully without some significant artistic reexpression of African life and the traditions associated with it. Art must serve Negro life as well as Negro talent serving art. Douglas's work, with his magazine illustrations representing some of his most dynamic early efforts, displays the African influences, the drama, and the emotion Locke encouraged Harlem Renaissance artists in all disciplines to employ.

Late in the summer of 1926, a small group of Harlem's young artists and writers met in the home of the recently married Alta and Aaron Douglas. Dubbed playfully as the "Niggerati" by Zora Neale Hurston, this group included Hurston, Langston Hughes, Bruce Nugent, and Aaron Douglas. The group talked about the need for a new, exciting vehicle to express the feelings of the young artists of Harlem, one that would go far beyond the *Crisis*, *Opportunity*, or the *Messenger*. Bruce Nugent said the idea derived from Langston Hughes's essay in *Nation*, "The Negro Artist and the Racial Mountain," and as a response to the black press and Harlem's reaction to Van Vechten's *Nigger Heaven*. Hughes was concerned that he would be censored, as Van Vechten had. He did not wish to idealize Harlem life or black life. One black poet had written Hughes telling him that he had liked Hughes's *Weary Blues*, but had cut out of the dust jacket "that hideous black 'nigger' playing the piano"—in other words, Aaron Douglas's drawing.[32]

In what proved to be one of the most important statements of the Harlem Renaissance, the "Niggerati" decided to create *Fire!!*, "A Quarterly Devoted to the Younger Negro Artists," to lash back at limits on artistic freedom. Wallace Thurman was chosen as editor, and Hughes, John P. Davis, Zora Neale Hurston, Gwendolyn Bennett, and Aaron Douglas would each contribute fifty dollars to get the first issue out. The group wrote to Locke in Europe, informing him of the new magazine, but the traditional leaders of the Renaissance, such as Locke and Du Bois, were not included. The magazine faced immediate problems. There was little money, and few even came through with their fifty-dollar pledges. Yet Thurman was determined to create a high-quality publication, with the finest grade of paper for Aaron Douglas's drawings. (Many black leaders criticized the magazine, one stating that Douglas had ruined "three perfectly good pages and a cover" with his illustrations.)[33]

Only one issue of *Fire!!* ever appeared, yet it was important because it showed an effort on the part of the organizers to break from the confines of Harlem leadership, both black and white, and express themselves freely and without censorship to a younger, separatist, and more militant black audience. Carl Van Vechten was listed as one of the patrons of the first issue. Douglas penned an artistic statement, a kind of manifesto written on *Fire!!* stationery he had designed. The letter was not addressed to anyone in particular and was the result of a meeting of the board of editors. It stressed their youth and militancy:

> We are all under thirty. We have no get-rich-quick complexes. We espouse no new theories of racial advancement, socially, economically or politically. We have no axes to grind. We are group conscious. We are primarily and intensely devoted to art. We believe that the Negro is fundamentally, essentially different from their Nordic neighbors. We are proud of that difference. We believe these differences to be greater spiritual endowment, greater sensitivity, greater power for artistic expression and appreciation. We believe Negro art should be trained and developed rather than capitalized and exploited. We believe finally that Negro art without Negro patronage is an impossibility.

Although acknowledging that the "rise of Negro musicals and light drama" was owing to white patronage, the editors felt that this increase was one of "volume rather than quality." They believed that the white demand for "Negro entertainment" helped preclude "any attempt or demand to widen and deepen" white America's "sense of artistic ex-

pression." They ended by insisting that "if there is any one thing more than another that we ask of our friends it is that they remove their Nordic (White folks) spectacles before they criticize or even praise our work."[34]

The magazine's foreword further emphasized its militancy. It described the word "Fire" as "flaming, burning, searing, and penetrating far beneath the superficial items of the flesh to boil the sluggish blood . . . a cry of conquest in the night, warning those who sleep and revitalizing those who linger in the quiet places dozing."[35] The issue included uplifting poetry, short stories, essays, a play, and an editorial by Thurman in support of Van Vechten's *Nigger Heaven*. Aaron Douglas served as chief artist, contributing the cover, incidental decorations, and three drawings.

Douglas's cover was an original interpretation of Africanism (Figure 42). In its geometric simplicity, it almost appeared abstract. The viewer has to look twice to see that the background is not merely a geometric pattern, but the entire cover is actually a profile of an African-looking face. The left side of the cover indicates eyes, nose, lips, and chin by simple geometric voids. At closer look, one discovers that the geometric shapes on the right are an ear and earring. A sphinx lines the base of the cover. The entire piece was printed in black and red and is one of Douglas's most original creations. The three interior drawings are very different than the cover and are far less interesting. They do not illuminate any particular story or poem but rather serve as visual essays in themselves. They resemble in style Douglas's farm life drawing in the February 1926 *Opportunity*. The three untitled drawings are contour renderings in pen and ink of a preacher, an artist (Figure 43), and a waitress. There is a touch of satire in the figures' slightly exaggerated postures and gestures. A few African symbols and Douglas's signature two-dimensional decorations are also included in the issue.

Douglas considered Wallace Thurman, as editor, to be the backbone of *Fire!!*. The magazine was organized around Thurman and drawn together by him. He knew the mechanics of a magazine and how to put it together. The founders were so enthusiastic about their venture that they "forgot that there was such a thing as . . . money. And that we knew what we wanted. We wanted a magazine to express our ideas, to set forth our ideas, and to run it the way they wanted to."[36] They also wanted to run the magazine without the management or supervision of

Du Bois or Charles S. Johnson, although the two did have some influence on the writers who published in the issue. Du Bois was particularly concerned that the magazine would overemphasize cabaret life. He hoped the founders would stress high culture.

For Douglas, "putting out a magazine was, well, just fantastic. I mean fantastic that we could only put out the whole of Negro life." Looking back years later, Douglas marveled that his group was "daring enough to come forth with a thing like that. It was outrageous, outlandish and everything else for us to do that . . . well, certainly we thought that was the greatest thing." To Douglas, the very name *Fire!!* captured "the uninhibited spirit that is behind life," while Langston Hughes saw the title as showing that the creators were trying to burn up old standards or inhibitions. But though their spirit and enthusiasm were impressive, the founders of *Fire!!* were disappointed by the commercial failure of their experiment. They had no money, or as Douglas explained, "Unless you had a policeman there, you just couldn't collect [the money]."[37] It was clear to all that the magazine died "from a lack of funds rather than from a lack of talent among their contributors."[38] Simply put, there was not a large enough black middle class or black public to support such a venture.

Douglas was happy to contribute whatever he could to the project, and it remained one of his fondest memories of the Harlem Renaissance. Collaboration was the essence of the movement, and though he had enjoyed his work for the *Crisis* and *Opportunity*, it did not compare to the experience of putting together *Fire!!*.

> These things had come out. Some good, some serviceable, and some of them never should have been produced, but they grabbed them up and published them. . . . I look at these things and wonder if they could have been any use to anybody, but I wasn't their editor then. They were happy to have these things. Sure, there were other artists. There were plenty good artists, but they didn't have this feeling.[39]

An effort was made to revitalize the magazine *Fire!!* under another name, *Harlem*. Like *Fire!!*, *Harlem* was an attempt to record the essential creations of the artists of the Harlem Renaissance. When Douglas was questioned about *Harlem* later in life, he had few memories of it. It did not have the impact that *Fire!!* had on him. *Harlem*, "A forum of Negro life," was also edited by Thurman, with contributions from Langston

Hughes, Walter White, Richard Bruce Nugent, Alain Locke, and others. Aaron Douglas was listed as the art editor and provided two drawings, including the cover. The cover, not one of Douglas's better efforts, featured the word "Harlem" in bold letters at the top, with a border of two heads in profile, a woman and a man facing each other, flanking the table of contents. On each side of the cover were skyscrapers and palm fronds. It was essentially a reworking of previous motifs developed by Douglas. Douglas also created a very conventional drawing for the magazine, *Luani of the Jungles*, which featured two lovers in silhouette, standing between tall palm trees, with sand, water, and mountains in the background.

Thurman called on blacks to write about themselves rather than to write based on outdated standards of the past or for a white audience. *Harlem* featured a directory of "where to go and what to do when in Harlem" and editorials, short stories, and poetry. The magazine appeared only once, in the fall of 1928, and sold for twenty-five cents, one-fourth the cost of *Fire!!*. It too died a premature death because of lack of funds and audience.[40]

Aaron Douglas was introduced to the editor of *Vanity Fair*, Frank Crowninshield, by Carl Van Vechten, and was pleased and excited to meet such an important figure. His reputation blossomed when men such as Van Vechten and Walter White spread the word that Douglas was the only black man ever to have his work accepted by the magazine. As a result of the meeting, White promised to give a press release to the New York newspapers to enhance Douglas's reputation.

Although Crowninshield admired Douglas's work and bought a drawing of his at their initial meeting, he never actually published Douglas's work. Several books state erroneously that Douglas's work appeared in *Vanity Fair*.[41] In an interview conducted in 1975, Douglas cleared up the misunderstanding: "After that, the story got out that the *Vanity Fair* had published some of my works, which wasn't true. I just let it go. Yet, I knew that in some time or other I had to correct it. But I never did. I was never called on. No one ever said 'you weren't in any *Vanity Fair*.' But I never bothered."[42]

Douglas executed one magazine cover that remains a complete mystery—a mock-up cover for the magazine *Spark: Organ of the Vanguard* (Figure 44). (The original is in the Schomburg Center for Research in Black Culture in New York.) The cover, signed at the bottom

by Douglas and dated 1934, is a black–and–white ink drawing or print of a black fist, strong and sure, complete with shackle and broken chain, crossed by rays and a curving line. The sections of the composition, formed by the intersecting lines of the rays, include a mob presumably looking for a black man, a cityscape, battleships, soldiers, a lynched man, and a man with a swastika on his chest. In the lower right are the letters "DEMO," an apparent allusion to unfinished, unfulfilled or broken democracy. It is a powerful, highly political composition and lacks the characteristic Douglas human silhouettes. The fist, which seems to foretell the symbol of black power, is the only one used in a Douglas composition to this date. It does show his interest in important issues of the time or the need to illustrate them for whoever commissioned the work. In this one small drawing Douglas deals with slavery, mob violence, the promise or failure of the city, lynching, war, and Nazi Germany. Unfortunately, the cover itself remains a mystery because there is no record of a publication named *Spark*, and Douglas never referred to the work itself. Originating during the period in which he was a self-avowed Marxist, the drawing shows Douglas's ability vividly to express contemporary political issues.

Six

The New Negro and Other Books

Aaron Douglas's book illustrations exhibit his innovative draftsmanship, a skill that impressed both authors and publishers. The book illustrations are executed in the same style as the magazine illustrations, heavily influenced by Art Deco, Art Nouveau, synthetic cubism, and Egyptian art. Some examples of Douglas's work have been lost because his cover jackets for books in the 1920s were not used on reprinted editions. Nevertheless, enough of his work exists to provide a representative sampling.

Douglas received an important commission in 1925, when Alain Locke asked him to add a few drawings to *The New Negro*. "Dr. Locke dropped in to see me yesterday," he wrote Alta. "He is getting out a book on the Negro in art. Somewhat of an extenuation of *Survey Graphic*. Some people had told him of my work and he wished to have at least one of my drawings in the book." The featured artist would be Douglas's teacher Winold Reiss, and Mexican artist Miguel Covarrubias would also contribute. "I'll be the only Negro artist with a drawing in it," Douglas added, commenting ironically, "Some sampling, eh?" Nevertheless, Douglas recognized that this commission would boost his career, less from the money than the company he would be keeping. "The book will be some class. It won't cost but five

smacks. I'm not making any money, but I'm making a 'rep' and getting up into real class."[1]

The New Negro was published in 1925 as an expanded, more comprehensive version of the March 1925 issue of Survey Graphic. It contained pieces by the same contributors as in the magazine, with more examples of their work. The same race pride, self-awareness, and celebration of all things black were evident in The New Negro. This time Douglas was not just an inspired bystander but a main contributor. His work, however, is very uneven. It was one of his earliest commissions, and some of his drawings were executed before he clearly developed his own style and are not his strongest works. They appeared at approximately the same time as his first works in the Crisis and Opportunity.

Douglas's first drawing, Meditation, is the same one that was reprinted in the February 1926 issue of Opportunity. The lounging figure is simply and crudely executed in profile, in Douglas's hard-edged manner, with exaggerated figures. This is the figure that he developed into a more sophisticated form for the October 1926 Opportunity to accompany Hughes's poem "Lonesome Place." The drawing executed a year later is more forceful in its simplicity. Now the reclining figure is an open silhouette, and his figure stands out more because he is surrounded by white. The palms are understated, the profile less exaggerated. The figure is long and lean.

Douglas's second drawing, Rebirth (Figure 45), is in the same style as the first one but much more complicated, with more and stronger African images. The composition is packed with symbols, including suns, jagged lines, plant life, eyes, and idol heads. It does not relate to the story with which it is featured; rather, it is an incidental illustration. The figures contain exaggerated features typical of Douglas's early works. His work Sahdji accompanies Bruce Nugent's short story of the same name (Figure 46). Sahdji was the wife of a chieftain. Nugent describes her beautiful dark, graceful body, with full lips, observing her as she danced to a funeral march, echoed by other mourning wives in the background. Douglas's drawing illuminates the writing, with Sahdji, seemingly nude, in black profile, standing on a circle amid jagged forms that by this time were widely used in sculpture and the decorative arts. Her face is as if painted (a rarity for Douglas), a large idol head presses behind her, and three widows dance in front of her. The composition is complex and angular. The viewer notices first the geomet-

ricity before taking in any actual details of the drawing. It is ideal for the Nugent essay: it is the essence of primitivism and of Douglas's perception of tribal ritual.

The poetry section of the book begins with a Douglas drawing, *The Poet*, which shows a very simple, somewhat crude rendering of a male figure, in profile, surrounded by palms and with the profile of a large face on the right side of the drawing. All of the forms are shadowed by two different gray-toned lines. It is not one of his more moving works, as much because of the printing as the drawing itself. The gray outlines seem blurry and detract from the overall effect of the drawing. *The Poet* is executed in the same style as *The Creation* (Figure 17). It was reprinted in the February 1926 *Opportunity* and accompanies a poem of the same name by James Weldon Johnson, which appeared in the form of a Negro sermon. Douglas would change his composition completely for the sermon "The Creation," which appeared in Johnson's book two years later.

Douglas recycled many drawings and reworked others, especially later in his life. Some of the drawings in *The New Negro* also appear in other publications. Douglas's drawing *The Emperor Jones* (Figure 40) was reprinted in Locke's article "The Negro and the American Stage" in *Theatre Arts Monthly* for February 1926. In the book it accompanies Montgomery Gregory's article "The Drama of Negro Life." The slightly less crowded composition, with large areas of white and a strong, geometrically patterned floor, is more successful than his darker, blurred works such as *Meditation. Roll, Jordan, Roll* appeared in the November 1926 *Opportunity*, accompanying Locke's "The Technical Study of the Spirituals" (Figure 10). It is another example of a Douglas drawing that was used in more than one context. The drawing served as the beginning of the book's unit on music. Many of these works resemble woodblock prints in their clarity and simplicity. *An' the stars began to fall* is included in the chapter titled "The Negro Spirituals," as it was in the issue of *Opportunity* of November 1926, accompanying Arthur Fauset's "The Negro's Cycle of Song" (Figure 12). Douglas's *Music* was included with J. A. Roger's essay "Jazz at Home." This drawing is executed in the simple style of *Meditation*, complete with blurred gray outlines. It features the simple profiled figures of a man and woman, playing instruments and singing, surrounded by jagged forms and musical notes floating in the air.

Occasionally Douglas's drawings were reprinted in journals and not labeled as having originally appeared in *The New Negro*. His *Spirit of Africa* (Figure 18) first appeared in the book as a frontispiece for the chapter "The Negro Digs Up His Past." It was reprinted in the February 1926 issue of the *Crisis*, labeled *Invincible Music, the Spirit of Africa*, with the caption "Drawn for THE CRISIS by Aaron Douglas." Although Du Bois was a contributor to *The New Negro* and knew the drawing had appeared there first, the readers of the *Crisis* were led to believe it was executed solely for Du Bois's journal. (In contrast, *Opportunity* was always careful to state that Douglas's drawings were reprinted from *The New Negro*.) *The Spirit of Africa* connects Africa to the creation of African-American music. The work shows the figure of an Egyptian-looking man in profile, mallet in hand, beating on a drum, with his head turned toward the sky.

The final Douglas drawing, originally titled *From the New World* (Figure 15), was appropriately used as a frontispiece for "The Negro Pioneers," an essay on advances in industry by *Survey Graphic*'s Paul Kellog. This drawing was on the cover of the February 1926 special industrial issue of *Opportunity*. It was more effective on the cover of the magazine because it was larger and clearer. The composition is exactly the same, but the cubist influences are more evident because the jagged edges and shadowing are sharp and expressive. Labor and industry symbolize the Negro in the New World and his progress.

The New Negro was Douglas's artistic and personal debut into the elite society of the Harlem Renaissance. He illustrated an article Alain Locke wrote on Negro theater for *Theatre Arts Monthly* and provided the illustrations for *Plays of Negro Life*, fifty-three prominent plays selected and edited by Locke, published in 1927 by Harper and Brothers, just one year after the article.[2] The drawings are executed in the same style as those in *Theatre Arts Monthly*. Locke had been pleased with Douglas's work and persuaded the publishers to allow him to provide illustrations for the volume. One of the drawings is another recycled Douglas work; his drawing of Brutus Jones from *Theatre Arts Monthly* accompanied *The Emperor Jones* in *Plays of Negro Life* (Figure 41). Titled *Forest Fear*, it is cleaned up and a little more sophisticated than in the earlier publication. Now Jones appears with a hard silhouette outline without thick, white, exaggerated lips. The surrounding forest, indicated by jagged edges as in the first drawing, differs only in that a few of

the sharp edges have been removed, barely discernible to the casual viewer. The book also contained an exact copy of *The Emperor* from the *Theatre Arts Monthly* article. His *Surrender* and *The Fugitive*, also executed for the same play, are particularly successful examples of the dramatic, flat, hard-edged, cutout, Douglas style. *Surrender* shows Jones fallen to his knees, hands thrown up in despair, mouth open and wailing, confronted by a dragonlike figure (Figure 47). The same stylized plants surround Jones, and he kneels on a wavy ground of alternating black and white stripes. His shoulders are extremely broad, his hips narrow, and his legs long and forceful. His eyes are slightly different; instead of narrow slits, they are squared at one end, pointed at the other, giving the impression of exhaustion or despair. *The Fugitive* features the long-legged Jones in open silhouette, head turned to the right in profile, mouth gaping, with a recently fired gun in his hand. He appears to be shocked and afraid (Figure 48). The composition is enclosed by patterned foliage, jagged and rectilinear at the top, rounded and curvilinear at the bottom.

Douglas's small decorations added a great deal to the book as well. At the top of each play and on the last page of some of them Douglas provided borders or vignettes, simple drawings, flat and decorative, the motifs derived from or suggesting African art (Figure 49). He provided a Deco-influenced pattern representing a sunburst, an African mask surrounded by foliage, and a pyramid flanked by two sunbursts and two masks. Another similar drawing featured a pyramid flanked by palm fronds and two faces in profile. Each rectangle is perfectly balanced, with identical images on each side of the central drawing. Small decorations consisted of heads and masks, influenced by Egyptian and African art. A particularly interesting head is a cross between Egyptian art and a horse's head and mane.

Locke's volume is an example of the growing importance of visual imagery in the arts. The visual arts lacked any real African-American heritage. Locke and others were determined to establish such a heritage by accompanying their works with visual imagery. Douglas provided the ideal artwork for such a venture: simple, sophisticated, and understated. The drawings enhanced rather than competed with the plays.

Douglas did not provide any illustrations for Carl Van Vechten's controversial *Nigger Heaven*, but he did do the advertisements that appeared in prominent journals of the time. These drawings are ex-

tremely forceful. The originals, executed in gouache on paper and gouache on pasteboard, are now in the James Weldon Johnson collection at the Beinecke Rare Book and Manuscript Library. Another version was executed in ink on paper. All were created solely in black and white. The first drawing (Figure 50) features an angular man on the right-hand side of the composition, his arms crossed over his head in a square position, his head turned skyward. His hands are delicate, suggesting those of a dancer. The left-hand side of the composition includes a ladder, most likely a reference to Jacob's ladder in Genesis and the African-American's struggle to uplift himself; in the middle are a miniature masklike profile, three smokestacks representing industry, a church as the ultimate symbol of black roots, culture, and spirituality, and finally a skyscraper, another symbol of modern New York life. The center of the composition is unusual for Douglas because it is completely barren of any decoration. This simplified format makes the drawing one of his more successful efforts.

The second advertisement for *Nigger Heaven* features two male figures holding up the title of the book in a caryatid fashion, in angular silhouette (Figure 51). They appear to be cutouts, so paired by Douglas, with arms forming a square around each of their faces, similar to the figure in the first advertisement. The words "Nigger Heaven" and "By Carl Van Vechten" are topped off by an interesting crowd of well-dressed blacks in a simple design resembling woodblock prints. The socializers, in suits and dresses, turn to each other and converse, perhaps at a theater performance or cabaret show. At first glance the crowd is merely a pattern; closer examination reveals a group of people all in black and white, voids and solids. Even the border that separates the group from the title of the book reflects contemporary Art Deco patterning.[3]

Douglas's connection with James Weldon Johnson also brought him interesting commissions. Knopf reprinted Johnson's 1912 *Autobiography of an Ex-Coloured Man* in 1927, at the height of the Harlem Renaissance. The previously anonymous book was printed under Johnson's name, and Douglas's book jacket is executed in black-and-white silhouettes against an orange background. The book tells of a black man, discouraged by racial violence and the limits society puts on him, who decides to pass for white. Douglas's cover features a seated black man in profile, a dreamer or a dejected individual, sitting on a hill of flowers

and plants, facing the big city, represented by skyscrapers and smoke-stacks.

Douglas's most important commission for Johnson was to illustrate *God's Trombones: Seven Negro Sermons in Verse*, published by Viking Press in 1927. Johnson personally asked Douglas to illustrate the book. Douglas was aware of Johnson's work with the NAACP and his involvement in the creative sides of Negro life, including fiction and poetry. He considered him an inspiration to younger members of the Harlem Renaissance. When Johnson asked Douglas if he would be interested in illustrating *God's Trombones*, Douglas was pleased but un-sure if he could deliver what Johnson wanted. Nevertheless, he was determined to try and accepted the challenge. He was not entirely pleased with what he created, but he considered it the best he could do in the limited time allowed. He hoped later to be able to develop the drawings and make them express "the enormous power, spiritual power that's behind Negro life."[4] The original title of the book was *The Gospel According to Jasper Jones*, and its subject was a Negro minister. Despite Douglas's misgivings, Johnson was very enthusiastic about the drawings. By now Douglas had truly developed his signature style of broad, flat figures in silhouette, with little or no perspective, pur-posefully fashioned after Egyptian tomb paintings.

Douglas's illustrations for *God's Trombones* are striking in their sim-plicity, readability, and expression of the influences of modernism. They provide an example of the collaboration of two artists from different disciplines; Douglas illuminated the author's words in visual form. The drawings were designed to accompany specific poems in the book. Johnson turned to Negro sermons as inspiration, looking to storytelling and folk heritage as his foundation. Douglas's first drawing accompanies the poem "Listen, Lord—A Prayer" (Figure 52). The poem tells of those who pray to the Lord with knee bowed and body bent. Douglas provides a figure from about knee up, in profile, shoul-ders parallel to the picture plane, reaching heavenward with one hand as he looks up toward God. He is praying to or pleading with God. A lightning bolt crosses his lower body, and rays of light pierce him from above, showing the influence of cubism. All the drawings exhibit the flatness, simplicity, and monumentality characteristic of synthetic cub-ism. These delicate illustrations for the sermons, with their subtle tonal contrasts, show how Douglas's style had matured. He had become

aware of the great history of graphic art and certainly knew Albrecht Dürer's Apocalypse series and others. He recognized the language of modernism and subtly assimilated modernism, cubism, and his knowledge of religious texts and art to create religious images that rightfully belong in a long tradition of graphic art.

The Creation (Figure 53) features a giant hand of God reaching down to man. Man, represented by one very small figure in profile, looks heavenward at the sky opening with bright light, piercing the darkness of the earth. The drawing is true to Johnson's poem. Circles float across the composition, one on top of the other, characteristic of Douglas's more sophisticated works and a technique he would employ regularly in his murals. He employs tones of black with some modulating to white. The circles may show the influence of modernists that Douglas may have read about in Sheldon Cheney, Charles Marriott, and Albert Barnes and the work of orphists Robert Delaunay and Frantisek Kupka. Delauney in *Simultaneous Contrasts: Sun and Moon* in 1913 and Kupka in *Disks of Newton (Study for Fugue in Two Colors)* in 1912 employed circles in their compositions.

For "The Prodigal Son," Douglas created a more contemporary composition, which appears to have been taken right off the dance floor of a cabaret (Figure 54). Douglas illustrates Johnson's modern prodigal son, who explores bars, music, and women before repenting. There is no African influence present here, only the silhouettes of three modern black figures, one man flanked by two women, dancing together under a single bright light. Brass horns blow down upon them, representing the jazz of the time, accompanied by symbols of playing cards, gambling, and the almighty dollar bill, all suggesting the temptations of modern life. The work is executed in subtle tones with strong black figures in the center. This was one of Douglas's more modern pieces to date, showing black Americans in contemporary dress, enjoying the night life of the cabaret scene.

In "Go Down Death: A Funeral Sermon" (Figure 55), Johnson describes death as a bright angel on a horse: "On Death rode, And the foam from his horse was like a comet in the sky; On Death rode, Leaving the lightning's flash behind."[5] Douglas illuminated Johnson's words in his own unique way, yet rooted in Death on a Horse from the Book of Revelations. A horse ridden by a winged angel gallops across the composition, totally in silhouette, with a stream of light, "the

foam," trailing from its mouth like a comet. The angel and horse are surrounded by Douglas's cubist and orphist-inspired circles and rays of light (sometimes known as cubist transparencies), giving the composition a celestial feeling.

Johnson's "Noah Built the Ark" is traditional subject matter, easily recognizable even as translated by Douglas's cubist-inspired style (Figure 56).[6] Two birds approach the ark, and two leopards or tigers enter across a plank as men load the ark with supplies. One man at the helm, presumably Noah, directs the process, standing under a stream of light from the sun above. A storm, represented by flashes of lightning, broods in the distance. The figure in the lower right-hand corner of the composition, a profiled black man observing the scene, with slits for eyes and thick lips, could represent the author, James Weldon Johnson.

The Crucifixion shows a giant Simon carrying the cross, with Jesus below, in a series of concentric circles of light, serving as a mandorla, his halo overhead, his disciples and enemies following behind (Figure 57). The illustration is true to Johnson's poem, "Black Simon, yes, black Simon; They put the cross on Simon, And Simon bore the cross."[7] Douglas places a large black figure in silhouette, struggling under the weight of the cross, while soldiers hold spears in his direction. A wedge of light streams from the top right-hand corner, presumably the light of God. Although Christ appears in brighter colors at the base of the composition, it is the dark body of Simon, the flat, broad shoulders of the black figure, that dominates. Douglas uses the wedge or ray of light throughout this volume, as well as in several of his more notable murals. This style shows the influence of Matisse, who includes cubist-influenced wedges in his *Piano Lesson* of 1916, and even more so of the precisionists, such as Charles Demuth's *High Tower* of 1916 in the Neuberger Museum and *Lancaster* of 1921 at the Albright-Knox Art Gallery.

Let My People Go features Moses at the right of the composition, standing under a ray of divine light, receiving God's word (Figure 58). Spear-carrying Egyptian figures appear on the left, representing the pharaoh and his soldiers, accompanied by horses. Large stylized waves, curving across the composition, form a decorative Red Sea. The soldiers wear headpieces which resemble the crown of Upper Egypt. Douglas was familiar with Egyptian art and might have obtained this

iconography from a source as simple as the *Palette of King Narmer*, ca. 3000 B.C. The discovery of Tutankhamen's tomb and the heightened popular interest in Egyptian art made such images easily accessible.

Douglas illustrated the final Johnson poem, "The Judgment Day" (Figure 59), with a hieratically sized Gabriel blowing his horn, holding a giant key to heaven's gates in his right hand (no key is mentioned in the poem). Sinners cower while others reach heavenward in the background. Gabriel straddles the composition with "one foot on the battlements of heaven, And the other on the steps of hell." The drawing, again influenced by synthetic cubism and orphism, is done in a flat, sophisticated, simple style, complete with concentric circles and rays of light.

Douglas's 1929 cover for Wallace Thurman's *The Blacker the Berry* in its simplicity is one of his finest efforts in the graphic arts[8] (Figure 60). The title was taken from the black folk expression "the blacker the berry, the sweeter the juice" and was meant to serve as an ironic statement concerning the protagonist of Thurman's book, a dark-skinned black woman who is rejected by both black and white society, including her own parents. Douglas features a woman, in silhouette completely black, on a geometric, jagged white background, surrounded by jagged black lines. Her short dress and heels give her the appearance of a modern woman; her head is turned upward in profile, perhaps in despair, toward the title of the book. Her hair consists of white wavy lines, possibly influenced by Egyptian hairstyles but also in line with the white/black, positive/negative composition. It is simple, flat, understated, and dramatic.

Douglas also created the cover for André Salmon's translated *Black Venus* of 1929.[9] The book, which featured among its characters noted painters, writers, and recent intellectual celebrities in France, tells the story of Mederic Bouthor, an unusual man who decides to start a rubber plantation in the hills of Montmartre. Bouthor builds a cabin, buys a dark-skinned slave girl, and surrounds himself with the artists and poets of the quarter. Douglas's cover depicts the young slave girl, nude, in flat silhouette with soft, curving, sensuous lines, gracefully crossing through the rubber plants and flowers. The characteristic hard-lined human form typical of Douglas is lacking here. The cover was printed in green, red, black, and white.

Finally, Paul Morand's *Black Magic*, published in 1929 by Viking Press, featured some of Douglas's most interesting illustrations. The book was translated into English just a year after its original printing in France. The fictional work chronicles "30,000 miles" in "28 Negro countries" and is broken down into three parts: the United States, the West Indies, and Africa. Eight of Douglas's most sophisticated drawings appear in the volume. One of the most notable accompanies "Congo," in the United States section of the book (Figure 61). Congo is a French dancer who is extremely popular in the nightclubs of Paris. Douglas illuminates this chapter by showing a group of people, presumably at a nightclub or cafe, dancing to their hearts' content. The figures in the foreground are shown in dark silhouette, faces in profile with heavily exaggerated features. Their faces are uplifted in song. The women have tight chignons and earrings, giving them an air of sophistication. Transparent concentric circles cross the composition: behind them dancers wildly and expressively dance in a much more primitive fashion than the patrons in the foreground. These background dancers have long hair, patterned and flowing, and their arms move freely. One dancer seems to be performing a back flip across the room. Douglas has contrasted sophisticated French society with the primitive expressions so popular at the time.

Douglas's illustration for the chapter "Charleston" was largely duplicated in his murals at the College Inn in Chicago (Figure 62). The chapter describes a trip back from Nice on the Riviera, an area well known for its jazz. Douglas shows a series of musicians in the center playing the drums, trombone, and a saxophone. A seated couple converses intimately at a small table in the background, and sophisticated, well-dressed black nightclub patrons observe from the foreground. The crowded cafe format indicates Douglas's awareness of the works of Toulouse-Lautrec. We see these patrons from the back, as they lead us into the composition, which is covered by a series of concentric, opaque circles. Again Douglas's composition seems influenced by orphism, and in particular Delauney and Kupka. It is unusual for two elements: first, the menacing, claw-hands that seem ready to pounce on the whole scene, positioned at the bottom front of the composition, and second, and even more dramatic, a noose, which dangles from an unknown source above and crosses in front of the saxophone player. All is not well in this seemingly jubilant all-black nightclub. Terror and violence lurk close by.

The second part of the book, "The West Indies," begins with a chapter titled "The Black Tsar"(Figure 63). People of West Indian descent are depicted as primitives, performing a nocturnal ritual. Figures clad in animal skins, covered by the signature concentric circles, meet in a forest and hold a head or idol over a pot and fire. Smoke streams lazily up from the pot, and a large group of participants observes the ceremony. The composition is framed by plants and trees, providing a darker frame for the lighter center. The light source, the circles, and the smoke draw the viewer into the ritual. Elements of primitivism are present in this work.

The third part of the book, "Africa," begins with a chapter titled "Good-bye, New York!," chronicling a cruise from New York to Africa (Figure 64). Douglas depicts Africa by showing the profiles of two individuals, with the signature slanted eyes showing the influences of Egyptian and Dan Ivory Coast art, looking up toward an idol. This idol is similar to idols in several Douglas compositions depicting Africa, resembling a Fang male reliquary guardian. Douglas learned of this art by viewing the substantial African art collection at the Barnes Foundation, from art books, and from the photographs in *The New Negro* featuring African art. Two seated figures, apparently nude, in the background also look up at the idol, which is surrounded by light concentric circles, as are the heads of the two front-profiled viewers. Tropical palms frame the top of the composition. Douglas seems to be contrasting peoples of different African origins, so the work is pan–Africanist in nature. The two front figures are contemporary, sophisticated figures indicated by the women's modern hairstyle and earrings; perhaps they are black visitors from New York in search of their heritage. The figures in the background seem to be native to the area. The two cultures come together, with common roots, as they observe the idol in the center of the composition.

The last drawing in the "Africa" chapter of the book features one of the more creative works in Douglas's repertoire, *The People of the Shooting Stars* (Figure 65). A giant masklike creature dominates the composition, its mouth wide to contain the people who are dancing below. The idol, dominating or watching over the dancers, is pierced by a series of concentric circles, as well as waves of smoke or fire coming from the right. People dance wildly in the background with complete abandon, and one dark silhouetted figure in the foreground leans back, holding

up his hand, apparently apprehensive or afraid of what stands before him, unseen to the viewer. This composition is the essence of primitivism, mysteriously featuring rituals about which the reader could only dream.

Douglas's illustrations for Morand's book do not depict actual moments in the text but relate loosely to the chapter titles and sections. They are some of his most lyrical, exotic, and creative drawings, indicating his artistic maturation and secure command of ideas and materials. Douglas contributed to several other publications as well, including four drawings for Charles S. Johnson's *Ebony and Topaz: A Collectanea* of 1927, which displayed the literary talents of black Americans in a relaxed mode influenced by Negro folk life. He also provided two illustrations and the book jacket for Arthur Fauset's *For Freedom* in 1927, as well as the jackets for Hughes's 1927 *Fine Clothes to the Jew*, Isa Glenn's *Little Pitchers* in 1927, and Claude McKay's *Home to Harlem* in 1928 and *Banjo* in 1929. Although he later regretted it, Douglas was persuaded to change the cover of *Home to Harlem* by white patron Charlotte Mason, who insisted that Douglas had featured the central figure with legs crossed "in a way that Negroes never did."[10] Douglas would provide two other jackets for McKay, for *Banana Bottom* in 1933 and *A Long Way from Home* in 1937.

Seven

The Hallelujah Period

Aaron Douglas's largest and most important commissions were executed at the end of the 1920s, when he started creating large-scale murals. Before and during his work on mural paintings, two important events took place in his life: a one-year fellowship at the Barnes Foundation in Merion, Pennsylvania, and a year abroad studying in Paris. Douglas never wrote or talked extensively about these experiences, but an examination of the evidence suggests that they did not meet his expectations or have as positive an effect on his career as he might have hoped.

Albert C. Barnes was a brash and highly opinionated white millionaire, a disciple of William James and a friend of John Dewey and artist William Glackens.[1] By 1907 his financial success allowed him to devote his life to teaching and collecting art. He hoped to make art accessible to the common man and was dedicated to "stripping [art] of the emotional bunk [with] which the long-haired phonies and that fading class of egoists, the art patrons, have encumbered it."[2] In 1922 he created the Barnes Foundation as the depository for his substantial art collection. Barnes had already acquired an impressive collection of modernists, including works by Matisse, Picasso, Cezanne, Renoir, Degas, and Monet. Barnes was known in the art world for his book *The*

Art in Painting, which included discussions of Matisse and Picasso, as well as reproductions and analyses of works such as Picasso's *Still Life* and Matisse's *Music Lesson*. Barnes's collection was also featured in Cheney's *Primer of Modern Art*, which included reproductions of Picasso's *Woman with a Mandolin* and *Man with a Mandolin* as well as the collage look of Albert Gleizes's *Three People Seated*.

Barnes also had a very large collection of African art and considered himself an expert in the field. Barnes claimed to have been fascinated with African-Americans since his childhood.

> My experience with the Negro began when I was eight years old. It was at a camp meeting in New Jersey and the impression was so vivid and so deep that it has influenced my whole life, not only in learning much about the Negro, but in extending the aesthetic phase of that experience to an extensive study of art in all its phases, and particularly the art of painting. I became an addict to Negro camp meetings, baptizings, revivals, and to seeking the company of individual Negroes.[3]

Barnes intended the foundation to be a teaching institution, the galleries to function as a laboratory. He hoped that the foundation would serve as a force for social action, and from its creation he stressed the nondiscriminatory conditions underlying the experiment. Awarding a fellowship to Aaron Douglas, the most promising African-American visual artist, would fit well into Barnes's philosophy. "We do not convey the impression that we have developed a crowd of savants, or art connoisseurs, but we are sure that we have stirred an intelligent interest in spiritual things created by living people . . . which has been the means of stimulating business life and affording a sensible use of leisure in a class of people to whom such doors are usually locked."[4]

Barnes had become a patron of the Harlem Renaissance through Alain Locke, whom he met in 1923, and through the NAACP's Walter White and the Urban League's Charles S. Johnson. These connections, as well as his wealth and influence, undoubtedly led the leaders of the Renaissance to include Barnes's ruminations on African art in both the issue of *Survey Graphic* and the book *The New Negro*. The position of Barnes's article in both collections was clearly meant as sign of honor for this eccentric white art collector and critic, a token of respect that had more to do with Barnes's power and connections than with the quality of the essay. Both works contained photographs of African

pieces from Barnes's collection to illustrate his essay. The patronizing tone and celebration of primitivism in the essay, "Negro Art and America," dismayed black leaders, especially Alain Locke. (Locke was so unhappy with Barnes's article that he responded with his own interpretation of African art in *The New Negro*.)[5]

Barnes began his essay by arguing that despite discrimination, the Negro had created wonderful works of art. He then discussed how crossing the Atlantic had changed a primitive race into a people held together by common yearnings and goals. To Barnes, Negro art originated from a primitive nature never burdened by the white man's education. It was great art because it embodied individual traits of blacks and reflected their suffering, aspirations, and joys during a long period of acute oppression and distress. Barnes romanticized the primitive elements of the Negro race, believing their daily habits of thought, speech, and movement were flavored with the picturesque, the rhythmic, the euphonious. The white man could not compete with the Negro's spiritual endowment. Discussing the forefathers of the Negro renaissance, including Paul Laurence Dunbar and Booker T. Washington, Barnes argued that they had exhibited the majesty of nature, the pathos, comedy, affection, and joy of daily life. The Negro's creative temperament contributed the most fundamental elements to American life, namely the poetry which the average Negro actually lived, and it was what "our prosaic civilization needs most."[6]

Both *Survey Graphic* and *The New Negro* had informed Douglas of the importance of Barnes and his influence within Harlem. He wrote Alta that he was "really wild" about the introduction to Barnes arranged through Charles Johnson. Their meeting went well, and Barnes invited Douglas to see the "pictures at the Barnes Foundation." He spent a day at the foundation and was pleased that Barnes even advanced funds for his transportation so that the trip cost him nothing. He told Alta that "[Barnes] undoubtedly has the largest single collection of modern paintings in America and certainly the finest collection of Negro sculptures."[7]

Douglas was anxious to immerse himself in modernism, including cubism, and a connection with Barnes was the ideal way to do so. Suddenly in 1928 Douglas was offered a year's fellowship at the foundation along with Gwendolyn Bennett, the first two blacks to receive Barnes Fellowships. Douglas kept his main residence in Harlem, but

over the next year he commuted between New York and Philadelphia. To attend lectures by the foundation's staff, he would leave on Tuesdays and return to Harlem on Fridays.

Douglas wrote very little about his time in Merion and never mentioned it as a major influence on his career in subsequent interviews. He did not write about receiving any inspiration from viewing the Barnes collection or attending lectures. Perhaps this reticence was because Douglas's style was already firmly developed. His work became slightly more sophisticated, especially the drawings in Paul Morand's *Black Magic* in 1929, which probably were executed in 1928 while Douglas was working in Harlem and commuting to Merion. It is not clear if his contact with the works of artists such as Matisse or Picasso altered his style because many of the elements, especially employing opaque, concentric circles and rays of light, related to synthetic cubism and orphism, appeared before he became involved with the Barnes Foundation.

Another possible explanation for his silence about his experience at the Barnes Foundation has more to do with his encounter with Albert C. Barnes than with the works of art. Douglas had gone to the foundation to study, despite the warnings of such people as Charlotte Mason, who felt Douglas would learn more by staying firmly planted in Harlem. The Barnes Fellowship paid him $125 a month, a tidy sum for 1928, money that he could have for "nothing, doing nothing, just go down there and looking at pictures and so on."[8] Douglas wanted to use the fellowship to educate himself more fully through exposure to works by Cezanne, Matisse, and others. He felt he could gain a better understanding of the modern movement at the Barnes Foundation than anywhere else in America. He was impressed not only by the collection but by the fact that Barnes had persuaded Matisse to do a mural for him at the collection. Douglas was fascinated by the building itself, made from stones brought from France. Barnes seemed to have more money than he could spend. Despite Barnes's patronizing attitude toward blacks, Douglas admired him as a writer and a critic. He knew that Barnes faced hostility from established Philadelphians, who considered him "an upstart" and who rejected Barnes's ideas about art and his collection.

After spending a year studying and attending lectures, Douglas still wondered why he and Bennett had received fellowships because he had still not met with Barnes. He and Bennett both hoped that their

fellowships would be extended so they could go abroad; Barnes had begun to take some students to Paris at his own expense. Finally, after this year of what he characterized as "cramped, pressured studies," Douglas learned why he had been awarded the fellowship. One afternoon toward the end of the fellowship year, Douglas and Bennett finally met with Barnes, and he "revealed what he was interested in." Barnes told the two blacks that he wanted them to write a statement or essay attacking Alain Locke. When they asked him what he wanted them to say, Barnes responded that he would provide them with all the material they needed. Barnes complained that Locke had plagiarized some of his work. In Barnes's view, Locke did not know anything about art when he wrote *The New Negro*, and what Locke wrote he "had got it from me." Clearly Barnes was still angry, even paranoid, over Locke's refutation of his views of the Negro in art in the essay "The Legacy of the Ancestral Arts," which immediately followed Barnes's piece in *The New Negro*.[9]

Barnes put both artists, especially Douglas, in a very difficult position. Douglas either had to betray Locke, who had featured his work in *The New Negro*, had helped him make connections, and had furthered his career, or to alienate a powerful patron. Both he and Gwendolyn Bennett wanted to ignore the situation and let the fellowship run its course, without attempting to extend their support for a year in Paris. Undoubtedly the sour taste that remained in Douglas's mouth from this experience with Barnes affected his views of the role of the foundation in his career. He felt used and manipulated in a manner that he never forgot.

It was not until a few years later, at a train station in Paris, that Douglas saw Barnes again. At the time he was waiting for Alta to arrive from America. He spoke courteously but briefly with Barnes and never met the eccentric millionaire again.[10]

Douglas's first mural commission was executed in 1927 at the Club Ebony. Although the work was destroyed years ago, it was carefully described in a 1927 interview in the *Kansas City Call*:

> The walls and ceiling vividly bespeak his artistry. He has created a distinctive Negroid atmosphere. There are tropical settings of huge trees and flowers, figures of African tom-tom players and dancers, pictures of the American Negro with banjo and in cakewalk. On the main panel silhouetted against a background of modern skyscrapers are the forms of contemporary race dancers and musicians. This effect is obtained with subdued tones of rich oranges, yellows, reds and blues.

The article went on to note that "a strong flavor of African influence" would give America modern art, which, in the view of Harlem's artists, should have as a formula "African art plus American Negro plus present-day American life."[11]

Douglas later recalled that the party for the unveiling was attended by important people, including Carl Van Vechten, Florence Mills, Alain Locke, Charles S. Johnson, Paul Robeson, W. E. B. Du Bois, and Albert C. Barnes, and that a new dance step that would become the rage of cabarets, the Lindbergh hop, was introduced. Douglas was particularly hurt when Barnes remarked, "You have painted the mural. Now do it in color." Barnes thought Douglas's pastel colors were pleasing but lacked the richness, depth, and plastic quality of great art, such as a Titian or Tintoretto painting. It took Douglas years and "an enormous amount of sweat and labor" to include Barnes's suggestions in his art.[12]

For Douglas, doing the Fisk University Library murals was one of the more pleasant experiences in his life. He said later that just looking at them made him so happy he was afraid they would dissolve. In 1929 Douglas and Alta were on their way to Kansas for a vacation. Before he got to Topeka, he received a telegram from Charles S. Johnson saying that Thomas E. Jones, then president of Fisk, wanted to commission some murals for the university. Douglas made a quick trip to Nashville but was not interested in the project. He spoke with both Johnson and Jones, and saw the plans for the new library. The three agreed that Douglas would return in 1930 to do some sketches for the library mural and teach a class at Fisk.

Although the class never materialized, Douglas returned to Fisk and completed his drawings in June 1930. They were accepted with great enthusiasm by the president, the architect of the library, Henry C. Hibbs, and the senior class. The university finally agreed to pay Douglas a sum that was lower than he requested but higher than he expected. Jones offered Douglas and his wife, Alta, the use of his home for the summer. There Douglas would also execute the College Inn Room murals. Charles S. Johnson had been instrumental in getting Douglas the contract, and he would eventually bring Douglas permanently to Fisk seven years later.

Douglas was not sure how to proceed with this project, which was much larger than anything he had ever attempted. He suspected that

some of the builders believed he would fall flat on his face, and he feared they might be right. Douglas hired four assistants, three of them students, one a mail carrier, and all of them untrained. The four had never held a brush in their hands. He also hired a skilled black portrait painter, Edwin Harleston from Charleston, South Carolina, to assist him with the murals. As director of the project, Douglas worked closely with his helpers. Harleston served as on-site supervisor and proved to be a tremendous help. All six painted together. Harleston's assistance allowed Douglas time to work on his Sherman Hotel murals as well; both projects were going on simultaneously.

Douglas worked on the project throughout the summer of 1930 and finished it that October. The works are not frescoed on the walls but painted on canvas, which is attached to the walls. Much of the painting is now obscured by walls and lowered ceilings, added when the building became the administration building for the university. Some of the cycles of the murals are totally covered by a ceiling of sheet rock; much of one cycle is only barely visible in what is now the computer center. The only murals that are completely visible are in the upstairs lobby of the old library.[13] Although the colors have changed greatly over the past sixty years, blue and green were the dominant notes in the color scheme of the decorations. Yellow was used for dramatic highlighting. (Today the murals appear to be a dark, muddy green.)

The cycle was to represent a panorama of the history of black people in the New World. Douglas began in Africa, with animal life and the pyramids of Egypt, and then moved on to slavery, emancipation, and freedom. Freedom was symbolized by Fisk University's Jubilee Hall, with the sun rising across it, and featured graduates from various disciplines. Across from that wall, Douglas depicted the spiritual elements of Negro life and on the other side, the south wall, labor, which he believed to be "one of the most important aspects of Negro development."[14] He wanted the Fisk students to realize the Negroes' important contribution to the building of America. Both the Fisk murals and the College Inn Room murals were executed during what Douglas called his "Hallelujah period," when he believed the Negro was destined to save the "soul" of America. The Negro's ability to sing, dance, and laugh in the face of adversity were qualities well worthy of emulation by his white brother.

Douglas described the works in great detail at the time. The murals

were designed to tell "the story of the Negro's progress from central
Africa to present day America."[15] Beginning at the east end of the
reserve book room are the jungles, from which Africans were enslaved.
Further along the wall there is a group of men, going down into Egypt
with packs on their heads. Three pyramids and a blazing sun constitute
the graphic expression for Egypt. Beyond the pyramids there is a group
of hunters and warriors. At the center of the wall is a group under the
"magic spell of the fetish, which plays so large a part in African reli-
gions." Under the beam there is a group on either side of a tom-tom
player, who sits beating his drum beneath a blazing sun. Douglas com-
mented that the "war dance," which inspired conflicts between tribes,
"was a boon to the slavers, who after the battle often made off with
both the victor and the vanquished." At the extreme west of this wall a
long line of slaves chained together march down to the sea. Around the
angle of the end wall a three-masted slaver awaits its cargo.

The story continues on the north wall of the reference room. From
left to right, the slaves march up from the shore massed against a
darkening background. Just beyond the window a slave in fetters kneels
on the auction block to be sold. Douglas described how "the light of
Christianity penetrates the encircling shadows and causes red and yel-
low ribbons of light to surround the figures." Douglas symbolized
Christianity with a skull—Golgotha—over which he depicted the
outstretched wings so often encountered in the spirituals. Wings also
symbolize the flight of a soul from death to eternal life. With burdens
upon their heads and shoulders the slaves march toward the light of
Christianity, for them an unfailing source of joy and beauty. Douglas
noted:

> The figure, conscious of another light, has put his burden aside. The
> other three figures in this group hurry forward to fall upon their knees in
> exultation before the rising star of freedom. Leaving their work in the
> cotton fields, the four figures to the right of the star hail the approaching
> light. The two remaining figures belonging to this group turn toward
> the rising light of learning, symbolized by Jubilee Hall massed against
> the rising sun.

For Douglas, Jubilee Hall was the "perfect symbol for Negro educa-
tion," which allowed blacks to "take their places in life as scientists,
ministers, and leaders of every kind." The last large figure in the mural

is measuring a building that has the outline of the new library. The small figure at the end of the wall, Douglas wrote is going out into the world "in search of truth—symbolized by a pyramid upon a hill with a star at its apex."[16]

The final murals in the series, in the lobby, are still visible today, although in great need of cleaning (Figures 66–72). The seven panels on the walls portray philosophy, drama, music, poetry, science, night, and day. Philosophy, Douglas noted, is represented by a single, isolated figure with lifted head, meditating on the ultimate purpose of time, space, and substance. Douglas described how "the decay and ruins of man's philosophical thought is symbolized by the broken and over-turned drums of Greek columns." On one side there is a factory on a hill, on the other rigid skyscrapers are outlined against a background of concentric circles that become larger and darker toward the top of the panel.

To express drama, Douglas used the traditional comic and tragic masks hung from a Greek column. The city, a soaring heap of concrete and steel, gives the work a modern touch. For music, which occupies the panel above the door, there are three figures, one singing, another playing a stringed instrument, a third blowing a trumpet. Parts of the musical instruments have been enlarged and so interlaced and toned as to form a rhythmic background for the foreground figures. Poetry is captured by the poet, a minute figure standing insecurely upon the thin edge of a revolving world. He is straining to catch some of the music produced by the progression of planets back and forth through space. Douglas portrayed science with a scientist holding a torch that gradu-ally lights up and reveals unknown worlds. To Douglas, the scientist remains too closely attached to the "penny-in-the-slot aspect of Greek logic, symbolized by a towering column." For night and day, the small panels over the doors, Douglas depicted "Diana, Goddess of the Moon, accompanied by her hounds, in full flight across the sky shooting her golden arrows. Apollo in his chariot guides his plunging steeds across the sky dispersing the shades of night."[17]

The entire cycle is executed in Douglas's signature style, employing silhouetted figures, cubist-inspired rays of transparent light, orphist-inspired concentric circles, and simple, readable, understandable story lines. Douglas also includes details that relate to the subject matter, such as a curtain framing the scene of drama. The mask of comedy faces a

figure who could be a minstrel performer; tragedy faces a woman who solemnly holds up a skull. The symbols are clear and recognizable. By reducing his stories to the bare necessities, Douglas makes the murals, although sophisticated in their simplicity, accessible and easily readable. Simplicity was essential to encourage the viewer to take in the entire cycle. The cycle is further proof of Douglas's knowledge of African and European history and art history.

Douglas was both pleased and surprised when in 1930 the owners of the Sherman Hotel in Chicago, Charles and Edward Byfield, sent him a telegram at Fisk, where he had barely begun work on the library murals, asking him to come to the hotel and paint a mural series for them. The designers of Chicago's Tribune Tower, Holabuird and Foot, who were also in charge of the renovation of the College Inn Room, had heard about Douglas's reputation and wanted a lively, upbeat mural for their hotel. They had seen *God's Trombones* and wanted murals painted in the same basic style. Despite the prestige of this project, Douglas initially refused the commission because he was busy with the Fisk library murals. He was later persuaded to do the work on a smaller scale.

Douglas began work on the panel while living in Nashville in the home of Fisk's president Jones. Douglas worked in the Jones's attic, with only about a foot to spare on either side of the canvas, executing it while he was at the same time painting and supervising the Fisk murals. Douglas was anxious to please the architects but was concerned that he would be unable to complete the job because he was so busy with the Fisk murals. He had already done a smaller panel for the College Inn Room, which was sent to Germany and enlarged to six feet.

Douglas finally accepted the commission and provided the Sherman Hotel with a mural, but he never finished it. It was hung, but Douglas felt he never perfected the form, color, and distribution of tone in the way he had hoped. He always planned to return to the hotel to work on the mural but never had the opportunity to because the hotel was torn down and the mural destroyed. Douglas used the same style in both the Fisk murals and on the Chicago series, a style with which he was familiar and comfortable and considered "his own." Some of the designs from Fisk are duplicated in the Sherman Hotel mural. Titled *Dance Magic*, the mural joined the traditions of African dance and music with modern jazz (Figure 73). He described the mural program as

"going back to the primitive thing before we came, our people were brought here and then up to the present. . . . Singing, dancing and cabarets, and that type of thing."[18]

The five panels for the hotel used the "gay, fanciful side of Negro life as subject matter . . . I tried to use a flowing, rhythmic, progressive series of tones and special areas to create a visual equivalent of joy, lightness of movement and laughter."[19] The main panel was twenty-seven feet long and five feet high. A reproduction appeared in the May 1931 issue of the *Crisis*. Douglas included a tripartite composition with a stagelike setting. A curtain separated the outer two parts from the central composition, which was very similar to Douglas's illustration *Charleston* for Morand's *Black Magic*. It celebrates the magic of modern jazz, with people seated at intimate tables socializing at a nightclub. Musicians, including a saxophone player, and African-Americans, who created the music, are enjoying the evening. The noose that was in the drawing in Morand's book was removed to give a positive, lighthearted effect to those enjoying the facility, making it appropriate as a backdrop for a room used for entertainment.

The outer compositions consisted of an African-looking woman on the left and several African dancers on the right, complete with wrist and ankle bands, dancing freely to their music. There are flowers at the base of the left composition, as well as Douglas's signature circles across the front of the dancer, depicting the sharp light of a spotlight. She is linked to the modern jazz central portion of the composition by a trombone or trumpet that seems to escape from the world of modern jazz and enter the African section of the work. This musical instrument provides the link between primitive African music and African-American jazz. Although whites considered jazz to be their creation, Douglas showed its legitimate black roots. The right section of the mural shows dancers, some in midair floating above others, with often only a limb visible. Its background, with the crossing streaks of light, is reminiscent of a precisionist composition, such as those executed by Demuth, Sheeler, and Ault. This precisionist influence reappeared throughout Douglas's mural commissions. The College Inn Room murals showed the "Negro at play," complete with drums, dancing, and musical instruments, similar to his mural for the Club Ebony a few years before, appropriate for a nightclub wall.

More murals followed. In 1930, in addition to the Fisk murals and

the College Inn Room, he completed a mural for Bennett College for Women in Greensboro, North Carolina. Harriet Tubman, who led more than three hundred Negro slaves to freedom by way of the Underground Railroad, was the primary theme of the mural (Figure 74). Douglas was asked to execute the work by Alfred Stern of Chicago, son-in-law of philanthropist Julius Rosenwald. (The Rosenwald Foundation, a strong supporter of black intellectual and artistic ventures, provided Douglas with a travel fellowship to the American South and Haiti in 1938.)

Tubman is at the center of the composition, enhanced by a ray of transparent light coming from the sky and a series of concentric circles. She is in complete silhouette, dramatically enhanced by the light background, with her arms overhead triumphantly holding the broken shackles and chains of slavery. She stands on a dismounted cannon with a smoking muzzle. Douglas stated that he used Tubman to idealize a superior Negro woman, a heroic leader breaking the shackles of bondage and pressing on toward a new day. Behind her and stretching back symbolically to Africa are the black men and women who toiled and prayed through three hundred years of servitude, gaining their freedom with the successful termination of the Civil War. The group of figures to the right of the center symbolizes the newly liberated people as laborers and heads of families. The last figure, who sits with hoe in hand and looks toward the center, symbolizes the dreamer who looks out to higher and nobler vistas, the modern city. He represents the preachers, teachers, artists, and musicians of the group. The beam of light that cuts through the center of the composition, typical of Douglas's works, symbolizes divine inspiration.[20]

In 1931, with his fame in Harlem as an artist in place and his murals in increasing demand, Aaron Douglas finally fulfilled a lifelong dream and sailed for Paris on the *Von Steuben* of the Hamburg American Line. With careful planning he had saved enough money to finance a year's study there. Douglas took a room in a small hotel on the left bank, probably at 4 rue de l'Ecole de Medecine, the Hotel St. Pierre.[21] He enrolled at the Academie de Grande Chaumiere, at 14 rue de la Grande Chaumiere in the Montparnasse arts district. As an American, Douglas did not have access to the art schools run by the state, but he did have greater opportunities to study in Paris as a black man than he would have found in the United States. The tuition at Grand Chaumiere was

moderate, but there was so little working space that Douglas immediately sought out an alternative.

At the end of his first week in Paris Douglas transferred to the Academie Scandinave, a school that featured such artists as Charles Despiau, Henri de Waroquier, and Othon Friesz.[22] The Academie Scandinave was at 6 rue Jules-Chaplain, only a few blocks away from his first school (Figure 75). The Academie Scandinave proved to be short-lived in a time when small painting schools in Paris came and went. Classes were probably held for only six years, for although the school was founded in 1930, by 1937 it was no longer listed in the *Annuaire General du Commerce* of Paris. The small school was located in a former teaching and studio space inhabited from 1892 until 1901 by James McNeil Whistler and his model, Carmen Rossi.[23] The tuition was much higher there, but there was more working space and an excellent staff of professors for both painting and sculpture. Douglas executed fairly traditional figure studies and received a traditional, classical training at the Academie Scandinave, including instruction from Charles Despiau in sculpture and Othon Friesz in painting.

The location was ideal in that the district boasted many such schools, among them the Academie Russe de Peinture on the same street, the Academie Ranson, the Academie Colarossi, and the Academie Delecluse, as well as numerous artists' studios. Douglas became established in an area inhabited by artists and academies and experienced some of the life of a "French artist." Walking to his classes daily through the Luxembourg Gardens to the studio, Douglas was initially disappointed with "the worn, grey, bent appearance" of Paris. But before long he had learned to love "every weather-worn wall and cobbled street as well as the spectacular sparkle and glitter" of the city.[24] Douglas's time and money were limited, so he was determined to work as hard and fast as possible. He knew that this "time-clock, lock-step approach to art" was ultimately self-defeating, but he was resolved to learn as much as possible in a brief period of time. Painting classes were held in the morning, sculpture in the afternoon. Douglas had been trained differently and found it difficult to adjust to the French system. Many of his peers would work on a sketch of a model and then take a few days off to enjoy life in the cafes of Paris. Douglas did not have the luxury of time. He had to keep working consistently even if he did not care for the model he was sketching.[25]

Douglas was not alone in his interest in studying abroad. Many black artists and intellectuals, including Hale Woodruff, Augusta Savage, and Palmer Hayden, writers Claude McKay, Countee Cullen, and Langston Hughes, and leaders Alain Locke and W. E. B. Du Bois, were in Paris at the same time. These and other artists made up what was known as the "Negro Colony." Although these artists were aware of the white "lost generation," including the writers Ernest Hemingway, F. Scott Fitzgerald, and Gertrude Stein and the painters Man Ray and John Graham, they were only names whose positions in the art world were known and respected, but with whom black artists had little or no contact personally.[26] Not all would-be painters were of the highest quality. Many mediocre painters also attempted to try their luck in Paris.[27] Some were more interested in pleasure than learning, but still they added spice to the life of the city.[28]

Hale Woodruff had also chosen to study at the Academie Scandinave. When Woodruff arrived in Paris he had originally hoped to study at the famous Academie Julien but discovered that this school had become too large and no longer had a reputation for excellence in teaching. Henry O. Tanner met Woodruff upon his arrival in Paris and found him a small flat. He was familiar with the art schools of Paris and may have recommended the Academie Scandinave. Douglas may have chosen the Academie Scandinave for the same reasons. It was small, intimate, and open to blacks.

His stay in Paris also afforded Douglas the opportunity to meet Henry O. Tanner, whom Douglas greatly admired. Tanner was one of the few black artists to receive critical acclaim before World War I. Tanner, born in 1859 in Pennsylvania of English, African, and Indian descent, provided a rare success story from which Douglas and other aspiring black artists could draw inspiration. Tanner's father was college-educated and attended the seminary, eventually becoming a minister in the African Methodist Episcopal Church. His mother was a former slave, who shared her husband's commitment to education. All of the Tanner children were educated and led successful professional lives, though Henry was the most notable. He became interested in painting at a young age when he watched a landscape painter work in a nearby park and copied him.[29] Tanner struggled against heavy odds to receive the training he needed to become a fine artist. Initially his father

found him employment as a manual laborer in a friend's flour business. Eventually Tanner was able to enroll in the Pennsylvania Academy of Fine Arts, where he trained for at least two years under the direction of the famous American painter Thomas Eakins, who was professor of drawing and painting there.

Tanner faced many of the same struggles Douglas would face, working as a black artist in a white artists' world. Ostracized by his fellow students, Tanner eventually found the American working environment of the 1890s too restrictive, too closed to the concept that a black man could be an artist. In 1891, like many artists of this period, he chose to go to Paris, where he remained until his death in 1937. Tanner attended the private Academie Julien because the Ecole des Beaux-Arts no longer admitted foreign students.[30] Not only was Paris considered to be the center of the art world, but it also gave Tanner a chance for creative freedom in an atmosphere less affected by racial prejudice. After 1895 Tanner began to paint biblical subjects, one of which Douglas later found especially moving: "I remembered seeing a painting of Nikodemus on the house, or Christ on the house of Nikodemus. As a very young child, it made a strong impression on me. It was a truly powerful picture, and there was a great deal of mysticism in it which appealed to me."[31] Douglas was referring to Tanner's *Christ and Nikodemus* of 1899, now in the Pennsylvania Academy of Fine Arts. This painting won Tanner the Pennsylvania Academy of Fine Arts Purchase Prize. This interest in biblical subjects could have been a result of Tanner's father's encouragement to pursue spiritual themes.[32] These were popular in Europe, and Tanner's spiritual works, executed in a sketchy, soft style reminiscent of the impressionists, were enthusiastically received by the art world. A trip to the Near East in 1897 helped give his paintings greater realism and accuracy.

Tanner was largely unaffected by modernist trends in early twentieth-century art, most of which emanated from Europe. Although his mystical works were influenced to some degree by the symbolists, Tanner's work never took on the expressive color of the Fauves or reflected any influence of cubism. Tanner, although an early inspiration to Douglas, greatly differed from Douglas in his choice of subject matter. Where Douglas would become immersed in political

and social issues in art, especially African-American themes, and was greatly influenced by African art, Tanner executed very few paintings on black subjects. His early black paintings include only *Old Couple Looking at a Portrait of Lincoln*, 1892–93, *The Banjo Lesson*, 1893 (one of his most famous works), and *Thankful Poor*, 1894.[33]

Douglas was a little apprehensive about meeting Tanner. He expected him to be "old and decrepit" and was surprised to find him alert and "spry." He was just a plain, ordinary man who had not lost his American mannerisms. Tanner encouraged Douglas to continue his studies and to work with models. Douglas must have taken Tanner's advice for his Paris sketchbooks are filled with traditional, classical nude studies of both men and women. Unlike Woodruff, who returned from Paris with a large body of work, including scenes of Paris, Douglas's Paris works consist primarily of traditional nude studies in his sketchbooks, presumably executed during class time. He also executed one full-figured traditional nude in oil, which is now in the private collection of Valena Williams Waits. Clearly his efforts were directed toward perfecting the basic elements of the human body (Figures 76, 77). He also did at least one loose ink sketch of a couple at a French cafe (Figure 78), a traditional subject for a young art student in Paris, and one page of African profiles not unlike those found in his magazine illustrations but more three-dimensional. Douglas's interest in mastering human anatomy is evidenced in an interview years later: "Our business is to learn to get this thing that Europe has put at our disposal, these patterns, these methods, the human figure, anatomy. The basis of anatomy. Anatomy is our base . . . you must understand that, the bones and the muscles and so on. . . . It is a tremendously powerful thing if you understand."[34]

Douglas's year abroad is so rarely and so briefly mentioned in any of his personal writings or oral interviews that it clearly did not have the same impact as his Harlem years. Perhaps he felt he was just one of many artists struggling in a large city, relatively unknown, whereas in Harlem he was a well-known member of the arts community. He also stated in his recollections about Henry O. Tanner that he was happy the famous artist had not adopted French mannerisms and had remained very American, perhaps indicating Douglas's ambivalence toward the French. The trip to Paris was a dream that needed to be fulfilled and was. Although certainly it was an enriching cultural and artistic experi-

ence, there is no indication that his Paris studies changed his style of painting.

Douglas's second cycle of library murals, for the Countee Cullen Branch of the New York Public Library, was executed in 1934 under the sponsorship of the Public Works Administration (PWA). Douglas was now determined to awaken blacks to the important issues of the time. The Great Depression's impact on African-Americans, more severe than on whites, radicalized both Douglas and his audience. The cycle, known as *Aspects of Negro Life*, consists of four massive panels that employ symbolism to convey a message, influenced by Marxist ideology, about the place of the Negro in history and society. Some historians consider this series the culmination of his work.[35]

The first of the four panels, *The Negro in an African Setting* (Figure 79), emphasizes the strongly rhythmic arts of music, dance, and sculpture, which have perhaps influenced the modern world more profoundly than any other aspect of African life. The fetish, the drummer, and the dancers, in the formal language of space and color, recreate the exhilaration, the ecstasy, the rhythmic pulsation of life in ancient Africa.[36] This panel is similar to his magazine and book illustrations, although it is a more crowded and sophisticated composition. Two central figures face each other in dance, surrounded by tribal members and with an idol looming in the background. The panels, which make subtle use of gradation in tones, as in his illustrations, gradually increase in color, losing some of the monochromatic qualities characteristic of analytical cubism. The colors used are pale golds, browns, blues, and purples. Rays of light and concentric circles are again employed as a highlighting motif. Douglas used the circles to show and heighten different areas of action by varying the degrees of light within progressively enlarging concentric circles, taking care always to maintain a constant relation between figure and background within each circle. Where two circles of light intersected, the area bounded by the intersecting circles, as well as all the objects within the circle, became lighter.[37]

These murals show the influence of Marxism, a philosophy that Douglas, like many other intellectuals of the time, adopted in the wake of the massive economic depression of the 1930s. Referring to his own earlier interest in Gurdjieff, Douglas rejected mysticism and spirituality in art, a rejection that was already evident in his Fisk and College Inn

Room murals. He told a reporter for the *New York Amsterdam News*, the city's leading black newspaper, that "I sought escape through so many of these theories . . . that, when I finally encountered the truth through the revolutionary movement, I was absolutely unable to face reality. I had to cast aside everything that I had once believed and begin anew." The article on Douglas, titled "Murals and Marx: Aaron Douglas Moves to the Left with PWA Decorations," opened with the statement, "Those who view Aaron Douglas's new mural at the 135th street branch library will hardly suspect the influence of Karl Marx on the delicately beautiful decoration. But the patron saint of the Revolution has left his mark there just the same." Both Douglas and his wife, Alta, became fascinated with Marxism and even joined a group of young intellectuals "who are making a serious study of Marx and his theories."[38] This fascination was particularly strong among black intellectuals and artists. Both Langston Hughes and Hale Woodruff made a ritual pilgrimage to the Soviet Union, considered at that time the workers' paradise.

The influence of Marx on Douglas was "subtle," as one writer put it, and would be difficult to discern were it not for Douglas's own words. Douglas stated that he would present historical fact in an orthodox manner in the same way history is taught in every school in the country. The second panel, *Slavery through Reconstruction*, shows, from right to left, the slaves' doubt and uncertainty transformed into exultation at the reading of the Emancipation Proclamation (Figure 80). A series of circles, culminating in the figure holding the Emancipation Proclamation, separates this segment of the composition. In the second section, in the center, a figure stands on a box, symbolizing the careers of outstanding Negro leaders of the time, a paper in his hand, apparently addressing a crowd, and urging freedmen to deposit their ballots in a box before him. He is also highlighted by concentric circles. Slaves in the fields, picking cotton, turn to listen to the speaker, who is pointing toward the horizon, where a silhouette of the Capitol is pictured. The third section shows the departure of Union soldiers from the South and the onslaught of the Ku Klux Klan that followed. Klansmen are pictured in hooded silhouette on horseback. Cotton blooms line the base of the panel, much in the way Douglas used tropical plants to frame his earlier compositions. The panel, oil on canvas, is impressive in size, a full 5′ × 11′7″. Douglas uses mauve, rose, browns, greens and blues in his colorful composition.

The third panel, *An Idyll of the Deep South* (Figure 81), portrays black laborers toiling in the fields on the right, singing and dancing in the center of the composition under the highlights of a series of concentric circles and a piercing ray of light, while on the left mourners grieve the death of a man who has been lynched. It reflects the state of race relations of the time when a condemnation of lynching was considered to be a political statement that "brought instant objections from [Douglas's] PWA superiors."[39] As mourners surround the body of the hanged man, one figure pulls himself to his knees and looks toward the distant ray of light, which crosses the scene, perhaps in a gesture of hope. Muted purples, blues, and clay browns provide contrast for a soft green sky.

The fourth mural, *Song of the Towers* (Figure 82), shows, from the right, a figure fleeing from the clutching hand of serfdom, symbolic of the migrations of Negroes from the South and the Caribbean into the urban and industrial North during and just after World War I. He dashes up a giant cog of industry; skyscrapers loom in the background and smoke billows out of factories. The middle of the panel represents the will to express oneself, namely the spontaneous creativity of the Harlem Renaissance, a brief period of joy that spread vigorously throughout the arts in an expression of anxiety and yearning from the soul of the Negro people. This outpouring is symbolized by a jazz player, in silhouette, with saxophone in hand, in the center of giant concentric circles that highlight the Statue of Liberty in the background, the symbol of hope. The last section of the panel attempts to re-create the confusion, dejection, and frustration resulting from the Depression of the 1930s. A dejected figure holds his head in his hand, as the hand of death looms over him. The smoke of industrialization crisscrosses this panel, which is executed in pale tones of peach, green and muted purple. In his 1934 interview, Douglas apologized for the note of defeat upon which his cycle ended. He would have liked to have executed a fifth panel that would point the way out for the Negro as outlined by Karl Marx in revolutionary struggle of black and white workers. Had he done this, however, Douglas was convinced that the PWA authorities would have rejected the entire mural. Douglas had already experienced an unpleasant run-in with the administrator of the program, who had attempted to censor his work.

"Under our present system," Douglas explained in reference to American capitalism, "the artist must paint what his employer wants,"

while trying "to maintain a certain honesty and present the picture as he sees it." Douglas did not consider himself a proletarian painter, but neither did he so classify the muralist Diego Rivera and other radical artists. "They paint what they personally think the proletariat feels. They must continue to do so until the day that the proletariat comes into power and makes its feelings so unmistakable that artists must express them." Douglas believed that under a "Soviet America," the artist would have more freedom of expression, more honesty. He rejected the argument that artistic life in the Soviet Union was regimented or that artists could suffer under "a misguided dictatorship of the proletariat" as much as under capitalism.[40]

Like many intellectuals of his day, Douglas embraced communism as an answer to the legitimate and significant problems of American society. It is likely that he abandoned his Marxism and revolutionary fervor sometime over the next few years, especially when he moved south to the more conservative climate of Nashville, Tennessee, and accepted a position as chairman of the Fisk University Art Department. Douglas was always interested in painting the common man, the common experience, the average worker. Yet in his earlier years he did not consider himself to be particularly political, just as he did not in his later years. The mural commissions for the Countee Cullen Library, executed in 1934 when Douglas was thirty-five years old, mark the most politically vocal point in his career. This politicization is matched dimly by statements made late in Douglas's life during the civil rights movement.

Douglas also completed a mural for the 135th Street YMCA in 1934, which he rarely commented on. It is not his best work and today is in terrible disrepair because of years of exposure to smoke, as it was located in a pool room, and more recent exposure to chemicals. (A hairdressing salon now occupies the room.) The wall was not adequately prepared for frescoeing, and the paint is peeling off.

Many of Douglas's later works, including portraits and reworked scenes from his Harlem years, were less original. Interestingly, his finest works, culminating in the Countee Cullen Library mural series, were done at the high point of his political involvement. Both his artistic innovations and political leanings lost some of their passion in the following decades.

Eight

The Father
of Black American Art

Aaron Douglas's most exciting, experimental, and fruitful years came
between 1925 and 1934. Although Douglas's career continued after this
period, his achievement and originality were at their peak during these
years of illustrating the *Crisis* and *Opportunity*, as well as other maga-
zines and books, especially *God's Trombones* and *Black Magic*. During this
time he explored Africanism more thoroughly than any other black
artist, in fact any artist of any color, had to date. Through the influences
of Alain Locke, Locke's African art collection, Albert Barnes's collec-
tion, and Douglas's own studies of European modernism, he was able to
incorporate African art into his work and adapt it to American themes.

During this period, Douglas developed his own unique style. He
chose to employ a flat, sophisticated silhouette of the human form,
although he also worked to perfect a realistic rendering of the human
body. He incorporated aspects of synthetic cubism, giving his works
the appearance of a flat, nonillusionistic construction, reducing the
picture to lines, planes, and values. Like the synthetic cubists, Douglas
learned to build up forms in ways so subjective and arbitrary as to yield
an image that seemed sometimes more a symbol than a representation
of visual fact. Synthetic cubism flourished through the mid-1920s and
clearly influenced Douglas's paintings and illustrations.

During this period of experimentation, Douglas was also influenced by orphism, especially works such as Robert Delaunay's *Simultaneous Contrasts: Sun and Moon* of 1913, which, although they had no reference in observed nature, provided a context for a series of intersecting circles and disks. Delaunay's fragmented images, a series of geometric shapes in works such as *Window on the City No. 3* (1911–12), could well have influenced the cubist-like ray-intersected Douglas compositions. Frantisek Kupka, another orphist who, like Delaunay, worked in France, also employed circles in compositions such as *Disks of Newton*, 1912. He used patterns of abstract color spheres in his nonrepresentational compositions. Both artists were fairly well-known among modernists by the 1920s. Until 1913, Francis Picabia was also working as an orphist, using lyrical, rhythmic curvilinear forms, as well as rectilinear forms and wedges in his abstract compositions that seem even closer to Douglas's use of concentric circles and rays of light, although Picabia remained nonobjective. New York was the center of the arts in the United States, the place most exposed to the new offshoots of cubism and the developments of modernism in general. In his letters and interviews Douglas exhibited an admiration for cubism and modernism as a whole. Douglas developed his own system of concentric circles and worked primarily with a muted, monochromatic palette that was similar to analytical cubism, although his use of colors expanded in his 1934 mural series.

Through lessons, books, and gallery visits Douglas had access to all these modernist influences in New York in the 1920s. Winold Reiss's influence on Douglas was also profound, through Reiss's contact with modernism and German and Austrian movements as well as an introduction to Africanism. Douglas studied African masks and sculpture and made them an integral part of his work. Douglas's Africanism was intimately linked to the black's African roots, to African-American culture, and to a search for a cultural heritage.

Although there were other important young black artists working at the time, none employed Africanism in their work to any significant extent. Aaron Douglas remained virtually the sole visual artist of the Harlem Renaissance. Sculptor Richmond Barthé included some African themes in his classic figures, but he did not become active until the Renaissance had ended. The three other significant black painters of the 1920s—Hale Woodruff, Palmer Hayden, and Archibald Motley—

are worthy of examination and comparison with Douglas, but they did not participate in the Renaissance and did not consistently use African motifs in their works.

Archibald Motley was born in New Orleans in 1891 but spent the majority of his life in Chicago. He received formal training from the School of the Art Institute of Chicago, graduating in 1918. Like Aaron Douglas, Motley had to work at a series of odd jobs to support himself while painting. Motley's earliest African-American works are straightforward portraits that are somewhat naive and romantic. They either lack background or are placed in domestic settings filled with objects that are symbolic for the artist.[1]

In 1928 Archibald Motley exhibited twenty-six paintings at the New Gallery on Madison Avenue. Five of these works focused on African themes. They were considered to be the most controversial pieces in the show, criticized as "imaginings of Voodooland."[2] They were somewhat dreamlike and romantic, reminiscent of Henri Rousseau's fantasy jungles. James Porter in his *Modern Negro Art* of 1943 described the works as starkly realistic, enhanced by distorted shapes of trees and disproportionate bodies of the savages, which he said corresponded with Motley's "notion of the Negro's past." Porter argued that Motley's works were not motivated by race consciousness but by a short-lived enthusiasm for exotic subjects.

Archibald Motley sailed for Paris in 1929, where he executed a series of street and club scenes in his traditional, realistic, slightly naive style. Motley became known for his depictions of blacks, sometimes with slightly exaggerated features, enjoying music, jazz, and dancing. In 1937 he executed *Africa*, a romanticization of the continent before colonization. Unlike Aaron Douglas, Motley did not seek in his painting to connect Africa historically to modern African-American life. Motley believed that artists must portray their own lives and people, and he later turned to scenes of African-American daily life for his inspiration.

Hale Woodruff, another Douglas contemporary, was born in Cairo, Illinois, in 1900 and educated at the John Herron Art Institute in Indianapolis. Woodruff spent the majority of the Harlem Renaissance in Paris at the Academie Scandinave, where he painted views of Paris heavily influenced by impressionism and Cezanne. He also served as an expatriate writer for the *Indianapolis Star*, which published Woodruff's column about Parisian life accompanied by his paintings. Woodruff did

not become actively involved in African-American heritage or African subject matter, with the notable exception of his moving woodblock prints and his most famous work, the Amistad Murals at Talladega College in Alabama. These murals, completed in 1939, chronicle the mutiny of the Spanish slave ship *Amistad* in 1839, led by the tribal chief Cinque. The panels are extremely dramatic in gesture, posture, and symbolism and have been characterized as Depression-era social protest art.[3] James Porter considered the series well researched and designed, a brilliant depiction of heroism and conflicting tensions. The murals fit into the style of regionalist and social realist murals of the 1930s, including those of Thomas Hart Benton, to whom Woodruff was superior in his sense of expression. Some have argued that Woodruff was a more talented artist than Aaron Douglas, an assessment that is difficult to understand considering the uneven quality of Woodruff's work. Woodruff never took the risks in his art that Douglas did. When Woodruff finally turned to abstraction, it proved an unfortunate choice for an artist whose talent lay elsewhere.

Palmer Hayden was first noted for winning the 1926 Harmon Foundation first prize while working as a house cleaner. Hayden used his prize money to study for the next two years in Paris. Like Woodruff and Motley, he did not participate in the Renaissance but was still considered a notable black painter of the time. Hayden was born in Virginia in 1893 and studied at Cooper Union. In Paris he became a student at the Ecole des Beaux-Arts. Unlike Douglas, Motley rarely turned to Africa for inspiration, with the exception of his 1926 *Fetiche et Fleurs*. This painting shows a Western interior, with a table covered by a swatch of African fabric. The table itself boasts a flowering plant, an ashtray with a cigarette, and an African sculpture head. Although clearly the work of an amateur, it does show Hayden's attempt to include a reference to Africa in his painting. His work after 1940 features African-Americans in everyday activities, sometimes bordering on caricatures. Porter described Hayden's work as being like one of those "ludicrous billboards that once were plastered on public buildings to advertise the blackface minstrels."[4]

Although Archibald Motley, Hale Woodruff, and Palmer Hayden were among the most prominent African-American artists of the 1920s, none of them actively participated in the Harlem Renaissance, none of them at that time received the national exposure Douglas received

through his magazine and book illustrations, and none of them turned to Africa as a strong source of inspiration in their work. All three chose to study abroad in Paris, as Douglas eventually would. Douglas returned from Paris continuing to employ his modernist, cubist-inspired style based on the African heritage, while Motley, Woodruff, and Hayden continued to paint in a more traditional vein, perhaps reinforced by figure studies in the Paris academies.

After Douglas's Countee Cullen Library mural commission, he tended to rework old compositions, including magazine illustrations, and further developed his signature style. Most of his portraits, although pleasant, were not exceptional. In 1934 he had a one-man show at the Caz-Delbos Gallery in New York. Douglas won Rosenwald Foundation fellowships in 1937 and 1938. The first allowed him to travel to the South, where he visited black educational institutions, including Fisk University in Nashville, the Tuskegee Institute in Alabama, and Dillard University in New Orleans. The second allowed him to tour the Dominican Republic and Haiti, where he produced a fairly conventional series of watercolors on island life.

The most profound change in Douglas's career came when he was offered an instructorship at Fisk University. Fisk asked Douglas to organize art classes and create a major in art for the university. In 1940 Douglas worked out an arrangement whereby he would teach at Fisk in the spring and attend Teacher's College at Columbia University in New York during the fall. Over the next four years Douglas continued with this arrangement, eventually receiving his master of fine arts degree in 1944.

Douglas had numerous commissions for portraiture and participated in several notable art exhibitions, including exhibitions at the Baltimore Museum in 1939, the Barnett Aden Gallery in Washington, D.C., the St. Louis Gallery in 1942, a one-man showing at Chabot Gallery in Los Angeles in 1948, and another in 1949, where he exhibited paintings completed on another Rosenwald Fellowship of 1948. He also exhibited regularly in both one-man shows and group exhibitions at smaller galleries throughout the 1940s and 1950s. He was a sought-after lecturer on the history of Negro art and was recognized for his contributions to art education, not only for his work during the Harlem Renaissance but for his insistence on rigorous training for young art students. Douglas attended the centennial celebration of the Emancipa-

tion Proclamation at the invitation of President John F. Kennedy. He was clearly recognized as a leading artist and educator.

Douglas's real commitment was to Fisk University, and his teaching and lecturing took up the majority of his time and took away from the production of his own art. He devoted a tremendous amount of energy to producing programs, bookplates, and general graphic designs for Fisk. As an artist, educator, and chairman of the Art Department, he was determined to direct and inspire his students, to pick up the ideals of the Renaissance and "go with it." He believed that Renaissance artists had only initiated an interest in black arts, and it was the duty of young students to expand the movement and carry on its goals and ideals. The need for the younger generation to assume this responsibility was even greater in the 1970s than it had been for the artists of the 1920s.

Douglas considered it essential that young students have a true understanding of the history of art, including the development of the human figure, Renaissance perspective, and design. Douglas criticized prominent contemporary black artists such as Elton Fax and John Biggers because he felt their work was not adequately rooted in a strong understanding of anatomy. Study and discipline were essential for the young artist to succeed in the art world. One of his students recalled Douglas telling the class that "one can't worry about breaking the rules, until you know what the rules are."[5] Douglas believed that the rules of art had to be learned thoroughly before the experimentation and innovation that occurred during the Renaissance could be attempted again.

Douglas's students remembered him during these later years as a sensitive, caring, gentle man, strongly classical in his training and academic in his teaching style. He allowed his students to work at their own pace, keeping to the side in his studio, often buried in a history or art history book. His art studio lessons were always strongly based in history and an understanding of the history of art. His students often worked from Greek plaster casts instead of nudes because of a Fisk University policy forbidding live nude models in studio classes. Keeping the art program strong at Fisk was a constant challenge and struggle.[6] For several years he was forgotten as he diligently worked in his studio. His students knew of his connections with the Harlem Renaissance leaders, but everyone else seemed to forget, until around the time of his retirement.

He also tried to encourage his students to undertake a study of black

history, saying, "Open your eyes to where we came from, where we have the possibility of going. Not what we are going to do, what we have done."[7] Douglas always considered this to be absolutely vital to his art. He chose to use his own unique style of geometric symbolism to show blacks as a proud, majestic people with a very rich heritage. He included history, politics, religion, myth, and pertinent social issues in his work, all of which helped "furnace the revolution of the 1960s."[8] With dignity and pride Douglas depicted the struggle from Africa, through slavery to emancipation, and the black man and woman's achievements in modern culture. He helped make visual arts a viable option for young black students at a time when images of African-inspired art were limited and were based more on the European's interpretation of African art than a knowledge of African culture.

Before the Harlem Renaissance and Aaron Douglas's appearance as an interpreter of the movement, conceptions of Africa were vague and what little was known was negative. Only a handful of black artists considered African influences before the Harlem Renaissance, and then only occasionally, as in the work of Meta Vaux Warrick Fuller. Africa was not considered legitimate subject matter until the Harlem Renaissance opened the doors to discovering its history, culture, and influence on African-American culture. Depictions of Africa as the Dark Continent, savage and wild, were slowly replaced by images such as those in Douglas's Countee Cullen Library mural series, which were based on a growing knowledge of the continent rather than on superstition and ignorance. This interest in and knowledge of Africa developed among the educated middle class. Artists such as Aaron Douglas saw it as their duty to teach others, including the average African-American, the "common man," about African art.

In seeking to make a foreign tradition accessible to black Americans, however, Douglas and his contemporaries took considerable liberty with that African tradition. African art was often reserved for the elite, especially the rulers of the various tribes. African art has also been described as "technical . . . controlled and disciplined; . . . sober, heavily conventionalized and restrained."[9] Douglas's depictions of African art were in some ways cursory, primarily because they were interpreted for the common man. African-American painting was much more stylistically open and unconstrained than actual African art. Black artists appropriated what was useful for their goals in order to connect

the African continent with New World culture and thus illuminate their own lost heritage. Because no literature on African-American art was available until years after the Harlem Renaissance was over, Douglas had to learn about his race's traditions on his own. As the primary and perhaps sole illustrator of the Harlem Renaissance, Douglas paved the way for a generation of artists who followed him.

Recent scholars have dealt harshly with the Harlem Renaissance, finding it narrow and parochial, controlled by white patrons, elitist, and excessively ambitious. These criticisms fall wide of the mark, especially in their failure to grasp the movement's larger social and collective psychological meaning and to understand the complicated issues of patronage in the arts. For the first time in any organized, unified way, the Harlem Renaissance artists delved into African-American and African culture. They were linked with the pan-Africanist movement through their interest in Africa and attempts to join it, however naive their efforts were. It is true that white patronage was important, but artists were still able to create unique works. Artists have always struggled to please their patrons and at the same time create original art forms. These artists were no exception. Many of the more prominent artists, such as Langston Hughes, eventually broke with their white patrons. Aaron Douglas was never dependent on patronage. He created African-inspired works largely under his own direction and the influences of prominent black leaders. Nathan Huggins criticized the movement as a group effort, concluding that the individual was sacrificed in the process. Yet the group effort, as Douglas's experience proves, was one of the most exciting aspects of this brief time. Artists such as Douglas, Hughes, McKay, and Thurman turned to each other for support and inspiration. They were a small band, but they opened doors that were previously closed and increased opportunities for black artists in the 1930s.

Artists produced works with pride, unity, strength, and a new dignity and racial self-awareness. Many of the artists created outstanding works, not the mediocre productions described in some historical accounts. Aaron Douglas was a pioneer in American art, breaking away from the traditions of such more famous white artists as Robert Henri, Reginald Marsh, and Ben Shahn to create unique, sophisticated works that interpreted modernism in a new light. He was the first African-American, indeed, the first American of any race, to create works consistently and

deeply rooted in African-American and African culture and history, and his important place in history cannot be denied. He created during a time when African-Americans had limited artistic freedom. Douglas had to confront the problem of trying to reach a public that was difficult to define and locate with limited patronage and a geographically isolated audience. Despite these challenges, Douglas successfully addressed important issues to a growing black middle class.

The Harlem Renaissance was based on assumptions of white European high culture, but it is impossible to imagine an alternative. The two cultures, Euro-American and African-American, were inseparable, as they remain today. The artists of the Harlem Renaissance, engaged in a new movement and a first effort among blacks to express a self-consciously African-American culture, could not have been expected to create art forms based entirely on non-Western standards. They had to work within an existing framework. African-American artists who searched for African roots did not deny their own American past, but rather combined the black American experience with African influences. The artists sought to find their heritage, a heritage lost through years of slavery and oppression. Race consciousness did not lead to provincialism and naiveté, but helped foster an awareness of one group's history and culture within a transatlantic framework. The black experience in the United States has always been inextricably tied to social reform, and the arts were no exception. The artists of the Harlem Renaissance proved that with determination and strength, they could expose centuries of oppression and tyranny aesthetically in a manner that would help forge the collective consciousness necessary to pursue racial equality. If the arts were not directly responsible for reform initiatives, they were certainly constituent elements of social change.

Douglas recognized the similarity between the years of the Harlem Renaissance and those of the civil rights movement. Both were times of rapid social, political, and economic change. He had tremendous hope during both periods for the possibilities of a better life for African-Americans, and he saw art, laced with the history of Africa and the black American, heavily influenced by African imagery, as a way of encouraging race pride and building black self-esteem.

In his later years, Douglas spoke of the successes of the Harlem Renaissance, reminding his students that it was a time "fraught with hope, bitter frustration and struggle against an indifferent and fre-

quently hostile environment." Knowing that they were in the midst of their own struggle to deal with contemporary America, he encouraged his students to remain optimistic and hopeful in keeping their eyes on the prize. As one of the few remaining from that era, Douglas assured his students that "we still rejoice that we were among those who were found able and willing to shoulder the heavy burden of the pioneer and the pathfinder, firm in the conviction that our labor was a small but withal an essential contribution to the continued flowering of the art and culture of the black people of this nation."[10] Douglas's students would need to make their own contribution to the flowering of black culture, but they could find no better guide for that journey than Aaron Douglas.

Aaron Douglas retired from Fisk in 1966 and died in Nashville in 1979, at the age of eighty. He ranks among the most important American artists of the twentieth century. Douglas's experiences and insights were essential to his students of the civil rights era and remain valuable to artists of a new generation who face many of the same obstacles and challenges.

Notes

Preface
1. Cary D. Wintz, *Black Culture and the Harlem Renaissance* (Houston: Rice University Press, 1988), p. 231. This book presents a more positive view of the Renaissance than earlier works but focuses on the literary aspects of the movement and ignores the visual arts.

Chapter One: A Hungry Spirit
1. Interview of Aaron Douglas by Ann Allen Shockley, November 19, 1975, Black Oral Histories (BOH), Fisk University Special Collections, Nashville, Tennessee. Information on the early years of Aaron Douglas's life is limited and sketchy; most of it is from Aaron Douglas's Autobiography, an eighteen-page typed document in Box 1, Folder 1, Aaron Douglas Papers, Fisk University Special Collections, Nashville, Tennessee. This information is also in Jacqueline Bontemps, "The Life and Work of Aaron Douglas: A Teaching Aid for the Study of Black Art" (M.A. thesis, Fisk University, 1971).

2. Thomas C. Cox, *Blacks in Topeka, Kansas, 1865–1915* (Baton Rouge: Louisiana State University Press, 1982), pp. 137–61.

3. The term "Negro" is used in this book when necessary to quote or paraphrase accurately.

4. Douglas Interview, Shockley, BOH, Fisk.

5. These words date his departure to July 11, 1917; the race riots broke out the following day. See Elliott Rudwick, *Race Riot at East St. Louis, July 12, 1917* (Carbondale: Southern Illinois University Press, 1964).

6. Autobiography, Douglas Papers, Fisk.

7. Douglas Interview, Shockley, BOH, Fisk.

8. Ibid.

9. Douglas Notes, Box 3, Folder 13, pp. 4–5, Douglas Papers, Fisk. These undated notes are probably from the late 1960s.

10. Autobiography, Douglas Papers, Fisk.

11. Ibid.

12. Douglas Interview, Shockley, BOH, Fisk. When teaching at Fisk years later, Douglas used plaster casts because live models were prohibited.

13. Ibid.

14. Ibid.

15. This issue is discussed in detail in the first volume of David Levering Lewis's masterful biography *W. E. B. Du Bois: Biography of a Race*, 1868–1919 (New York: Holt, 1993).

16. David Levering Lewis, *When Harlem Was in Vogue* (New York: Oxford University Press, 1981), p. 13. For a more recent treatment, which argues that Du Bois's strong public support for the war was designed to obtain a commission in military intelligence, see Mark Ellis, " 'Closing Ranks' and 'Seeking Honors': W. E. B. Du Bois in World War I," *Journal of American History 79* (June 1992): 96–124.

17. Speech by Aaron Douglas at Fisk University's Negro Culture Workshop, ca. 1970, "Harlem Renaissance," Box 3, Folder 3, Douglas Papers, Fisk.

18. Autobiography, Douglas Papers, Fisk.

19. Ibid.

20. Dawson went to Harlem and became successful as well. His "Negro Folk Symphony No. 1" was directed by Leopold Stokowski with the Philadelphia Orchestra in November 1934.

21. Aaron Douglas, Personal writings (incomplete file), Box 3, Folder 15, Douglas Papers, Fisk.

22. The hundreds of letters recently discovered in the basement of a brownstone on Edgecomb Avenue in Harlem and now in the Schomburg Center for Research in Black Culture, New York Public Library (NYPL), are a tremendous source of information on Douglas's life during this period. The Douglas-Sawyer letters are extremely insightful, articulate, and romantic. Douglas expressed his views on the leaders of the Harlem Renaissance and the problems they faced, as well as his involvement in the movement. The letters are often undated, although all were written between 1924 and 1926.

23. Douglas, two letters to Sawyer, n.d., Box 1, Folder 4, Douglas Papers, Schomburg, NYPL.

24. Douglas, letters to Alta Sawyer, from Kansas City, n.d. (1924 or early 1925), Box 1, Folder 7, ibid.

25. Ibid.

26. Tanner's influence on Douglas is discussed in Chapter 7.

27. "Harlem Renaissance," speech, Box 3, Folder 3, Douglas Papers, Fisk.

28. Douglas, letter to Sawyer, ca. 1925 (probably late spring), Box 1, Folder 5, Douglas Papers, Schomburg, NYPL.

29. "Harlem Renaissance," speech, Box 3, Folder 3, Douglas Papers, Fisk.

30. Douglas Interview, Shockley, BOH, Fisk.

31. "Harlem Renaissance," speech, Box 3, Folder 3, Douglas Papers, Fisk.

32. Ibid.

33. Autobiography, Douglas Papers, Fisk.

34. Letter from "Jimmie" to Aaron Douglas, July 13, 1924, Box 1, Folder 11, Douglas Papers, Schomburg, NYPL.

35. "Harlem Renaissance," speech, Box 3, Folder 3, Douglas Papers, Fisk.

36. Aaron Douglas, Personal writings, Box 3, Folder 15, Douglas Papers, Fisk. The importance of the issue of *Survey Graphic* raises a question about the timing of Douglas's arrival in Harlem. There has been some confusion over this point, but it is significant for the influences that led him to come to the city. Douglas indicated in every document that he arrived in Harlem in 1925 after seeing the issue in Kansas City. But Mary Schmidt Campbell, *Harlem Renaissance: Art of Black America* (New York: Abrams, 1987), p. 174, states that Douglas arrived in Harlem in 1924, before the publication of the issue. Incontrovertible evidence proves that Douglas saw the issue before arriving in Harlem, which puts his arrival date at 1925. He wrote to Alta Sawyer commenting on the issue and indicating that he had received in Kansas City (Box 1, Folder 51, Douglas Papers, Schomburg, NYPL). Further proof that Douglas arrived in Harlem in 1925 is a clipping from the March 1927 issue of *Crisis*. The short biography of Douglas on page 13 of the "Poetry and Painting" section states: "He was teacher of drawing in Lincoln High School, Kansas City, Missouri, from 1923 until 1925, when he came to New York City to study under Winold Reiss." The biography of Douglas compiled by the Schomburg Center for Research in Black Culture states: "In 1925 Douglas left his job as a teacher at the black high school in Kansas City, to study art with Austrian artist Winold Reiss, who instilled in Douglas the concept of drawing on his black cultural heritage for this art work" (Douglas Biography, Box 1, Folder 21, Douglas Papers, Schomburg, NYPL).

Chapter Two: The Pulse of the Negro World

1. Mary Schmidt Campbell, *Harlem Renaissance: Art of Black America* (New York: Abrams, 1987), pp. 62–63.

2. Ibid., p. 63. Along with this issue, Charles Johnson decided to institute in the Urban League's magazine *Opportunity* new awards for outstanding achievement as incentive for the new artists. He announced this innovation in his September editorial, saying the awards would commence the following May (1925). The *Crisis*, the NAACP's monthly magazine, also announced that it would award literary prizes backed by the NAACP.

3. *Survey Graphic* 6 (March 1925): 628.

4. *Survey Graphic* 6 (March 1925): 627. The magazine actually listed Locke as professor of philosophy at Harvard University.

5. Alain Locke, ed., *The New Negro* (New York: Albert and Charles Boni, 1925), p. 254.

6. Alain Locke, "Enter the New Negro," *Survey Graphic* 6 (March 1925): 631.

7. Although Locke was correct to note these changes, the vast majority of black Americans remained in the South.

8. Locke, "Enter the New Negro," p. 632.

9. Ibid.

10. Ibid., p. 633.

11. Ibid.

12. Alain Locke, "Youth Speaks," *Survey Graphic* 6 (March 1925): 659.

13. For the German-educated Du Bois, such a celebration of what was unique and honorable about blacks derived from Hegelian philosophy. A similar celebration of white genius in the beginning of the twentieth century has been termed by the historian Joel Williamson "Volksgeistian Conservatism" (*A Rage for Order: Black/White Relations in the American South Since Emancipation* [New York: Oxford University Press, 1986], pp. 65–69, 206–7).

14. Locke, "Youth Speaks," p. 660.

15. Ibid.

16. Ibid.

17. For another view, see Gilbert Osofsky, *Harlem, The Making of a Ghetto: Negro New York, 1890–1930* (New York: Harper & Row, 1966). Osofsky is far more negative than *Survey Graphic*, although many of the same points—about price gouging in rents, discrimination in employment, poor housing, substandard health care, crime, and poor sanitation—are raised in the special issue.

18. James Grossman, *Land of Hope: Chicago, Black Southerners and the Great Migration* (Chicago: University of Chicago Press, 1989), pp. 27–31, discusses the desire of black migrants to better their economic opportunities by migrating north. This is also chronicled in painter Jacob Lawrence's migration series, sixty panels dating to 1942, now in the Phillips Collection and Museum of Modern Art.

19. Alain Locke, "Harlem," *Survey Graphic* 6 (March 1925): 630. The social problems are discussed by several contributors to the *Survey Graphic* issue, among them Eunice Hunter, Winthrop Lane, Charles S. Johnson, W. E. B. Du Bois, and Rudolph Fisher.

20. James Weldon Johnson, "The Making of Harlem," *Survey Graphic* 6 (March 1925): 639.

21. Ibid.

22. Melville Herskovits, "The Dilemma of Social Pattern," *Survey Graphic* 6 (March 1925): 676.

23. Alain Locke, "The Art of the Ancestors," *Survey Graphic* 6 (March 1925): 673. This article was only a page, with four illustrations. Locke ex-

panded this essay for the November 1925 publication of *The New Negro* and included it under the heading "The Negro Digs Up His Past."

24. Countee Cullen, "Heritage," a series of poems and reproductions of Barnes Foundation African art in *Survey Graphic* 6 (March 1925): 674–75.

25. David Driskell, "Aaron Douglas," in Campbell, *Harlem Renaissance*, p. 110.

26. Douglas, Personal writings, Box 3, Folder 15, Douglas Papers, Fisk.

27. *Survey Graphic* 6 (March 1925): 652–53.

28. This discussion of Reiss is based on Jeffrey Stewart, *To Color America: Portraits of Winold Reiss* (Washington D.C.: National Portrait Gallery, 1989), pp. 17–23.

29. Ibid., p. 17.

30. Ibid.

31. *Survey Graphic* 6 (March 1925): 653. Some of these drawings are today housed in the Fisk University Library on the first floor, a gift to Fisk by Winold Reiss in 1953, at the urging of Aaron Douglas.

32. J. A. Rogers, "Jazz at Home," *Survey Graphic* 6 (March 1925): 666.

33. Locke, ed., *The New Negro*, p. 7.

34. Douglas to Locke, n.d., Box 164–25, Correspondence, Alain Locke Papers, Moorland-Spingarn Research Center, Manuscript Division, Howard University, Washington, D.C.

Chapter Three: An Artist Concerned with Black Life

1. Nathan Huggins, *The Harlem Renaissance* (New York: Oxford University Press, 1971), p. 9.

2. Douglas, Speech, "New Horizons in Art," n.d. (its contents seem to date it from the 1960s), Box 3, Folder 9, Douglas Papers, Fisk.

3. Houston A. Baker, Jr., *Modernism and the Harlem Renaissance* (Chicago: University of Chicago Press, 1987), p. 76.

4. Huggins, *Harlem Renaissance*, p. 85.

5. Ibid., p. 128.

6. Ibid., p. 65.

7. Aaron Douglas, Interview, L. M. Collins, July 16, 1971, BOH, Fisk.

8. Douglas, Interview, Shockley, BOH, Fisk.

9. Douglas, Interview, David Levering Lewis, Voices of the Harlem Renaissance, July 1974, Schomburg Center for Research in Black Culture.

10. Huggins, *Harlem Renaissance*, p. 135. See also Arnold Rampersad, *The Life of Langston Hughes*, Vol. 1 (New York: Oxford University Press, 1986), pp. 156–210.

11. Huggins, *Harlem Renaissance*, p. 179.

12. Ibid., p. 136.

13. James Weldon Johnson, ed., *The Book of American Negro Poetry*. (New York: Harcourt, Brace, 1922), pp. 35–36.

14. Robert C. Toll, *Blacking Up: The Minstrel Show in Nineteenth-Century America* (New York: Oxford University Press, 1974).

15. Douglas, Interview, Shockley, BOH, Fisk.

16. Mason to Locke, April 7, 1929, Correspondence, Charlotte Mason, Folder 26, Alain Locke Papers, Moorland-Spingarn Research Center, Howard University, Washington, D.C.

17. Douglas, Interview, Lewis.

18. Douglas, Interview, Collins, BOH, Fisk. The original plan for the bathroom is in the James Weldon Johnson papers at the Beinecke Library, Yale University, New Haven, Conn.

19. Douglas, Interview, Shockley, BOH, Fisk.

20. Gary Reynolds, *Against the Odds: African American Artists and the Harmon Foundation* (Newark, N. J.: Newark Museum, 1989).

21. Evelyn Brown, "Negro Achievement Revealed by Harmon Award," *Opportunity* 5 (January 1927): pp. 20–22.

22. Quoted in Cedric Dover, *American Negro Art* (Greenwich, Conn.: New York Graphic Society, 1960), p. 31.

23. Quoted from Reynolds, *Against the Odds*, p. 67.

24. Douglas, Interview, Collins, BOH, Fisk.

25. Langston Hughes, "The Looking Glass," *Crisis* 31 (March 1926), p. 246.

26. Douglas, Interview, Collins, BOH, Fisk.

27. Ibid.

28. Hughes, "The Looking Glass," p. 246.

29. Douglas, Interview, Shockley, BOH, Fisk.

30. Douglas, Interview, Collins, BOH, Fisk.

31. *Crisis* 37 (July 1930): 235.

32. William Ferris, "African Influence on the Art of the United States," in Ferris, ed., *Afro-American Folk Art and Crafts* (Jackson: University Press of Mississippi, 1983), pp. 27–66.

33. Douglas Interview, Collins, BOH, Fisk.

34. Huggins, *Harlem Renaissance*, p. 187.

35. Mason to Locke, ca. August–November 1927, Locke Papers.

36. Sally Price, *Primitive Art in Civilized Places* (Chicago: University of Chicago Press, 1989), p. 89.

37. Douglas Interview, Shockley, BOH, Fisk.

38. *Kansas City Call*, November 4, 1927, reprinted from an article by Lester A. Walton in the *New York World*.

39. *Crisis* 33 (December 1926): pp. 81–82.

40. James Weldon Johnson, "Romance and Tragedy in Harlem—A Review," *Opportunity* 4 (October 1926): 316.

41. Douglas, Interview, Shockley, BOH, Fisk.

42. Frederick Lewis Allen, *Only Yesterday: An Informal History of the Nineteen-Twenties* (New York: Harper and Brothers, 1931).

43. Douglas, Speech, "Harlem Renaissance," ca. 1970, Box 3, Folder 3, Douglas Papers, Fisk.

44. Aaron Douglas, Speech, "New Horizons in Art," n.d., Box 3, Folder 9, Fisk University Special Collections, Nashville, Tennessee.

45. Alain Locke, ed., *The New Negro* (New York: Albert and Charles Boni, 1925), p. 7.

46. Douglas, Interview, Collins, BOH, Fisk.

47. Douglas, foreword to "Dillard Speech," ca. 1970, Box 1, Folder 1, Douglas Papers, Fisk. The speech itself is missing.

48. Douglas, Interview, Shockley, BOH, Fisk.

49. Rudolph P. Byrd, *Jean Toomer's Years with Gurdjieff: Portrait of an Artist, 1923–1936* (Athens: University of Georgia Press, 1991).

50. David Levering Lewis, *When Harlem Was in Vogue* (New York: Oxford University Press, 1981), p. 72.

51. Rampersad, *Life of Langston Hughes*, p. 285.

52. Douglas to Alta Sawyer, n.d., Box 1, Folder 3, Douglas Papers, Schomburg, NYPL.

53. Douglas, Interview, Lewis.

54. Douglas Interview, Collins, BOH, Fisk.

55. Huggins, *Harlem Renaissance*, pp. 171–72.

Chapter Four: A Visual Artist with an Authentic Voice

1. Douglas to Alta Sawyer, n.d. (late spring or early summer 1925), Box 1, Folder 5, Douglas Papers, Schomburg, NYPL. In the same letter he told Alta, "I wished you were going to teach here. This place is so different."

2. Douglas to Alta Sawyer, n.d., Box 1, Folder 8, ibid.

3. Lewis, *When Harlem Was in Vogue*, pp. 96–97.

4. Douglas, Interview, Collins, BOH, Fisk.

5. Douglas to Alta Sawyer, ca. 1925, Box 1, Folder 1, Douglas Papers, Fisk.

6. "Award Programs," Box 113, Harmon Foundation Papers.

7. Aaron Douglas to Alta Sawyer, n.d., Box 1, Folder 4, Douglas Papers, Fisk.

8. Douglas to Alta Sawyer, n.d., Box 1, Folder 2, Douglas Papers, Schomburg, NYPL.

9. Douglas to Alta Sawyer, n.d., Box 1, Folder 2, ibid.

10. Recommendation for Harmon Award, Box 42, Harmon Foundation Papers.

11. "Holbein of the Humble" was a reference to the famous artist of the Northern Renaissance, Hans Holbein, who was particularly noted for his superb and penetrating portraits.

12. Douglas to Alta Sawyer, n.d. (probably summer 1925), Box 1, Folder 5, Douglas Papers, Schomburg, NYPL.

13. Douglas, Interview, Shockley, BOH, Fisk.

14. Douglas to Alta Sawyer, n.d. (sometime in summer 1925), Box 1, Folder 5, Douglas Papers, Schomburg, NYPL.

15. Robert Hayden, Preface to Alain Locke, ed., *The New Negro* (New York: Atheneum, 1968), p. xii.

16. Douglas to Alta Sawyer, 1925, Box 1, Folder 1, Douglas Papers, Schomburg, NYPL.

17. Lewis, *When Harlem Was in Vogue*, p. 97.

18. Douglas, Interview, Shockley, BOH, Fisk.

19. Douglas, Speech, "Harlem Renaissance," ca. 1970, Box 3, Folder 3, Douglas Papers, Fisk.

20. Douglas to Alta Sawyer, n.d., Box 1, Folder 6, Douglas Papers, Schomburg, NYPL.

21. Douglas to Alta Sawyer, n.d., Box 1, Folder 1, ibid.

22. Douglas to Alta Sawyer, n.d. (ca. 1925), Box 1, Folder 6, ibid.

23. Lewis, *W. E. B. Du Bois*, p. 513.

24. Huggins, *Harlem Renaissance*, p. 39.

25. Lewis, *W. E. B. Du Bois*, p. 512.

26. Douglas, Interview, Shockley, BOH, Fisk.

27. W. E. B. Du Bois, "Criteria of Negro Art," speech delivered at the Chicago NAACP conference and reprinted in *Crisis* 32 (October 1926): pp. 290–97.

28. Douglas to Alta Sawyer, sometime in 1925, Box 1, Folder 1, Douglas Papers, Schomburg, NYPL.

29. Douglas to Alta Sawyer, n.d., Box 1, Folder 4, ibid. The Du Bois Papers indicate that Douglas held this position for at least a year and a half (September 11, 1927, 23:1018, W. E. B. Du Bois Papers, microfilm edition, University of Massachusetts, Amherst).

30. Douglas to Alta Sawyer, n.d., Box 1, Folder 6, Douglas Papers, Schomburg, NYPL.

31. Douglas to Alta Sawyer, n.d., Box 1, Folder 6, ibid.

32. Douglas to Alta Sawyer, n.d., Box 1, Folder 1, ibid.

33. Douglas to Alta Sawyer, n.d., Box 1, Folder 8, ibid.

34. Douglas, Speech, "Harlem Renaissance," Box 3, Folder 3, Douglas Papers, Fisk.

35. Douglas to Alta Sawyer, n.d., Box 1, Folder 2, Douglas Papers, Schomburg, NYPL.

36. Du Bois to Aaron Douglas, October 23, 1926, 20:525, Du Bois Papers.

37. Douglas, Interview, Collins, BOH, Fisk.

38. Douglas to Du Bois, September 11, 1927, 23:1018, Du Bois Papers.

39. Douglas to Du Bois, May 1931?, 34:853, ibid.

40. Du Bois to Douglas, May 20, 1931, 34:854, ibid.

Chapter Five: The Evolution of Douglas's Artistic Language

1. Douglas to Alta Sawyer, n.d. (ca. 1925), Box 1, Folder 8, Douglas Papers, Fisk.

2. Georgia Douglas Johnson, "The Black Runner," *Opportunity* 3 (September 1925): 258.

3. Ibid. Drawing by Aaron Douglas. This is a published illustration. The original and most of the others discussed in this book have been lost. It is likely, however, that most were executed in either pen and ink or gouache, judging from the few surviving drawings.

4. Aaron Douglas, "Self-Portrait," *Opportunity* 3 (September 1925): 285.

5. Douglas to Alta Sawyer, n.d., 1925, Box 1, Folder 1, Douglas Papers, Schomburg, NYPL.

6. Douglas to Alta Sawyer, n.d., Box 1, Folder 3, ibid.

7. Douglas to Alta Sawyer, n.d. (ca. January 1926), Box 1, Folder 4, Douglas Papers, Fisk.

8. Aaron Douglas, Drawing, *Invincible Music, the Spirit of Africa, Crisis* 31 (February 1926): 169. This drawing gives the illusion of a cutout silhouette, black and white, with wavy lines of gray tones.

9. This flower design, like others Douglas used in his illustrations, is similar to one found in Theodore Menten, ed., *Art Nouveau and Early Art Deco Type and Design* (New York: Dover, 1972), p. 9.

10. Douglas Interview, Collins, BOH, Fisk.

11. Giorgio Lise, *How to Recognize Egyptian Art* (New York: Penguin, 1979), pp. 42–43.

12. Douglas Interview, Collins, BOH, Fisk.

13. These plants, which are repeated throughout Douglas's illustrations, are clearly influenced by Art Nouveau and early Art Deco patterning, and can be found in Menten, ed., *Art Nouveau and Early Art Deco Type and Design*, pp. 9 and 15.

14. James Porter, *Modern Negro Art* (1943; reprint, New York: Arno Press, 1969), p. 114.

15. Ibid., p. 115.

16. Douglas to Hughes, December 21, 1925, James Weldon Johnson Memorial Collection of Negro Arts and Letters, Beinecke Rare Book and Manuscript Library, Yale University.

17. Douglas and Hughes, "Feet O'Jesus," *Opportunity* 4 (October 1926): cover.

18. J. M. Nash, *Cubism, Futurism and Constructivism* (Woodbury, N. Y.: Barron's), p. 17.

19. John Golding, *Cubism: A History and Analysis, 1907–1914* (Cambridge, Mass.: Harvard University Press, 1988), p. 146.

20. Douglas, "Autobiography," n.d., Douglas Papers, Fisk.

21. Douglas, Untitled (head of man), *Crisis* 33 (November 1926): cover.

22. W. E. B. Du Bois, "Peace," *Crisis* 33 (December 1926): 59.

23. Douglas Interview, Collins, BOH, Fisk.

24. Ibid.

25. These skyscrapers, showing modern city life, resemble those found in architectural drawings of the 1920s, such as Alfred J. Tulk's designs for a repoussé plaque for the executive offices in the Chanin Building, in Alastair Duncan, *American Art Deco* (New York: Abrams, 1986), p. 11. Skyscrapers adhering to setback laws were appearing all over Manhattan, often adorned with Deco detailing. Skyscrapers also appeared in precisionist works by Charles Sheeler as early as 1920 in *New York*, in the Art Institute of Chicago. See Lillian Dochterman, *The Quest of Charles Sheeler* (Iowa City: University of Iowa Press, 1963).

26. These sketchbooks are undated, but Douglas refers to his interest in cubism in numerous letters to Alta Sawyer dating from 1925–26. Sketchbooks, Box 2, Folder 1, Douglas Papers, Fisk.

27. Katherine Lochridge, ed., *The Precisionist Painters, 1916–1949: Interpretations of a Mechanical Age* (Huntington, N. Y.: Heckscher Museum, 1978), pp. 17–21.

28. Alain Locke and Aaron Douglas, "The Negro and the American Stage," *Theatre Arts Monthly* 10 (February 1926): 112–20, and illustrations, 117–18.

29. Ibid., p. 117. The original of this drawing was probably executed in gouache. Douglas later made a plate of it to reproduce in print form.

30. Jeffrey Stewart, *To Color America: Portraits by Winold Reiss* (Washington, D.C.: National Portrait Gallery, 1989), p. 57.

31. Alain Locke, "The Negro and the American Stage," *Theatre Arts Monthly* 10 (February 1926): 118.

32. Rampersad, *Life of Langston Hughes*, pp. 134–36.

33. Ibid., p. 138.

34. Handwritten Letter by Aaron Douglas on *Fire!!* stationery, n.d., Box 1, Folder 9, Douglas Papers, Schomburg, NYPL.

35. Wallace Thurman, ed., *Fire!!* (November 1926).

36. Douglas Interview, Collins, BOH, Fisk.

37. Ibid.

38. Bruce Kellner, ed., *The Harlem Renaissance: A Historical Dictionary for the Era* (New York: Methuen, 1987), p. 154.

39. Douglas Interview, Shockley, BOH, Fisk.

40. Kellner, ed., *Harlem Renaissance*, p. 154.

41. Campbell, *Harlem Renaissance*, p. 110.

42. Douglas Interview, Shockley, BOH, Fisk.

Chapter Six: *The New Negro* and Other Books

1. Douglas to Alta Sawyer, ca. 1925, Box 1, Folder 8, Douglas Papers, Schomburg, NYPL. Although Locke told him he would play second fiddle to Covarrubias, eleven of Douglas's drawings appeared in the book and only one by Covarrubias.

2. Alain Locke, ed., *Plays of Negro Life* (New York: Harper and Brothers, 1927).

3. This pattern resembles those found in Menten, *Art Nouveau and Early Art Deco Type and Design*, p. 5.

4. Douglas Interview, Collins, BOH, Fisk.

5. James Weldon Johnson, *God's Trombones: Seven Negro Sermons in Verse* (New York: Viking Press, 1927) p. 29.

6. The original oil painting *Noah's Ark* by Aaron Douglas is in the Aaron Douglas Collection of African-American Art, Fisk University, Nashville, Tennessee.

7. Johnson, *God's Trombones*, p. 41.

8. Wallace Thurman, *The Blacker the Berry* (New York: Macaulay, 1929).

9. André Salmon, *The Black Venus* (New York: Macaulay, 1929).

10. Douglas Interview, Lewis.

Chapter Seven: The Hallelujah Period

1. Kellner, ed., *Harlem Renaissance*, p. 24.

2. Carl McCardle, "The Terrible Tempered Barnes," *Saturday Evening Post*, March 21, 1942, p. 9.

3. Richard Wattenmaker, "Dr. Albert C. Barnes and the Barnes Foundation," in Wattenmaker, *Great French Paintings from the Barnes Foundation* (New York: Knopf, 1993), p. 3.

4. *New Republic*, March 1923, quoted ibid., p. 6.

5. Kellner, ed., *Harlem Renaissance*, p. 25.

6. Ibid., p. 25.

7. Aaron Douglas to Alta Sawyer, n.d., Box 1, Folder 8, Douglas Papers, Schomburg, NYPL.

8. Douglas Interview, Shockley, BOH, Fisk.

9. Ibid.

10. The Barnes Foundation has two letters in its archive between Douglas and Barnes, but despite repeated requests to examine the letters, I have received no reply from the foundation.

11. *Kansas City Call*, November 4, 1927, reprinted from an article by Lester A. Walton in the *New York New World*.

12. Douglas, Speech, "Harlem Renaissance," p. 14, Douglas Papers, Fisk.

13. Fisk University is now organizing a restoration of the murals.

14. Douglas Interview, Collins, BOH, Fisk.

15. Much of this description is a paraphrase from Douglas's own account of this work, written in 1930, in Fisk University Library.

16. Ibid.

17. Aaron Douglas, Autobiography, n.d., pp. 14–15, Box 1, Folder 1, Douglas Papers, Fisk.

18. Douglas Interview, Shockley, BOH, Fisk.

19. Douglas, Autobiography, Douglas Papers, p. 14, Box 1, Folder 1, Douglas Papers, Fisk.

20. Douglas's description of the Harriet Tubman mural at Bennett College for Women, Greensboro, North Carolina, was originally printed in the college bulletin and reprinted in *Crisis* 39 (January 1932): 449.

21. The *Annuaire General du Commerce* of Paris indicates that the Hotel St. Pierre was the only hotel located on the rue de l'Ecole de Medecine. This street, as its name indicates, consisted primarily of medical services. A small hotel exists at the same address today.

22. Campbell, *Harlem Renaissance*, p. 175.

23. Whistler's connection with 6 rue Jules-Chaplain is mentioned in John Milner, *The Studios of Paris* (New Haven: Yale University Press, 1988), p. 218.

24. Douglas, Autobiography, p. 16, Box 1, Folder 1, Douglas Papers, Fisk.

25. Douglas Interview, Lewis.

26. Interview with Hale Woodruff by Al Murray, November 18, 1968, pp. 1–3. Hale Woodruff Papers, Amistad Research Center, Tulane University, New Orleans.

27. Letter from Hale Woodruff to his mother, October 11, 1927, ibid.

28. Letter from Hale Woodruff to Countee Cullen, November 2, 1930, ibid.

29. Lynda Roscoe Hartigan, "Henry Ossawa Tanner," in *Sharing Traditions:*

Five Black Artists in Nineteenth Century America (Washington, D.C.: National Museum of American Art, 1985), p. 100.

30. Ibid., p. 103.

31. Douglas Interview, Shockley, BOH, Fisk.

32. Hartigan, "Henry Ossawa Tanner," p. 106.

33. All of these paintings by Henry O. Tanner are described or reproduced, ibid., pp. 99ff.

34. Douglas Interview, Collins, BOH, Fisk.

35. Huggins, *Harlem Renaissance*, p. 169.

36. Notes from Aaron Douglas, October 27, 1949, Schomburg, NYPL.

37. This description is paraphrased from an article on Aaron Douglas's library murals in the Fisk University newspaper, n.d. but ca. 1930.

38. T. R. Poston, "Murals and Marx," *New York Amsterdam News*, November 24, 1934. Despite his public avowal of Marxism, the FBI never opened a file on Douglas. There are more than one hundred pages of material in which his name appears. Although requests under the Freedom of Information Act to view this material were made in 1990, they remain "pending" because of what the FBI claims is an enormous backlog.

39. Ibid.

40. Ibid.

Chapter Eight: The Father of Black American Art

1. This sketch of Motley relies heavily on Jontyle Theresa Robinson and Wendy Greenhouse, *The Art of Archibald Motley, Jr.* (Chicago: Chicago Historical Society, 1991).

2. Ibid., p. 12.

3. Elsa Honig Fine, *The Afro-American Artist* (New York: Hacker Books, 1982), p. 125.

4. Porter, *Modern Negro Art*.

5. Interview with LiFran Fort, former student of Aaron Douglas and lecturer of art at Fisk University, June 11, 1991.

6. Interview with Minnie Miles, former student of Aaron Douglas and former director of the Fisk University Art Collections, June 11, 1991.

7. Douglas Interview, Shockley, BOH, Fisk.

8. *Hidden Heritage: The Roots of Black-American Painting*, film by David Driskell, Cue Productions, British Arts Council, 1990.

9. Fine, *Afro-American Artist*, p. 2.

10. Douglas, Speech, "Harlem Renaissance," p.17, Box 3, Folder 3, Douglas Papers, Fisk.

Bibliography

Primary Sources

Countee Cullen Papers. Letters, 1927. Amistad Research Center, Tulane University, New Orleans, Louisiana.

Aaron Douglas Papers. Fisk University Special Collections, Nashville, Tennessee.

Aaron Douglas Papers. Schomburg Center for Research in Black Culture, New York Public Library.

W. E. B. Du Bois Papers. University of Massachusetts, Amherst. Microfilm edition.

Harmon Foundation Papers. Manuscript Division, Library of Congress, Washington, D.C.

Langston Hughes Papers. Beinecke Library, Yale University, New Haven, Connecticut.

Charles S. Johnson Papers. Beinecke Library, Yale University, New Haven, Connecticut.

James Weldon Johnson Memorial Collection of Negro Arts and Letters. Beinecke Rare Book and Manuscript Library, Yale University, New Haven, Connecticut.

Alain Locke Papers. Moorland-Spingarn Research Center, Howard University, Washington, D.C.

NAACP Papers. Manuscript Division, Library of Congress, Washington, D.C.

Rosenwald Fund Archives. Letters, 1931–1948. Amistad Research Center, Tulane University, New Orleans, Louisiana. Microfilm.

Walter White Papers. Manuscript Division, Library of Congress, Washington, D.C.

Hale Woodruff Papers. Amistad Research Center, Tulane University, New Orleans, Louisiana.

Oral Histories

Interview of Aaron Douglas by L. M. Collins, July 16, 1971. Black Oral Histories, Fisk University Special Collections, Nashville, Tennessee.

Interview of Aaron Douglas by David Levering Lewis. Voices of the Harlem Renaissance. July 1974. Schomburg Center for Research in Black Culture, New York.

Interview of Aaron Douglas by Ann Allen Shockley. November 19, 1975. Black Oral Histories, Fisk University Special Collections, Nashville, Tennessee.

Interviews

Interview with LiFran Fort. Instructor of Art at Fisk University. (Former student of Aaron Douglas.) June 11, 1991.

Interview with Minnie Miles. Curator, Van Vechten Gallery, Fisk University. (Former student of Aaron Douglas.) June 11, 1991.

Interview with Valena Minor Williams. (Heir to Aaron Douglas.) Oakland, California, January 2, 1991.

Contemporary Periodicals and Newspapers

The Crisis. Vol. 7, December 1913–Vol. 38, May 1931.

Opportunity. Vol. 3, No. 33, 1925–Vol. 5, No. 11, November 1927.

"Show the Light and the People Will Find the Way." *West African Pilot,* May 18, 1939.

Thurman, Wallace, ed. *Fire!!* Vol. 1, No. 1, November 1926.

———. *Harlem: A Forum of Negro Life.* Vol. 1, No. 1, Fall 1928.

Winslow, Vernon. "Negro Art and the Depression." *Opportunity,* February 1941, pp. 40–42, 62–63.

Periodicals and Newspapers

"Aaron Douglas, Painter, at 79; Founded Fisk Art Department." *New York Times,* February 22, 1979.

"Artist Shows Blacks as 'Proud, Majestic.'" *Chicago Defender,* February 24, 1973.

Bearden, Romare. "Farewell to Aaron Douglas." *Crisis,* May 1979, reprinted from *New York Amsterdam News,* February 24, 1979.

"Black Academy Honors Trio of Peers." *San Francisco Chronicle,* October 10, 1972, p. 43.

"Black Sounds." *Christian Science Monitor,* July 16, 1971, p. 15.

Bontemps, Alex. "Black Painter's 1929 Mural Still Provocative." *Nashville Tennessean,* February 14, 1971.

Churchwell, Robert. "Aaron Douglas Restoring Fisk Murals from 1930." *Nashville Banner,* July 28, 1965, p. 12.

———. "Wing Named for Art Expert Aaron Douglas." *Nashville Banner,* July 12, 1972.

Davis, Donald F. "Aaron Douglas of Fisk: Molder of Black Artists." *Journal of Negro History*, Spring 1974, pp. 95–99.

Fax, Elton. "Aaron Douglas, Gifted Black Painter and a Fighter of Every Form of Sham." *Daily World*, March 13, 1979.

Glueck, Grace. "Negro Art from 1800 to 1950 Is on Display at City College." *New York Times*, October 16, 1967, p. 47.

"Governor's Mansion Will Get Art Work." *Milwaukee Journal*, January 3, 1967.

Lane, James W. "Afro-American Art on Both Continents." *Art News*, October 1941, p. 25.

Lewis, David Levering. "The Politics of Art: The New Negro, 1920–35." *Prospects: An Annual Journal of American Cultural Studies*, 1977, pp. 237–61.

McBride, Marian. "Negro Art to Enhance Mansion." *Milwaukee Sentinel*, December 10, 1966.

McCardle, Carl. "The Terrible Tempered Barnes." *Saturday Evening Post*, March 21, l942, p.9.

"Mural in Fisk University Library," *Saturday Review of Literature*, March 12, 1932.

"No Show." *New Republic*, February 16, 1948, p.7.

Poston, T. R. "Murals and Marx." *New York Amsterdam News*, November 24, 1934, p. 1.

———. "New Mural Unveiled in Assembly Hall of Library Here." *New York Amsterdam News*, December 28, 1934.

"Tarnished Renaissance: Harlem Art in the 1920s." *Washington Post*, December 26, 1971, p. k–1.

Unpublished Works

Bontemps, Jacqueline. "The Life and Work of Aaron Douglas: A Teaching Aid for the Study of Black Art." M.A. thesis, Fisk University, 1971.

Gilpin, Patrick Joseph. "Charles S. Johnson: An Intellectual Biography." Ph.D. dissertation, Vanderbilt University, 1973.

Gordon, Allan. "Cultural Dualism in the Themes of Certain Afro-American Artists." Ph.D. dissertation, Ohio University, 1969.

Other Published Sources

African American Artists, 1880–1987: Selections from the Evans-Tibbs Collection. Washington, D.C.: Smithsonian Institution Traveling Exhibition Service, 1989.

Allen, Frederick Lewis. *Only Yesterday: An Informal History of the Nineteen-Twenties.* New York: Harper & Brothers, 1931.

Baigell, Matthew. *Dictionary of American Art.* New York: Harper & Row, 1979.

Baker, Eric, and Tyler Blik. *Trademarks of the 20's and 30's.* San Francisco: Chronicle Books, 1985.

Baker, Houston A., Jr. *Afro-American Poetics: Revision of Harlem and the Black Aesthetic.* Madison: University of Wisconsin Press, 1988.

————. *Modernism and the Harlem Renaissance.* Chicago: University of Chicago Press, 1987.

Barksdale, Richard K. *Langston Hughes, The Poet and His Critics.* Chicago: American Library Association, 1977.

Barnes, Albert C. *The Art in Painting.* New York: Harcourt, Brace, 1925.

Bearden, Romare, and Harry Henderson. *Six Black Masters of American Art.* New York: Zenith Books, 1972.

Bergson, Henri. *Creative Evolution.* New York: Holt, 1911.

Berry, Mary Frances, and John Blassingame. *Long Memory: The Black Experience in America.* New York: Oxford University Press, 1982.

Bohan, Ruth L. *The Société Anonyme's Brooklyn Exhibition: Katherine Dreier and Modernism in America.* Ann Arbor: UMI Research Press, 1982.

Bone, Robert. *Down Home: A History of Afro-American Short Fiction from Its Beginnings to the Harlem Renaissance.* New York: G. P. Putnam, 1975.

Bontemps, Arna. *The Harlem Renaissance Remembered.* New York: Dodd, Mead, 1972.

Bontemps, Arna Alexander, and Jacqueline Fonvielle-Bontemps. *Forever Free: Art by African American Women, 1862–1980.* Alexandria, Va.: Stephenson, 1980.

Brawley, Benjamin. *The Negro Genius: A New Appraisal of the Achievement of the American Negro in Literature and the Fine Arts.* New York: Dodd, Mead, 1937.

Brown, Ina Corinne. *The Story of the American Negro.* New York: Friendship Press, 1936.

Brown, Milton Wolf. *American Painting from the Armory Show to the Depression.* Princeton: Princeton University Press, 1955.

Brown, Sterling. *Negro Poetry and Drama and the Negro in American Fiction.* 1937. Reprint. New York: Atheneum, 1969.

Butcher, Margaret Just. *The Negro in American Culture.* New York: Knopf, 1956.

Byrd, Rudolph P. *Jean Toomer's Years with Gurdjieff: Portrait of an Artist, 1923–1936.* Athens: University of Georgia Press, 1991.

Campbell, Mary Schmidt. *Harlem Renaissance: Art of Black America.* New York: Abrams, 1987.

Cantor, Gilbert M. *The Barnes Foundation: Reality vs. Myth.* Philadelphia: Consolidated/Drakes Press, 1974.

Cederholm, Theresa Dickason, ed. *Afro-American Artists: A Bio-Bibliographical Directory.* Boston: Trustees of the Boston Public Library, 1973.

Charters, Samuel Barclay, and Leonard Kunstadt. *Jazz: A History of the New York Scene*. Garden City, N. Y.: Doubleday, 1962.

Chase, Judith Wragg. *Afro-American Art and Craft*. New York: Van Nostrand Reinhold, 1971.

Cheney, Sheldon. *A Primer of Modern Art*. New York: Boni and Liveright, 1924.

Clarke, Henrik, ed. *W. E. B. Du Bois: An Anthology by the Editors of Freedomways*. Boston: Beacon Press, 1970.

Cooper, Wayne F. *Claude McKay: Rebel Sojourner in the Harlem Renaissance, A Biography*. Baton Rouge: Louisiana State University Press, 1987.

Cox, Thomas C. *Blacks in Topeka, Kansas, 1865–1915*. Baton Rouge: Louisiana State University Press, 1982.

Cronon, Edmund David. *Black Moses: The Story of Marcus Garvey and the Universal Negro Improvement Association*. Madison: University of Wisconsin Press, 1955.

Cruse, Harold. *Crisis of the Negro Intellectual*. New York: William Morrow, 1967.

Davis, Arthur P. *From the Dark Tower: Afro-American Writers, 1900–1960*. Washington, D.C.: Howard University Press, 1974.

Degler, Carl N. *Neither Black nor White: Slavery and Race Relations in Brazil and the United States*. New York: Macmillan, 1971.

De Jongh, James. *Vicious Modernism: Black Harlem and the Literary Imagination*. New York: Cambridge University Press, 1990.

Dover, Cedric. *American Negro Art*. Greenwich, Conn.: New York Graphic Society, 1960.

Driskell, David. *Two Centuries of Black American Art*. Los Angeles and New York: Los Angeles County Museum of Art and Alfred A. Knopf, 1976.

Driskell, David, and Earl J. Hooks. *The Afro-American Collection, Fisk University*. Nashville: Department of Art, Fisk University, 1976.

Duncan, Alastair. *American Art Deco*. New York: Abrams, 1986.

Essien-Udom, E. U. *Black Nationalism: A Search for Identity in America*. New York: Dell, 1964.

Fax, Elton. *Seventeen Black Artists*. New York: Dodd, Mead, 1971.

Ferris, William, ed. *Afro-American Folk Art and Crafts*. Jackson: University Press of Mississippi, 1983.

Fine, Elsa Honig. *The Afro-American Artist: A Search for Identity*. New York: Hacker Books, 1982.

Fleming, Robert E. *James Weldon Johnson*. Boston: Twayne, 1987.

———. *James Weldon Johnson and Arna Wendell Bontemps: A Reference Guide*. Boston: G. K. Hall, 1978.

Floyd, Samuel A., ed. *Black Music in the Harlem Renaissance: A Collection of Essays*. New York: Greenwood Press, 1990.

Franklin, John Hope. *From Slavery to Freedom: A History of Negro America*. 6th ed. New York: McGraw-Hill, 1988.

Friedman, Martin L. *Charles Sheeler: Paintings, Drawings, Photographs*. New York: Watson-Guptill, 1975.

Gallagher, Buell G. *Color and Conscience: The Irrepressible Conflict*. New York: Harper and Brothers, 1946.

Golding, John. *Cubism: A History and an Analysis, 1907–1914*. Cambridge, Mass.: Harvard University Press, 1988.

Goldwater, Robert J. *Primitivism in Modern Art*. New York: Harper, 1938.

Greenfield, Howard. *They Came to Paris*. New York: Crown, 1975.

Grossman, James R. *Land of Hope: Chicago, Black Southerners, and the Great Migration*. Chicago: University of Chicago Press, 1989.

Hammond, Leslie King. *Ritual and Myth: A Survey of African American Art*. New York: Studio Museum in Harlem, 1982.

Harris, Trudiere, ed. *Afro-American Writers from the Harlem Renaissance to 1940*. Detroit: Gale, 1987.

Hartigan, Lynda Roscoe. *Sharing Traditions: Five Black Artists in Nineteenth Century America*. Washington, D.C.: Smithsonian Institution Press, 1985.

Hemenway, Robert. *Zora Neale Hurston: A Literary Biography*. Urbana: University of Illinois Press, 1977.

Henri, Florette. *Black Migration: Movement North, 1900–1920*. Garden City, N. Y.: Doubleday Anchor Press, 1975.

Herbert, Robert L., ed. *The Société Anonyme and the Dreier Bequest at Yale University: A Catalogue Raisonne*. New Haven: Yale University, 1984.

Honey, Maureen, ed. *Shadowed Dreams: Women's Poetry of the Harlem Renaissance*. New Brunswick: Rutgers University Press, 1989.

Huggins, Nathan. *The Harlem Renaissance*. New York: Oxford University Press, 1971.

———, ed. *Voices from the Harlem Renaissance*. New York: Oxford University Press, 1976.

Hughes, Langston. *Weary Blues*. New York: Knopf, 1926.

Hughes, Langston, and Arna Bontemps. *The Poetry of the Negro, 1746–1970*. Garden City, New York: Doubleday and Company, 1970.

Hughes, Langston, and Milton Meltzer. *Black Magic: A Pictorial History of the Negro in American Entertainment*. Englewood Cliffs, N. J.: Prentice-Hall, 1967.

Hull, Gloria T. *Color, Sex and Poetry: Three Women Writers of the Harlem Renaissance*. Bloomington: Indiana University Press, 1987.

Igoe, Lynn M. *Two Hundred and Fifty Years of Afro-American Art: An Annotated Bibliography*. New York: Bowker, 1981.

Johnson, Charles S., ed. *Ebony and Topaz: Collectanea.* 1927. Reprint. Freeport, N.Y.: Books for Libraries, 1971.

Johnson, James Weldon. *Autobiography of an Ex-coloured Man.* New York: Knopf, 1927.

————. *Black Manhattan.* New York: Knopf, 1930.

————. *God's Trombones: Seven Negro Sermons in Verse.* New York: Viking Press, 1927.

————. *The Book of American Negro Spirituals.* New York, Viking, 1925.

————, ed. *The Book of American Negro Poetry.* New York: Harcourt, Brace, 1922.

Kandinsky, Wassily. *The Blaue Reiter Almanac.* New York: Viking Press, 1974.

Kellner, Bruce. *Carl Van Vechten and the Irreverent Decades.* Norman: University of Oklahoma, 1968.

————, ed. *The Harlem Renaissance: A Historical Dictionary for the Era.* New York: Methuen, 1987.

————, ed. *Keep a-inchin' along: Selected Writings of Carl Van Vechten about Black Art and Letters.* Westport, Conn.: Greenwood Press, 1979.

————, ed. *Letters of Carl Van Vechten.* New Haven: Yale University Press, 1987.

Kery, Patricia Frantz. *Art Deco Graphics.* New York: Abrams, 1986.

Kramer, Victor A., ed. *The Harlem Renaissance Re-examined.* New York: AMS Press, 1987.

Lemann, Nicholas. *The Promised Land: The Great Black Migration and How It Changed America.* New York: Knopf, 1991.

Levine, Lawrence. *Black Culture and Black Consciousness.* New York: Oxford University Press, 1977.

————. *High Brow, Low Brow: The Emergence of Cultural Hierarchy in America.* Cambridge, Mass.: Harvard University Press, 1988.

Levy, Eugene. *James Weldon Johnson, Black Leader, Black Voice.* Chicago: University of Chicago Press, 1973.

Lewis, David Levering. *W. E. B. Du Bois: Biography of a Race, 1868–1919.* New York: Holt, 1993.

————. *When Harlem Was in Vogue.* New York: Oxford University Press, 1981.

Lewis, Samella. *Art: African American.* New York: Harcourt Brace Jovanovich, 1978.

Lochridge, Katherine, ed. *The Precisionist Painters, 1916–1949: Interpretations of a Mechanical Age.* Huntington, N. Y.: Heckscher Museum, 1978.

Locke, Alain. *Negro Art: Past and Present.* Washington D.C.: Associates in Negro Folk Education, 1936.

————. *The Negro in Art*. Washington, D.C.: Associates in Negro Folk Education, 1940.

————, ed. *The New Negro*. New York: Albert and Charles Boni, 1925. Reprint. New York: Atheneum, 1968.

————, ed. *Plays of Negro Life*. New York: Harper and Brothers, 1927.

Lueders, Edward. *Carl Van Vechten*, New York: Twayne, 1964.

————. *Carl Van Vechten and the Twenties*. Albuquerque: University of New Mexico Press, 1955.

Makela, Maria Martha. *The Munich Secession: Art and Artists in Turn-of-the-Century Munich*. Princeton: Princeton University Press, 1990.

Marriott, Charles. *Modern Movements in Painting*. London: Chapman and Hall, 1920.

Martin, Tony. *Literary Garveyism: Garvey, Black Arts and the Harlem Renaissance*. Dover, Mass.: Majority Press, 1983.

————, ed. *African Fundamentalism: A Literary and Cultural Anthology of Garvey's Harlem Renaissance*. Dover, Mass.: Majority Press, 1991.

May, Henry. *The End of American Innocence: A Study of the First Years of Our Own Time, 1912–1917*. New York: Knopf, 1959.

McKay, Claude. *Harlem: Negro Metropolis*. New York: Dutton, 1940.

————. *Harlem Shadows*. New York: Harcourt, Brace and World, 1922.

Meier, August. *Negro Thought in America, 1880–1915*. Ann Arbor: University of Michigan Press, 1963.

Meier, August, and Elliot Rudwick. *From Plantation to Ghetto*. Toronto: McGraw-Hill, 1966.

Menten, Theodore, ed. *Art Nouveau and Early Art Deco Type and Design*. New York: Dover, 1972.

Milner, John. *The Studios of Paris. New Haven: Yale University Press, 1988.*

Mitchell, Loften. *Black Drama: The Story of the American Negro in the Theatre*. New York: Hawthorne, 1967.

Morand, Paul. *Black Magic*. New York: Viking Press, 1929.

Nash, J. M. *Cubism, Futurism and Constructivism*. Woodbury, New York: Barron's, 1978.

New Muse Community Museum of Brooklyn, New York. *The Black Artists in the WPA, 1933–43*. Charlene Chase Van Derger, Curator; George Carter, Assistant Curator. February 15–March 30, 1976.

Nichols, Charles H. *Arna Bontemps–Langston Hughes Letters, 1925–67*. New York: Dodd, Mead, 1980.

Olsson, Martin. *A Selected Bibliography of Black Literature: The Harlem Renaissance*. Exeter, England: University of Exeter, 1973.

Osofsky, Gilbert. *Harlem, the Making of a Ghetto: Negro New York, 1890–1930*. New York: Harper & Row, 1966.

Ottley, Roi, and William Weatherby, eds. *The Negro in New York: An Informal Social History*. New York: Praeger, 1969.

Perry, Margaret. *Silence to the Drums: A Survey of the Literature of the Harlem Renaissance*. Westport, Conn.: Greenwood Press, 1976.

Ploski, Harry A. and Warren Marr. *The Negro Almanac: A Reference Work on the Afro-American*. New York: Bellwether, 1976.

Poore, Henry R. *The Conception of Art and the Reason of Design*. New York: G. P. Putnam's Sons, 1913.

Powell, Richard. *African and Afro-American Art: Call and Response*. Chicago: Field Museum of Natural History, 1984.

————. *The Blues Aesthetic: Black Culture and Modernism*. Washington, D.C.: Washington Project for the Arts, 1989.

Porter, James. *Modern Negro Art*. 1943. Reprint: New York, Arno Press, 1969.

Price, Sally. *Primitive Art in Civilized Places*. Chicago: University of Chicago Press, 1989.

Rampersad, Arnold. *The Life of Langston Hughes*. Vol. 1. New York: Oxford University Press, 1986.

Reynolds, Gary. *Against the Odds: African American Artists and the Harmon Foundation*. Newark, N.J.: Newark Museum, 1989.

Robinson, Jontyle Theresa, and Wendy Greenhouse. *The Art of Archibald Motley, Jr.* Chicago: Chicago Historical Society, 1991.

Rose, Barbara. *American Art Since 1900*. New York: Praeger, 1975.

Rosenblum, Robert. *Cubism and Twentieth-Century Art*. New York: Abrams, 1966.

Rourke, Constance Mayfield. *Charles Sheeler, Artist in the American Tradition*. New York: Harcourt, Brace, 1938.

Rozelle, Robert, ed. *Black Art: Ancestral Legacy, the African Impulse in African-American Art*. Dallas: Dallas Museum of Art, 1989.

Salmon, André. *The Black Venus*. New York: Macaulay, 1929.

Schaumann and Masareel. *Des Grosse Hesdes*. Vols. 9 and 10. 1934, 1935.

Schmutzler, Robert. *Art Nouveau*. New York: Abrams, 1978.

Schoener, Allan, ed. *Harlem on My Mind: Cultural Capital of Black America, 1900–1968*. New York: Random House, 1968.

Scruggs, Charles. *The Sage in Harlem: H. L.Mencken and the Black Writers of the 1920s*. Baltimore: Johns Hopkins University Press, 1984.

Sterling, Dorothy, and Benjamin Quarles. *Lift Every Voice: The Lives of Booker T. Washington, W. E. B. Du Bois, Mary Church Terrell, and James Weldon Johnson*. Garden City, N. Y.: Zenith Books, Doubleday, 1965.

Stewart, Jeffrey. *To Color America: Portraits by Winold Reiss*. Washington, D.C.: Smithsonian Institution Press, 1989.

————, ed. *The Critical Temper of Alain Locke: A Selection of His Essays on Art and Culture*. New York: Garland, 1983.

Spate, Virginia. *Orphism: The Evolution of Non-Figurative Painting in Paris, 1910–1914*. Oxford: Clarendon Press, 1979.

Studio Museum in Harlem, New York. *Hale Woodruff: 50 Years of His Art*. April 29—June 24, 1979. Catalog essays by Mary Schmidt Campbell, Gylbert Coker, and Winifred Stoelting.

————. *New York, Chicago: WPA and the Black Artist*. November 13, 1977–January 8, 1978. Ruth Ann Stewart, Guest Curator.

Thompson, Robert Farris. *Flash of the Spirit: African and Afro-American Art and Philosophy*. New York: Random House, 1983.

Thurman, Wallace. *The Blacker the Berry*. New York: Macaulay, 1929.

Toll, Robert C. *Blacking Up: The Minstrel Show in Nineteenth-Century America*. New York: Oxford University Press, 1974.

Toomer, Jean. *Cane*. 1923. Reprint. New York: Norton, 1975.

Torgovnick, Marianna. *Gone Primitive: Savage Intellects, Modern Lives*. Chicago: University of Chicago Press, 1990.

Vincent, Theordore G. *Voices of a Black Nation: Political Journalism in the Harlem Renaissance*. San Francisco: Ramparts Press, 1973.

Vlach, John M. *The Afro-American Tradition in Decorative Arts*. Cleveland: Cleveland Museum of Art, 1978.

Waldron, Edward E. *Walter White and the Harlem Renaissance*. Port Washington, N. Y.: Kennikat Press, 1978.

Wattenmaker, Richard J. *Great French Paintings from the Barnes Foundation*. New York: Knopf, 1993.

Williamson, Joel. *A Rage for Order: Black/White Relations in the American South Since Emancipation*. New York: Oxford University Press, 1986.

Wilmerding, John. *American Art*. New York: Penguin Books, 1976.

Wintz, Cary D. *Black Culture and the Harlem Renaissance*. Houston: Rice University Press, 1988.

Woodward, C. Vann. *The Strange Career of Jim Crow*. New York: Oxford University Press, 1974.

Index

Academie, Colarossi, 117
Academie de Grande Chaumiere, 116–17
Academie Delecluse, 117
Academie Julien, 118, 119
Academie Ranson, 117
Academie Russe de Peinture, 117
Academie Scandinave, 117, 118, 127
Africa, 26, 44, 46, 95, 103, 111, 112, 127, 131, 133; Congo-Angola, 44; Ivory Coast, 30, 45, 49, 78, 81, 83, 103; Nile River, 81
African art and culture, 15–17, 20, 25–26, 27, 30, 34, 43–47, 49, 54, 61–62, 79–80, 86, 96, 103, 106–07, 110, 112, 114–15, 121, 126–27, 128, 131–32, 133
Alabama, 2, 128, 129
Albright-Knox Art Gallery, 100
Alpha Assisi Charity Club, 2
Amistad (slave ship), 128
Archipenko, Alexander, 25
Art Deco, 30, 76, 77, 78, 81, 83, 92, 96
Art Institute of Chicago, 80, 127
Art Nouveau, 27, 92
Ault, George, 84, 115; Construction Night, 84

Baker, Houston, Jr., Modernism and the Harlem Renaissance, 33
Bannister, Edward, 10, 11; Newspaper Boy, 10

Barnes, Albert C., 80, 99, 105–09, 110, 125; The Art in Painting, 105–06; "Negro Art and America," 107, 109
Barnes, Dorothy, 56
Barnes Foundation, 25, 26, 36, 37, 45, 56, 69, 80, 83, 85, 103, 105, 106, 107–09
Barthé, Richmond, 54, 126
Beinecke Rare Book and Manuscript Library, 97
Bennett, Gwendolyn, 51–52, 57, 87, 107, 108–09
Benton, Thomas Hart, 82, 128
Bergson, Henri, Creative Evolution, 63
Berlin University, 16
Biggers, John, 130
Black Topeka Federation, 3
Blaue Reiter almanac, 28
Blumenschein, 28
Blyden, Willmot, Islam, Christianity, and the Negro Race, 44
Bontemps, Arna, 52, 53
Book of American Negro Poetry, 23
Bortnyik, Sandor, Red Locomotive, 10
Braithwaite, Stanley, 11
Braque, Georges, 46, 75, 79; Landscape at L'Estaque, 75; Nude, 79
Breedlove, Sarah, 52
Bruce, R. K., 57
Burleigh, H. T., 11
"Bushongo," 83
Byfield, Charles and Edward, 114

Capitalism, 123–24
Carter, William, 2
Cezanne, Paul, 79, 105, 108, 127
Cheney, Sheldon, 9, 10, 79–80, 99;
 Primer of Modern Art, 9, 10, 106
Chesnutt, Charles, 11
Christianity, 112
Cinque, 128
Civil rights movement, 133
Club Ebony, 36
Coleridge, Samuel Taylor, 11
Collection Berggruen, 79
College Art Association, 40
Columbia University, 129
Commission on the Church and Race
 Relations, 39
Communist Party, 42
Conception of Art and the Reason of Design
 (Poore), 9–10
Contemporary Negro Art exhibition, 40
Cooper Union, 128
Covarrubias, Miguel, 58, 92
Crisis, 8, 12, 13, 20, 39, 41, 47, 58, 65,
 66–67, 68, 69, 70, 73, 76–78, 81–84,
 86, 89, 93, 95, 115, 125
Crowinshield, Frank, 38, 90
Cubism, 10, 27, 29, 30, 74–75, 79, 80,
 82, 84, 92, 95, 98, 99, 100, 101, 107,
 108, 113, 119, 121, 125, 129
Cullen, Countee, 20, 26, 45, 52, 59, 74,
 118
cummings, e. e., 45
Czechoslovakia, 16, 17, 32; Prague, 17

Dan sculpture, 30, 83, 103
Dark Tower, 52
Davis, John P., 51, 87
Dawson, William L., 9
Degas, Edgar, 105
Delaunay, Robert, 99, 102, 126; Simul-
 taneous Contrasts: Sun and Moon, 99,
 126; Window on the City No. 3, 126
Demuth, Charles, 115; High Tower, 100;
 Lancaster, 100
Depression, the, 121, 123, 128
Derain, André, 79; Last Supper, 80

Despiau, Charles, 117
Detroit Museum of Art, 6
Dett, Nathaniel, 11
Dewey, John, 105
Die Brücke posters, 82
Diez, Julius, 27
Dillard University, 129
Douglas, Aaron, Jr., Africanism, 27, 43,
 44–45, 47, 61, 64, 66, 73, 76, 77–78,
 80, 82, 86, 96, 103, 109, 114–15, 121,
 125, 126–27, 129, 131, 133; anatomy
 studies, 120; as art editor of Crisis, 69;
 as art editor of Harlem, 90; artistic
 friendships, 50–54, 56–60, 66–69,
 69–70, 86, 132; artistic independence,
 37, 41, 45, 132; artistic training, 6, 7,
 8, 9, 27, 58, 60, 61–64, 116–17, 120–
 21; awards and prizes, 7, 69, 81, 82;
 birth, 2; death, 134; education, 2, 3,
 6–7, 8; employment, 3, 5–7, 8, 66–
 67; fellowship from Barnes Founda-
 tion, 105, 106, 107–09; fellowship
 from Rosenwald Foundation, 116,
 129; Hallelujah period, 111; influ-
 ences, 9–11, 26–27, 29, 30, 44, 45,
 53, 73, 78, 79–80, 92, 99, 125–26; as
 lecturer, 129; Marxism, 42, 82, 91,
 121–22, 123–24; military service, 7–
 8; move to Detroit, 3–6; move to
 Dunkirk, N.Y., 6; move to Harlem,
 11–13, 23, 31, 55; move to Kansas
 City, Mo., 9; move to Lincoln, Neb.,
 6, 8; move to Minneapolis, 7; primi-
 tivism, 46–47, 94, 102, 103, 104, 115;
 teaching career, 8–9, 11, 37, 129–31,
 133–34; trip to American South, 116,
 129; trip to the Dominican Republic
 and Haiti, 116, 129; trip to Paris,
 105, 116–18, 120–21; white patrons,
 36–37, 38–39, 45, 107–09, 132
Books illustrated: Autobiography of an
 Ex-Coloured Man, 97–98; Banana Bot-
 tom, 104; Banjo, 104; Black Magic,
 102–04, 108, 115, 125; Black Venus,
 101; The Blacker the Berry, 101; Ebony
 and Topaz: A Collectanea, 104; Fine

Clothes to the Jew, 104; *For Freedom,* 104; *God's Trombones,* 38, 41, 80, 98–101, 114, 125; *Home to Harlem,* 104; *Little Pitchers,* 104; *A Long Way from Home,* 104; *The New Negro,* 60–61, 73, 75–76, 92–95; *Plays of Negro Life,* 95–96; *Weary Blues,* 86

Exhibitions: Baltimore Museum, 129; Barnett Aden Gallery, 129; Caz-Delbos Gallery, 129; Chabot Gallery, 129; St. Louis Gallery, 129

Magazines illustrated: *Crisis,* 68, 69, 70, 76–78, 81–84, 95, 125; *Fire!!,* 52–53, 75, 87, 88; *Harlem,* 90; *Opportunity,* 57, 69, 70, 71–76, 78–79, 80–81, 82, 85, 88, 94, 95, 125; *Spark: Organ of the Vanguard,* 90–91; *Theatre Arts Monthly,* 68–69, 85–86, 94, 95

Mural locations: Bennett College, 64, 116; Club Ebony, 36, 64, 109–10, 115; College Inn, 64, 102, 110, 111, 114, 115, 121–22; Countee Cullen Library, 64, 121–23, 124, 129, 131; Fisk University, 41, 45, 64, 69, 110–14, 121–22; Sherman Hotel, 41, 111, 114–15; YMCA, 64, 124

Works: *The African Chieftain,* 69; *An' the stars began to fall,* 73, 94; *Aspects of Negro Life,* 121–23; *The Burden of Black Womanhood,* 82–83; *The Creation,* 75, 94, 99; *Dance Magic,* 114–15; *The Emperor Jones,* 94, 96; *Forest Fear,* 95–96; *From the New World,* 95; *The Fugitive,* 96; *I couldn't hear nobody pray,* 73; *I needs a dime for a beer,* 80; *An Idyll of the Deep South,* 123; *Invincible Music, the Spirit of Africa,* 68, 76–77, 95; *Let My People Go,* 100–01; *Luani of the Jungles,* 90; *Ma Bad Luck Card,* 81; *Meditation,* 75–76, 93, 94; *Mulatto,* 72; *Music,* 94; *The Negro in an African Setting,* 121; *On de No'thern Road,* 80; *The People of the Shooting Stars,* 103–04; *Play de Blues,* 80; *The Poet,* 94; *Poster of the Krigwa Players Little Negro Theatre of Harlem,* 77, 78;

Rebirth, 93; *Roll, Jordan, Roll,* 73, 94; *Sahdji,* 93–94; Self-portrait, 72; *Slavery through Reconstruction,* 122; *Song of the Towers,* 123; *Spirit of Africa,* 95; *Surrender,* 96; *Tut-Ankh-Amen,* 78; *Weary as I can Be,* 80; *The Young Black Hungers,* 83–84

Douglas, Aaron, Sr. (father), 2
Douglas, Alta Sawyer (wife), 9, 11, 37, 51, 53, 55, 57, 58–59, 61, 62, 63, 64, 66, 68–69, 86, 92, 107, 109, 110, 122
Douglas, Elizabeth (mother), 1, 2
Du Bois, Felix, 44; *Timbuctoo the Mysterious,* 44
Du Bois, W. E. B., 7, 8, 14, 20, 44, 47–48, 50, 52, 55, 59, 64–70, 77, 78, 81, 87, 89, 95, 110, 118; "Criteria of Negro Art," 65–66; "Peace," 81; *Souls of Black Folk,* 65
Dumas, Alexandre (père and fils), 11
Dunbar, Paul Laurence, 11, 20, 36, 107; "We Wear the Mask," 36
Duncanson, 11
Dürer, Albrecht, 99
Düsseldorf Academy, 27

Eakins, Thomas, 119
Ecole des Beaux-Arts, 119, 128
Egypt, 111, 112
Egyptian art, 30, 62, 73, 76, 77, 79, 80, 81, 82, 83, 92, 96, 98, 100–01, 103
Emancipation, 111
Emancipation Proclamation, 122, 129–30
Exodusters, 2
Exposition de la Croisier Noire, L', 82
Expressionism, German, 10

Fauset, Arthur, 73; *For Freedom,* 104; "The Negro's Cycle of Song—A Review," 73, 94
Fauset, Jessie, 20, 52
Fax, Elton, 130
Federal Council of Churches, 39
Fire!!, 51–52, 75, 82, 85, 87–90
Fisher Body Company, 5

Fisk University, 37, 45, 59, 110–14, 124, 129–31, 134
Fitzgerald, F. Scott, 118
Folk culture, 62, 73, 98, 104
Foster, Edward, 3, 4, 6
France, 25, 59, 126; Paris, 11–12, 25, 57, 58, 79, 85, 109, 116–21, 127, 128, 129
Fresnaye, Roger de La, 80; *La Conquête de l'Air*, 80
Friesz, Othon, 117
Fuller, Meta Vaux Warrick, 10–11, 20, 45, 131; *The Awakening of Ethiopia*, 11

Galerie Alex Maguy, 79
Garvey, Marcus, 26
Gauguin, Paul, 28, 79
Germany, 16, 25, 30, 82, 84; Karlsruhe, 27; Munich, 27, 28
Glackens, William, 105
Gleizes, Albert, *Paysage*, 10; *Three People Seated*, 106
Glen, Isa, *Little Pitchers*, 104
Graham, John, 118
Gregory, Montgomery, "The Drama of Negro Life," 94
Guillaume, Paul, 25, 45
Gurdjieff, George Ivanovitch, 52–54, 121

Hampton Institute, 57
Harleston, Edwin, 111
Harlem magazine, 89–90
Harlem Renaissance, 12; aims, 32–33; artistic integrity of black artists, 40–41, 132; critics, 33–34, 54, 132; elitism, 33–34, 132, 133; group identity, 34, 35, 50–54, 132; legacy, 130; literature, 34; music, 34–35; origins, 12–13, 32; theater, 36; visual arts, 34–35, 54, 68, 96, 126, 132; white patronage, 33, 34, 35–41, 45–46, 54, 106–07, 108, 132. *See also* "New Negro" movement
Harmon, William E., 39

Harmon Foundation, 39–40, 57, 59, 128
Harvard University, 16
Hayden, Palmer, 39–40, 59, 118, 126–27, 128, 129; *Fetiche et Fleurs*, 128
Hayden, Robert, 60–61
Hayes, Roland, 26–27, 59, 81
Hemingway, Ernest, 118
Henri, Robert, 132
Herskovits, Melville, "The Dilemma of Social Pattern," 24–25
Hibbs, Henry C., 110
Holabuird and Foot, 114
Holland, 27
Howard University, 16
Huggins, Nathan, 32, 33–34, 36, 37, 41, 44–45, 46, 47, 49, 50, 54, 132
Hughes, Langston, 8, 20, 35–36, 38, 40–41, 42, 43–44, 48, 51, 52, 74, 78–79, 80–81, 86, 87, 89–90, 118, 122, 132; "Afro-American Fragment," 43–44; "Bound No'th Blues," 80; "Down an' Out," 80; "Feet o'Jesus," 79; *Fine Clothes to the Jew*, 104; "Hard Luck," 81; "Lonesome Place," 80, 93; "Misery," 80; "The Negro Artist and the Racial Mountain," 86; "To Midnight Nan at Leroy's," 74; *Weary Blues*, 86
Hurston, Zora Neale, 35, 51, 74, 86, 87

Illinois, Alton, 4; Cairo, 127; Chicago, 102, 114, 116, 127
Impressionism, 10, 119, 127
Indiana, Indianapolis, 127
Indianapolis Star, 127
Interstate Library Association, 2
Iowa, Des Moines, 7
Ireland, 15, 16, 17, 32; Dublin, 17

Jackman, Harold, 52
Jackson, May, 20
James, William, 105
Jazz, 29–30, 34, 41, 114–15
Jazz Age, 80–81
John Herron Art Institute, 127

Johnson, Charles S., 14, 50, 55–59, 68, 70, 74, 89, 106, 107, 110; *Ebony and Topaz: A Collectanea*, 104
Johnson, Georgia Douglas, 71–72; "The Black Runner," 71–72
Johnson, James Weldon, 14, 18–19, 20, 23–24, 38, 48, 97–101; *The Autobiography of an Ex-Coloured Man*, 23, 97–98; "Black Simon," 100; "The Creation—A Negro Sermon," 75, 94, 99; "Go Down Death: A Funeral Sermon," 99–100; *God's Trombones: Seven Negro Sermons in Verse*, 38, 41, 80, 98–101, 114, 125; "The Judgment Day," 101; "Listen, Lord—A Prayer," 98; "The Making of Harlem," 23; "Noah Built the Ark," 100; "The Prodigal Son," 99; "To America," 18–19
Johnson, Joshua, 10
Johnson, Sargeant, 45
Jones, Eugene Kinkle, 57
Jones, Thomas E., 110, 114
Jubilee Hall, 111, 112
Jugendstil, 27

Kansas, Topeka, 1, 2–3, 6, 110
Kansas City Call, 109–10
Kansas Hospital Aid Association, 2
Kansas Industrial and Educational Institute, 2
Kellog, Paul, 14, 35; "The Negro Pioneers," 95
Kennedy, John F., 130
Kirchner, Ernst Ludwig, 82
Krigwa Players, 67, 68, 77
Ku Klux Klan, 33, 122
Kunstgewerbe Schule (Munich), 27
Kunstmuseum (Basel), 75
Kupka, Frantisek, 99, 102, 126; *Disks of Newton (Study for Fugue in Two Colors)*, 99, 126

League of Nations, 16
Lehmbruck, Wilhelm, 25

Lewis, David Levering, 34, 65; *When Harlem Was in Vogue*, 34
Lewis, Edmonia, 10, 11; *Forever Free*, 10
Library and Literary Society (Topeka), 2
Lincoln High School (Kansas City), 9
Lipchitz, Jacques, 25
Little Theatre Movement, 67
Locke, Alain, 12, 13, 15, 16–23, 25, 26, 27, 28–29, 30, 31, 33, 34, 35, 37, 41, 45–46, 50, 59, 60–61, 72, 85, 86, 87, 90, 92, 95, 106, 107, 109, 110, 118, 125; "The Legacy of the Ancestral Arts," 17, 109; "The Negro and the American Stage," 94; "The Negro Spirituals," 73, 94; "Negro Youth Speaks," 19–20, 73; *The New Negro*, 13, 17, 26, 30–31, 32, 33, 60–61, 73, 75–76, 92–95, 103, 106–07, 109; *Plays of Negro Life*, 95–96; "The Technical Study of the Spirituals—A Review," 72–73, 94
Louisiana, New Orleans, 127, 129
Lozowick, Louis, 84; *Pittsburgh*, 84

Marriott, Charles, 9, 10, 99; *Modern Movements in Painting*, 9, 10
Marsh, Reginald, 132
Marshall Hotel, 23
Marx, Karl, 122, 123
Marxism, 122
Mason, Charlotte, 35–38, 39, 45–46, 104, 108
Matisse, Henri, 10, 25, 79, 80, 100, 105, 106, 108; *Music Lesson*, 106; *Piano Lesson*, 100
McKay, Claude, 20, 45, 118, 132; *Banana Bottom*, 104; *Banjo*, 104; *Home to Harlem*, 45, 104; *A Long Way from Home*, 104
Messenger, 13, 82, 86
Mexico, 15
Michigan, Detroit, 4, 5–6
Migration of blacks, 2, 3–4, 17, 21–22, 32, 123
Mills, Florence, 110

Minneapolis Steel Machinery Company, 7
Minnesota, Minneapolis, 7, 8
Minnesota, University of, 7, 8
Minstrelsy, 36, 85
Mississippi, 2, 4, 24
Missouri, East St. Louis, 4; Kansas City, 4, 9, 11, 12, 13, 23, 55; St. Louis, 4
Modernism and modern art, 10, 61, 79–80, 99, 107, 108, 125, 126, 129, 132
Modigliani, Amedeo, 25
Monet, Claude, 105
Morand, Paul, *Black Magic*, 102–04, 108, 115, 125
Motley, Archibald, 126–27, 128, 129; *Africa*, 127
Munich Academy, 27
Munro, Thomas, 45
Museum of Modern Art, 80

Nance, Ethel Ray, 12, 56, 68
Nation, 86
National Association for the Advancement of Colored People (NAACP), 23, 48, 58, 65, 84, 98, 106
National Federation of Colored Women's Clubs, 2
National Urban League, 12, 14, 55–56, 57, 58, 66, 106
Nebraska, 60; Lincoln, 6, 8
Nebraska, University of, 6, 8
Negro Awards program, 39
Negro Colony (Paris), 118
"Negro Digs Up His Past, The," 95
"Negro" question, 3, 66
Neuberger Museum, 100
New Gallery, 127
"New Negro" movement, 12–13, 15–16, 17, 65; centrality of Harlem, 17, 19, 21–25, 26, 30–31, 65; importance of artists, 16–17, 19–20; racial cooperation, 18, 19; white patronage, 18, 22. *See also* Harlem Renaissance
New York, Brooklyn, 53; Dunkirk, 6; Harlem, 9, 11–13, 14, 15–16, 17, 19, 21–22, 23, 24, 25, 26, 30–31, 47–49, 51, 65, 86, 120; New York City, 21, 24, 31, 108, 126, 129
New York Amsterdam News, 122
New York University, 64
Nugent, Richard Bruce, 51, 52, 86, 90; "Sahdji," 93–94

Ohio, Cleveland, 4–5
O'Neill, Eugene, 85; *All God's Chillun Got Wings*, 85; *The Emperor Jones*, 85–86, 95–96
Opportunity, 8, 12, 13, 39, 55, 56, 57, 58, 59–60, 67, 68, 69, 70, 71–76, 78–79, 80–81, 82, 85, 86, 88, 89, 93, 94, 95, 125
Orphism, 99, 100, 101, 102, 108, 113, 126
Oxford University, 16

Palette of King Narmer, 101
Pan-Africanism, 26, 78, 81, 103, 132
Pechstein, Max, 82
Pennsylvania, 118; Merion, 69, 105, 108; Philadelphia, 37, 108; Pittsburgh, 24
Pennsylvania Academy of Fine Arts, 119
Phillips collection, 84
Picabia, Francis, 126
Picasso, Pablo, 25, 27, 46, 79, 105, 106, 108; *Demoiselles d'Avignon*, 79; *Man with a Mandolin*, 106; *Still Life*, 106; *A Woman*, 10; *Woman with a Mandolin*, 106
Poland, 16
Poore, Henry R., 9–10, 80
Porter, James, 40, 78, 127, 128; *Modern Negro Art*, 78, 127
Precisionism, 100, 115
Primitive art, 79, 80
Primitive Negro Sculpture (Guillame and Munro), 45
Primitivism, 33, 35–36, 45–49, 86, 94, 102, 104, 107
Progressivism, 3
Public Works Administration (PWA), 121, 123

Punkett, Professor, 57
Pushkin, Aleksandr Sergeyevich, 11

Racial violence, 1, 4, 65, 91, 123
Racism, 1, 4, 7, 24, 33, 65; in the military, 7–8
Ray, Ethel. *See* Nance, Ethel Ray
Ray, Man, 118
Reiss, Fritz Mahler, 277
Reiss, Winold, 16, 26–30, 45, 46, 51, 55, 59–64, 66, 67–68, 70, 72, 73, 76, 78, 79, 81, 83, 84, 85–86, 92, 126; *A Boy Scout*, 29; *A college lad*, 29; *Dawn in Harlem*, 29, 83; *Elise Johnson McDougald*, 30; *Four Portraits of Negro Women*, 30, 72; *Girl in the white blouse*, 29; *Interpretations of Harlem Jazz*, 30, 85–86; *The Librarian*, 30; *Two Public School Teachers*, 30; *A woman lawyer*, 29
Renoir, Pierre Auguste, 105
Rivera, Diego, 124
Robeson, Paul, 20, 23, 59, 85, 110
Rogers, J. A., 29–30; *From Man to Superman*, 29; "Jazz at Home," 29–30, 94
Rosenwald, Julius, 116
Rosenwald Foundation, 116
Rossi, Carmen, 117
Rousseau, Henri, 127
Ruckteschell, Walter von, 19
Ruskin, John, 10
Russia, 15

Salmon, André, *Black Venus*, 101
Savage, Augusta, 118
Scherenschnitt, 28, 30, 80, 82
Schmidt-Rottluff, Karl, 82
Schomburg Center for Research in Black Culture, 90
Schwitters, Kurt, 80
Scott, William, 20
Shahn, Ben, 132
Sheeler, Charles, 29, 84, 115; *Offices*, 84
Slavery, 50, 91, 111, 112, 116, 122, 133
Société Anonyme, 10, 80
South Carolina, Charleston, 111

Soviet Union, 122, 124
Stein, Gertrude, 118
Stella, Joseph, 29
Stern, Alfred, 116
Stewart, Jeffrey, 28
Stuck, Franz von, 27
Student Army Training Corps (SATC), 7
Survey Graphic, 13, 14–16, 17, 24, 25, 26–27, 29, 30–31, 32, 35, 56, 59, 60, 72, 73, 76, 83, 92, 93, 95, 106–07
Sweden, 27

Talladega College, 128
Tanner, Henry O., 10, 11, 20, 118–20; *The Banjo Lesson, Christ and Nikodemus*, 119; *Old Couple Looking at a Portrait of Lincoln*, 120; *Thankful Poor*, 119
Taos school, 28
Ten Lectures in Art (Ruskin), 10
Tennessee, 2; Nashville, 37, 59, 110, 114, 124, 129, 134
Theatre Arts Monthly, 68–69, 85–86, 94, 95
Thompson, Louise, 35
Thurman, Wallace, 51, 52, 53, 82, 87, 88, 89, 90, 132; *The Blacker the Berry*, 101
Toomer, Jean, 20, 52–54, 59; *Cane*, 52
Toulouse-Lautrec, 102
Tribal art. *See* Primitive art
Tribune Tower, 114
Tubman, Harriet, 116
Tuskegee Institute, 2, 129
Tutankhamen, 101

Ufer, 28
Underground Railroad, 116
Union Pacific Materials Yard, 3
Union Pacific Railroad, 8
Universal Negro Improvement Association, 26
Urban League. *See* National Urban League
Urbanization of blacks, 16, 17, 32

Van Vechten, Carl, 35, 37, 38–39, 47–
 49, 56, 87, 90, 110; *Nigger Heaven*,
 37, 47–49, 86, 88, 96
Vanity Fair, 38, 68, 90
Versailles Peace Conference, 16
Vinci, Leonardo da, 8
Virginia, 128
Vorticism, 10

Waits, Valena Williams, 120
Walker, A'Lelia, 52
Walker Museum (Minneapolis), 8
Walrond, Eric, 12, 74
Waroquier, Henri de, 117

Warrick, Meta. *See* Fuller, Meta Vaux
 Warrick
Washington, Booker T., 2, 65, 107
Wechsler (Nancy) collection, 84
West Indies, 26
Western Reserve University, 57
Whistler, James McNeil, 117
White, Walter, 58, 90, 106
Whitney Museum of Art, 84
Wilson, Woodrow, 16, 32
Woodruff, Hale, 39, 118, 120, 122,
 126–28, 129; Amistad Murals, 128
World War I, 4, 7–8, 16, 32, 49, 65,
 118, 123